Beauty (and the Banana)

Beauty (and the Banana)

A Theopoetic Aesthetic

BRIAN C. NIXON

Foreword by Joseph M. Holden

WIPF & STOCK · Eugene, Oregon

BEAUTY (AND THE BANANA)
A Theopoetic Aesthetic

Wipf & Stock
An Imprint of Wipf and Stock Publishers
199 W. 8th Ave., Suite 3
Eugene, OR 97401

www.wipfandstock.com

PAPERBACK ISBN: 978-1-7252-8532-3
HARDCOVER ISBN: 978-1-7252-8533-0
EBOOK ISBN: 978-1-7252-8534-7

04/29/21

To the four ladies of my life,
showing me beauty in many forms and ways:

My grandmother, Agnes Sutherland
My mother, Kay Lynn
My wife, Melanie Raquel
My daughter, Sutherland Raquel

And to my first grandchild, Abraham.

Beauty is, and it speaks your name.

God is a bottomless Emptiness, an infinite wooden trough, who wanders through the universe picking and gathering up all the beauties and guaranteeing that none will be lost, and saying that all that was loved and lost will return.[1]

—RUBEM ALVES

[Beauty] contains a summons; in it there dwells a *sursum corda*; it awakens awe in us; it elevates us above that which is base; it fills our hearts with a longing for the eternal beauty of God.[2]

—DIETRICH VON HILDEBRAND

1. Alves, *Transparencies of Eternity*, 24.
2. Hildebrand, *Beauty in the Light of the Redemption*, 22

Contents

Foreword

It's all too common in this contemporary culture to redefine, and even re-invent, what it means to identify something or someone as *beautiful*. The notion of beauty goes much deeper than one's imagination or perspective of the attractiveness, symmetry, or the exquisite balance structure of an object (or subject). It appears this important issue has been reduced to a mere relativistic and mystical notion of personal preference. The only way to escape such a superficial perspective is to ground beauty in truth, reality, and the nature of God. As this work will attest, beauty at its fundamental core is involved in every area of human life, including the arts, theology, ethics, poetry, logic, metaphysics and our very being and purpose of exis-tence. Recognizing this means that, for the author, beauty is more than skin deep—it lies within the warp and woof of being and reality itself, and what greater form of ultimate reality is there besides the being of God—hence beauty is discoverable through an analysis of *theo poetics*!

The implications stemming from the study of theopoetics cannot be overstated; it will have far-reaching and profound effects on how we under-stand what is *beautiful* and how we view and relate to others. Our thinking on this issue will become a major part of how we interpret the world and will most certainly guide our thoughts on virtually every subject known to man. It has been rightly said that "ideas have consequences," thus what comes into our mind when we think about God and beauty is the most important thing about each person. From these ideas flow thought and behavior, that is, we choose to either abase or abound, rise higher in life or become stunted, love or hate, and either become bitter or better. To be certain, we can rise in life no higher than our concept of what is true, good, holy, and beautiful. After

all, man tends to become like the object to which he aspires. This means that our belief about what is beautiful will guide and inform us in the manner and form we treat others, worship God, choose a spouse, and form public policy among many other things. What is more, knowing what is beautiful does not necessarily guarantee we *do* what is beautiful; however, it's clearly the first step to practically and skillfully living a beautiful life.

A thoroughgoing investigative journey through *Beauty (and the Banana)* should at once contribute to the reader's insight and character. Consequently, *Beauty (and the Banana)* is a fascinating journey into the foundational factors of beauty. As a result, you will appreciate the objective nature of beauty and its inseparable existence from God himself. Your investment into this volume will undoubtedly leave you yearning for the captivating "beautific-vision" that occurs when meeting God face-to-face, forever conjoined to the Lord's eternal beauty.

Tolle Lege! (Take up this book and read!)

Joseph M. Holden, PhD
President, Veritas International University

Preface

I'm writing this book during the COVID-19 crisis. Hundreds of thousands of people around the globe have lost their lives fighting the virus. The question arises: Why write about beauty in the midst of natural brutality? The answer: God is in the midst of the anguish. His beauty is still there—even when we can't seem to find it. There is beauty in the person leaving groceries on a doorstep for an elderly neighbor. It is found in the doctor who continues to provide care, despite the high risk of contracting the virus. It is found in the opera singer sitting on his porch and serenading his community at sunset. It is found in the simple prayers of people who ask for protection. It is found in the sky that shelters above; in the mountains framing our landscapes; in the waters letting us sail; in the trees that giving shade; in the flowers that continue to bloom. Beauty is.

Maybe in the end Dostoevsky was right: Beauty will help save the world.[3] So this is why I continue to write about beauty, even in the midst of a barbarous virus. Beauty is a salve for the situations we find ourselves in—wars, political unrest, and poisonous disease. And it's not only a contemplative beauty, it's a commissioned beauty, a beauty practiced and proclaimed.

In this spirit, I offer a poem to begin a beautiful journey.

3. Dostoevsky, *Idiot*, 382. For me, this is beauty with a capital "B," God; beauty invested in God's character as infused in the world.

EVENING CONVERSATION

The sun flickers off the
Sandia mountains,
offering skips of sunlight
to the barren trees and

frost-formed park.

I stare across the leaf-
worn grass, past the
willows, to the patches
of clouds kissing the sky.

I wonder at what you

said last night. "I have
feelings that need to be
expressed, but you don't
reveal yours." You cry;

I mumble.

But here are my thoughts,
dear woman of grace,
set like trepid foliage
upon the ground I now

gaze: Life is but a mystery,

sometimes at ease,
other moments an
unknown so deep all
serenity is lost in an instant

when words cease to be.

Yet look around, beauty
continues, softly, forever,
and we are part of its majesty.
So, breath, listen to its sound, be still.

Let the butterfly flutter, and watch it

splash its colors upon the sky.
The glimmer
will linger
for as long

as you let it.

LAETARE SUNDAY IN LENT, 2020

Acknowledgments

This book would not have happened if it were not for the suggestion of Dr. Joseph Holden, President, Veritas International University. While discussing a class on theopoetics, Dr. Holden suggested that I write a book on beauty. Little did he know I'd take him up on his offer. Thanks, Joe, for lighting the fire.

Thank you to Rodney Clapp and the team at Wipf & Stock. They've taken a chance with a book entitled *Beauty (and the Banana)*. Need I say more. And to Mike Surber, who created a fantastic cover. And to Jeff LeFever, whose triple exposure camera work fit perfectly for the front cover image. And Caleb Shupe. He was a maestro editor, catching many things my tired eyes missed. Thank you. A special thanks to Karl Coppock, who tracked down all the endorsements. Thanks to Savanah N. Landerholm for her layout and typesetting work. As one who appreciates fonts and typesetting (I used to work at a printer), it's always refreshing to see fine work.

I'm also indebted to three key readers. First, Kenneth Wessell (MA, University of New Mexico). With a degree in philosophy, teaching aesthetics at an art college, Kenneth helped unpack Kant. Furthermore, Kenneth provided invaluable perceptiveness into key themes on beauty. Second, Quentin Guy (MA, University of Colorado, Boulder), a friend, trusted reader, and fellow football (soccer) fan. Your input is invaluable, and your insight immense. And finally, a long-time friend and colleague, Rebekah Hanson (BA, University of Illinois-Urbana; JD, The Ohio State University). Though trained in law, her new passion is people, studying psychology. She's started her new journey at University of California, Berkeley, "Breathing dreams like air" (F. Scott Fitzgerald) and making "everything around [her]

beautiful" (Elsie de Wolfe). Rebekah helped smooth things out, giving style to the substance.

To three professors I had the honor of studying under in the course of my academic affairs (mostly through books, but for a couple, in person). First, while enrolled in the certificate program of apologetics at Biola University, Dr. William Lane Craig—during a couple of modular courses—tossed out so much information our heads turned on their axis. I sat in the back and said not a word, but I'm indebted to his work. And years after my completion of the certificate program in 2006, Dr. Craig put forth a challenge of sorts. In an interview with Kevin Harris in 2018, Harris asked, "Could one run an argument from beauty akin to the argument from morality?" Dr. Craig's response was "I hope so. I would like to see someone argue that God serves to ground objective aesthetics values in the same way that I've argued he ground objective moral values."[4] And though this book takes a slightly more Thomistic slant than Craig would support, his impetus has provided the groundwork.

Second, to one of William Lane Craig's professors and my professor at Veritas International University, Dr. Norman Geisler. Since a young believer I've been beholden to his books. And after taking his theology and apologetics courses at Veritas International University, I've found that his Thomistic leanings provided a fine backdrop for a discussion on beauty. I was honored that he approved of my syllogism on beauty before his death, where he received his own Beatific Vision. Just because he approved of my syllogism doesn't make it right, but it does make it relevant to me.

Third, Vernard Eller. Though I never met the influential philosophy professor from the University of La Verne,[5] as a newly licensed minister I was given his books as a means of study. It was through him that I learned someone can be a thinker and one with artistic sensibilities. As a philosopher-theologian (*Kierkegaard and Radical Discipleship*), author (*His End Up*, *The Promise*, *The Mad Morality*, etc.), playwright (*The Time So Urgent*), and poetry translator (*A Pearl for the Brokenhearted*), Eller showed me that one does not need to pick or choose between fields—all is open in the theo-poetic quest. Eller's is the only picture I have framed in my study. I bought it on eBay; it shows him looking at papers, a Smith-Corona typewriter faithfully by his side.[6]

4. Harris, "Questions from Facebook," 9:26–50.

5. We did, however, come close. At a Brethren conference held at La Verne, I was one of the performing musicians; Eller was the resident guest. Why our paths didn't cross, I don't know, but I am the lesser because of it.

6. See Nixon, "eBay, Vernard Eller, and the Promise."

I'm thankful for Scott Holland and Steven Schweitzer, both of the theopoetics program at Bethany Theological Seminary. Scott and Steven provided great insight and divergent views in the field of theopoetics, helping me find where I fall within the field.

A special acknowledgment to all of the various academics I gleaned from throughout the writing process: Aquinas, Balthasar, Hildebrand, Evdokimov, Eco, Scruton, Hart, Sammon, Carpenter, Nanay, Bentley, Gilson, Gadamer, and others—all named in footnotes and bibliography. And a very special thanks to Dr. Richard Viladesau. He was always quick with his email replies and encouraging in his remarks.

Finally, for the lifelong interaction with various people I've encountered in my quest for beauty: the bands I played in, the musicians I've worked alongside, the painters I'm captivated by, the churches I've exhibited (thanks, Father Graham Golden and the Norbertines), and poets that have graced me with their works.

Gratias tibi for the inspiration.

Introduction

I need you to do two things.

First, imagine you're standing at the Museum of Modern Art (MOMA) in New York.

You're staring at a painting with squiggly lines and funky colors. You don't know what to make of it. So, you hang around it for a little while, waiting to see what other people say, eavesdropping. You hear one person say, "My kindergartner could do that," and briskly walk away. Another person stays a while, studies it, and declares the painting a "masterpiece." And yet a third, a student, tilts her head and tries to come to grips with its meaning. She jots things down in a notebook, and finally remarks, as if to herself, "I just don't get it." She tumbles away from the painting, glancing over her shoulder at it once more to get one last look.

After listening to the three, you pull out your phone and Google the painting. You find that the painting sold for $20 million dollars. You almost choke.

We've all been here in some form or fashion. It may not be a painting; maybe a book, a natural setting, a city. We hear something is amazing or sublime or transcendent. But when we gaze at it ourselves, we don't find it like that. We feel like we've missed something, been duped.

What gives?

Second, I need you to bear with me.

Why? Because I know what you might be thinking right now: "What's with the title? Beauty and a banana?" I know, it's odd. And to place the words next to a heady subtitle such as "a theopoetic aesthetic!" This is where I want your patience. It'll take time for us to uncover an answer. It's coming,

I promise. But let's get a couple things out of the way. Let's me define three words and give a warning. Here's the warning: You'll be introduced to a lot of names and concepts throughout this book. Don't worry. I provide copious footnotes for you to follow along for further study—if you are so inclined.

Now to one of the big words: *aesthetics*.

According to the Oxford dictionary, *aesthetics* is "a set of principles concerned with the nature and appreciation of beauty, especially in art." Aesthetics is taken from the Greek word *aisthētikos*, "perceptible things," and from the word, *aisthesthai*, which means to "perceive."[7] Concerning aesthetics, philosopher Bence Nanay[8] writes, "When the German philosopher, Alexander Baumgarten,[9] introduced the concept of 'aesthetics' in 1750, what he meant by it was precisely the study of *sensory experience*"[10] (emphasis added). Theologian and philosopher Richard Viladesau notes that Baumgarten "also calls aesthetics the 'art of thinking beautifully' . . . and the 'art of forming taste.'"[11] Nanay continues, "Aesthetics is a way of analyzing what it means to have these experiences,"[12] suggesting that "aesthetics is not the same as philosophy of art."[13] Philosophy aside, it's clear that one aspect of aesthetics is beauty.

Based upon the various streams of thought in aesthetics, Viladesau positions three "interconnected but distinct centers of interest within aesthetics:

1. The general study of sensation and imagination and/or 'feeling' in the wider sense of nonconceptual on nondiscursive knowledge.

2. The study of beauty and/or of 'taste.'

3. The study of art in general and/or the fine arts in particular."[14]

7. Viladesau, *Theological Aesthetics*, 6. Viladesau (b. 1944) is a philosopher, theologian, and priest, writing many books on the confluence between theology and beauty.

8. Bruce Nanay is a philosopher and a co-director of the Centre for Philosophical Psychology in Antwerp.

9. Alexander Gottlieb Baumgarten (1714–62) was a German philosopher, known for his work in aesthetics.

10. Nanay, *Aesthetics*, 2.

11. Viladesau, *Theological Aesthetics*, 6.

12. Nanay, *Aesthetics*, 2.

13. Nanay, *Aesthetics*, 4. Nanay may be correct in that aesthetics is not a philosophy per se. However, others argue that aesthetics is part of philosophy.

14. Viladesau, *Theological Aesthetics*, 7.

Viladesau notes that Christians who disregard aesthetics "results in a truncated conception of faith."[15] Expanding the dialogue, theologian Brendan Thomas Sammon[16] writes, "theological aesthetics aspires to do theology from the perspective of an alliance between beauty and reason."[17] And Roger Scruton[18] states that aesthetics' "purpose was to denote a human universal."[19] Faith, reason, taste, and human universals: each of these are within the study of aesthetics—particularly beauty.

Aesthetics aside, the main thrust of *Beauty (and the Banana)* is the foundational factors of beauty, the features that afford one to reason and judge an object or idea beautiful, interesting, sublime—any value placed upon the thing.[20]

In *Beauty (and the Banana)*, I'll provide an introductory level treatment of the theological, historical, and philosophical implications of beauty and how these connotations connect to the Christian faith. For if the study of aesthetics—and by extension, beauty—is not philosophy proper, it is definitely part of theology and, by extension, theopoetics. Monroe Beardsley[21] noted how the Medieval mind saw the arts: "Painting and architecture belongs among the mechanical arts, poetry with rhetoric in trivium, music in the quadrivium, and the problem of beauty was part of theology."[22] Beauty is part of theology proper, an attribute and activity of God. Incidentally, my treatment here is written for students of theology.

And now to the second big word: *transcendentals*.

Beauty is one of the classical transcendentals, along with unity, truth, and goodness. Beauty is often placed within a subset of philosophy and theology called metaphysics. Metaphysics is the part of philosophy that concerns itself with first principles—being, time, essence, and the like.

15. Viladesau, *Theological Aesthetics*, 30.

16. Brendan Thomas Sammon is a theologian, philosopher, author, and professor.

17. Sammon, *God Who Is Beauty*, 113.

18. Sir Roger Scruton (1944–2020) was an English philosopher, author, and academic.

19. Scruton, *Beauty*, 54.

20. In his book *Called to Attraction: An Introduction to the Theology of Beauty*, Sammon provides three reasons for a theology of beauty over aesthetics. "First, beauty is more original and therefore more historically rooted than aesthetic . . . Second, there is a practical advantage for using the language of beauty rather than aesthetics. For one thing it is more common . . . Third, using the language of beauty rather than the aesthetic ensures that our inquiry begins in the world of things, the world outside the human mind" (5–6).

21. Monroe Beardsley (1915–85) was an American philosopher who concentrated on art and aesthetics.

22. Beardsley, *Aesthetics*, 105. Today, the trivium and quadrivium are known as the liberal arts.

Concerning unity, truth, beauty, and goodness, philosopher Peter Kreeft[23] said these transcendentals "will never die. . .[and] we will never get bored with [them]."[24] Why? Because they are attributes of God: "Absolutely universal properties of all reality."[25] Philosopher W. Norris Clarke[26] describes the transcendentals as "a property of being, a positive attribute that can be predicated of every real being . . . Such a property is called 'transcendental' because it leaps over all barriers between different kinds and levels or modes of being."[27] For Clarke, who echoed Aquinas,[28] the "leaping over" is akin to reality itself, properties encompassed in being.

I know, lots of jargon! We'll try to define beauty later on; in the meantime, just remember that beauty "leaps over" various kinds of existence.

The final word is *theopoetics*.

Theo is the Greek word for God. *Poetics* originates from the Greek word *poietes* (in Latin, *poeticus*): "that which pertains to poetry." In its simplest form, theopoetics is God-poetry, or the poetry of God. But there is much more to the field of theopoetic study than just a name.

Generally speaking, there are two streams of theopoetical thought. One stream gravitates towards postmodern philosophy and process theology.[29] We'll call it the First School.[30] In the contemporary world, this group is led by individuals such as Scott Holland, Steven Schweitzer, L. Callid Keefe-Perry, and Silas Krabbe. First School Theopoetics takes its cue from writers such as Amos Wilder, Stanley Hooper, Rubem Alves, and David Miller. In the late 1960s, Wilder and his contemporaries began a series of conversations on the intersection of literary and artistic qualities found within culture and theology.[31] First School Theopoetics values embodied experience,[32] linking it to an existential understanding of the Christian faith.[33]

23. Peter Kreeft (b. 1937) is an American philosopher, theologian, author, and academic.

24. See Kreeft's introduction to Baggett et al., *C. S Lewis as Philosopher*, esp. 17.

25. See Kreeft's introduction to Baggett et al., *C. S Lewis as Philosopher*, esp. 17.

26. W. Norris Clarke (1915–2008) was an American philosopher, theologian, and academic. He specialized in the philosophy of Thomas Aquinas.

27. Clarke, *One and Many*, 291.

28. Thomas Aquinas (1225–74 AD) was an Italian theologian, philosopher, author, and Dominican priest.

29. See Krabbe, *Beautiful Bricolage*.

30. The designation of First and Second schools was provided by Dr. Scott Holland.

31. See Wilder, *Theopoetic*.

32. See various references in L. Callid Keefe-Perry's *Way to Water*.

33. See Krabbe, *Beautiful Bricolage*, 3.

The second group is what we'll call Second School, or Classical Theo-poetics. This group of theopoetical study is rooted in classical Christian thought, found in the writings of Augustine of Hippo, Maximus the Confessor, Bonaventure, Thomas Aquinas, and Nicolas of Cusa.[34]

The main modern proponent of the Classical School of theopoetics is Hans Urs von Balthasar.[35] Other thinkers include Jacques Maritain, Pavel Florensky, Etienne Gilson, Dietrich von Hildebrand, Austin Marsden Farrer,[36] C. S. Lewis,[37] Paul Evdokimov, and Karl Rahner. Contemporary Classical School proponents include Richard Viladesau[38] and theologian Anne M. Carpenter.[39] To a lesser degree, but still insightful, is philosopher and theologian David Bentley Hart.[40]

As opposed to an embodied experience using literary forms to render one's engagement with God, Classical Theopoetics incorporates three over-arching fields of thought: metaphysics, Christology, and language.[41]

Furthermore, Carpenter lists three "qualities" of Balthasar's theopoetics.[42] First, "is a preference for the use of images in theology," emphasizing "a certain sensuous flexibility, since an image can of itself bear several meanings at once."[43] Second, "the theological poetic is ordered according to theological-metaphysical presuppositions," and "a theo-poetic itself must presume elements of classical metaphysics to be coherent."[44] And finally, "a theological poetic bears the marking of poetic 'logic,' which is poetry's peculiar manner of expressing its meaning," "the flexible resonation of multiple meaning together with one another, so that its exactness is found only

34. See Carpenter, *Theo-poetics*, ch. 3. Carpenter is an American theologian, philosopher, teacher, and Balthasar scholar.

35. Hans Urs von Balthasar (1905–88) was a Swiss theologian, author, and priest.

36. "Poetry, like football, rests on certain invariable facts. Man expresses himself by language, being repetitive noise, is capable of musical arrangement. . .[and] cannot apprehend anything without an act of imaginative creation" (Farrer, *Glass of Vision*, 114). *The Glass of Vision* deals with the interconnectedness of the Bible, metaphysics, and poetry. Austin Farrer (1904–68) was a friend of C. S. Lewis.

37. See Baggett et al., *C. S. Lewis as Philosopher*.

38. See Viladesau, *Theological Aesthetics*.

39. See Carpenter, *Theo-poetics*.

40. David Bentley Hart (b. 1965), *Beauty of the Infinite*. Hart is an American philosopher and Orthodox theologian.

41. Carpenter, *Theo-poetics*, 4.

42. Carpenter, *Theo-poetics*, 137.

43. Carpenter, *Theo-poetics*, 158.

44. Carpenter, *Theo-poetics*, 159.

in the whole 'sound' of theological insight taken as a 'symphony.'"[45] In short, theological images, metaphysics, and poetic-logic are all important factors off Classical Theopoetics.

Viladesau approaches the study of theopoetics in two broad ways. First, "the practice of imaginative and/or beautiful discourse ("theopoiesis"). And, second, "the theories thereof ("theopoetic")."[46] In other words, practice (*theopoiesis*) and principles (*theopoetic*). For example, C. S. Lewis practiced *theopoieses*, whereas Hans Urs von Balthasar and Austin Marsden Farrer performed *theopoieses*, elaborating on guiding principles in theology and the arts.

It's important to note two major differences between the First School and Classical/Second theopoetics.

Classical theopoetics seeks not to "confuse imagination—and thus the imaginative use of images—with knowledge of God, who transcends imagination."[47] Hence, one "cannot claim that imaginative works somehow grasp God better than—say—philosophical prose."[48] In short, both philosophy (metaphysics) and the imagination are important in classical theopoetics. Contrast this with the idea as presented by Scott Holland who values non-metaphysical theopoetics,[49] with an emphasis on the religious imagination and a community of faith.[50] When philosophy is used within the First School of theopoetics, it usually falls within a postmodern framework, whereas Classical theopoetics values historic orthodox theology, and classical metaphysics.

At the heart of the Classical theopoetic approach is the Thomistic idea of "being" and the historicity of Jesus Christ. Concerning von Balthasar's use of being, Carpenter states, "Balthasar strives to found his theology on a metaphysic of being and a thoroughgoing Christology. The language of being suffuses his work, always operating as the backdrop to his theology, including his aesthetics . . . beauty can be subjected to the law of being."[51] In other words, there is "something" rather than nothing ("being"), and Jesus is the finest example of this "something" because, ultimately, He is Being. In this manner, Classical theopoetics is Christ-centric, whereas First School

45. Carpenter, *Theo-poetics*, 158.

46. Viladesau, *Theological Aesthetics*, 13.

47. Carpenter, *Theo-poetics*, 144.

48. Carpenter, *Theo-poetics*, 144.

49. Holland, "Theopoetics Is the Rage." Holland is a professor at Bethany Theological Seminary and the Earlham School of Religion. He is a leading thinker in the field of theopoetics and directs the theopoetics program at Bethany Theological Seminary.

50. Holland, "So Many Good Voices in My Head."

51. Holland, "So Many Good Voices in My Head," 84.

theopoetics lean towards a more subtle "God-centric" position, particularly as it relates to the post-modern philosophy.

I reached out to Dr. Holland to gain greater insight on the difference between the two schools. Holland emails me that there are various possible schools in theopoetics, but the original school (First School) began with Wilder, Miler, and Hooper. Holland writes, "David Miller,[52] as one of the three founders of the first theopoetics movement in the 1960s, became rather firm in asserting the following:

"[The Second School] is really theology *and* poetry. His [Miller] argument is that theology and poetry as a method really poeticizes classical theology and received revelation. In contrast, theopoetics proper was born at the intersection of imaginative construction and composition around hermeneutics, critical theory, aesthetics, art, activism, philosophy, poetry, myth, religious studies, theology and other existential adventures. Methodologically, it is not theology and poetry carrying forward a proper, if beautiful, orthodoxy. It is rather poetry as theology, art as theology, etc."[53]

In the April 2017 issue of *Messenger Magazine*, Holland clarifies First School theopoetics as follows:

> What is theopoetics? It is not merely poetry about God, as a literal rendering of the term might suggest. Neither is it a call for all spiritual writing to be composed in rhyming or free verse, although that might be lovely indeed. Reaching back to the ancient Greek *poieses*, which means "to make" or "to artfully construct," those drawn to this genre of writing emphasized the inventive, intuitive, and imaginative possibilities of representing both humanity and divinity in their writing—remembering that "God is the poet of the world," as several theologians have proclaimed. It is a call to manifest the artful spirit of the Creator as those created in that divine image seek to write about God, world, self, and others.[54]

There are similarities between the two movements: the use of images and imagination, language, story, analogy, metaphor, visual art, the use of poetry, articulations towards beauty, and an ongoing dialogue within various artistic fields. Both schools pursue the classical transcendentals: truth, beauty, and goodness.

52. David L. Miller is one of the three 1960s founders of the First School theopoetic movement, along with Amos Wilder and Stanley Hopper. He is a Bethany Theological Seminary graduate and a retired Syracuse professor, author, and academic.

53. Ideas expressed via email correspondence.

54. Holland, "From Theo-logics to Theopoetics," 7.

With this in mind, *Beauty (and the Banana)* concentrates on a classically informed theopoetic approach to beauty (connecting it to "being"), not a practical one. There are, however, some practical applications. I won't tell you how to decorate a room, but I will, hopefully, help give insight into why you feel a particular painting you picked for the room is beautiful—at least to you.

Beauty (and the Banana) addresses the basic language used to describe beauty (ontology, teleology and immutability), placing it within a biblical framework. Just as language uses differing features to extol its structure and meaning, so, too, does beauty. A poem may use several characteristics to express itself (metaphor, analogy, symbolism, etc.). Likewise, beauty simultaneously presents several facets within itself, providing explanatory verities to an ethereal value.[55]

To help us understand beauty and being a little more, we'll let a banana lead the way.

55. This idea was expressed poignantly in Cleanth Brooks's chapter in *Well Wrought Urn*, "Heresy of Paraphrase."

Chapter 1

What Is Being and Beauty?

BANANA, BEING, AND BEAUTY

Banana

The world was aghast, or at least flummoxed.

In December 2019, Italian artist Maurizio Cattelan taped a browning banana to a white wall using gray electrical tape. Cattelan called the artwork "Comedian." It was displayed at Art Basel in Miami Beach, Florida. To many, it was a joke. To others, very serious. In the end, the artwork sold for $150,000, with four similar editions selling for even more.[1] It became an internet sensation, with people lining up to snap photos near it—only to have another artist, David Datuna, eat the banana. No bother—Cattelan taped a new banana to the wall and the festivities commenced. The banana became so popular it had to be removed from the exhibition.[2]

The rest, if you will, is art history. Or should it be?

To say the least, "Comedian" is a commentary on the wild world of contemporary art, communicating how culture understands, interprets, and engages with the arts. Furthermore, "Comedian" tells us about our society and the changing nature of what is considered art—or beauty—for that matter.

1. See *Art Assignment*.
2. Pogrebin, "Banana Splits."

Someone reading the various news articles on the Art Basel event may scratch his or her head. "What in the world has the artworld come to?" they may ask. "How is a banana with electrical tape considered art?" "I mean," the person continues, "Maurizio Cattelan didn't make or create either the tape or banana, so how can he claim to make the sculpture—or whatever it is? And quite frankly, it's not that beautiful!"

These are great questions and points. Many of the answers go beyond the scope of this chapter. But for the contemporary art world, art is not so much about the creation or manipulation of material objects, but of the creation of ideas, original thought. In the end, the institutions or individuals that bought "Comedian" were not buying material objects (the banana and tape) so much as they were purchasing an impression, intellectual property, the rights to own and showcase the work. For the most part, the clients bought an idea, a metaphysical reality.

Strange. But it happens all the time. People and institutions purchase ideas, not necessarily objects. What does "Comedian" have to do with beauty? The short answer is found in the objectivity of beauty within being. So, the question is: does "Comedian" have beauty? Hopefully, we'll find the answer when I address the topic later in *Beauty (and the Banana)*.

For now, I need to tell you about this book.

Guiding Principle

The guiding principle within this book is to explore beauty as an objective and subjective reality—a physical and metaphysical certainty—that permeates in various forms (what I'll later refer to as dimensions). In short, I hope to break down beauty into its fundamental factors: being, teleology,[3] and immutability. Along the way, we'll meet people and concepts who have helped shape our understanding of beauty. At some point, we'll get back to the banana.[4] By no means is *Beauty (And the Banana)* meant to be a full treatment on beauty.[5] In the book I'll approach beauty as elementary versus elaborate, preparatory versus panoramic, minimal versus maximal.[6]

3. Later, I'll argue that teleology has two senses: one connected to being and teleology—form and organization; the other connected to our understanding and judgment, the appreciation of the form and organization.

4. In modern times, many do not see beauty as objective, immutable, or as an eternal value. Rather, to some, beauty is purely subjective and relative to a person and culture.

5. As an example, I won't unpack beauties relationship to nature, *eros*, style, fashion, content versus form, emotion, expression, and the various mediums.

6. For more comprehensive books that cover these topics, refer to the footnotes and bibliography.

To help guide our quest to understand beauty, we'll follow a three-part outline, looking at the nature of beauty historically, hermeneutically, and heuristically. It's in this last section that we'll touch on "Comedian," answering whether the art may or may not have any actual semblance of beauty.

Before we delve into these topics, let's stop and define our terms. To begin, we'll touch upon two important concepts: being and beauty.

Being

The Oxford English Dictionary defines *being* as "existence," and the "nature or essence of a person."[7] Thomas Aquinas[8] understood being as something that "subsists in itself."[9] He rendered a clear definition: "*Being* means that-which-is, or exists (*esse habens*)."[10] Aquinas continues with other understandings of the concept, then divides *being* into ten categories, or modes, and distinguishes between *ens* (being) and *esse* (essence).[11] Broadly, the difference between *ens* (being) and esse (essence) is act of *ens* (being).[12]

In *Summa of the Summa*, philosopher Peter Kreeft writes:[13]

Essence has two senses: a broad sense, "what a thing is," and a narrow sense, "the definition, or genus plus specific difference of a thing."[14]

And *existence* is "the actuality of an essence, that act by which something is."[15]

Theologian Austin Ferrar connects being and essence in this way: "To say that the actual quality or pattern of our existence is determined by our place in a system of being which transcends ourselves: that in all our existence we are conforming to or falsifying the relation of a creature to its creator, we are denying or actualizing a nature which has been assigned to us."[16]

7. See https://www.lexico.com/en/definition/being.

8. Thomas Aquinas (1225–74) was a medieval scholastic philosopher, writer, friar, and poet, a doctor of the Roman Church.

9. Aquinas, *Introduction to the Metaphysics*, 24.

10. Aquinas, *Introduction to the Metaphysics*, 19.

11. Aquinas, *Introduction to the Metaphysics*, 24.

12. Aquinas explains the difference between *existence* and *essence* in more detail in his works. See Carpenter, *Theo-poetics*, 92.

13. Peter Kreeft (b. 1937) is a Roman Catholic philosopher, author, and theologian, influenced by the thought of Thomas Aquinas.

14. Aquinas, *Summa of the Summa*, 25.

15. Aquinas, *Summa of the Summa*, 25.

16. Farrer, *Glass of Vision*, 122.

If none of this helps, think of the noun, *being*, as related to the verb, *to be*. Being is to be.

Maybe David Bentley's Hart's poetic description will help us understand:[17] "One realizes that everything about the world that seems so unexceptional and drearily predictable is in fact charged with an immense and imponderable mystery. In that instant one is aware, even if the precise formation eludes one, that everything one knows exists in an irreducibly gratuitous way: "what it is" has no logical connection with the reality "that it is."[18]

I like that. Being is "what it is" and "that it is," though with no apparent "logical connection."

Here's my point: *Being* is king when it comes to reality. Why? There is something rather than nothing. We can't make judgments of any kind—concerning beauty or anything else—if there is no reality, being, essence, or existence. We cannot judge anything at all if we (or anything else) don't exist.

Does *being* presuppose a "Beginner," as cause does an effect, or as design a "Designer"? This is too vast a subject, too unique and wonderful, to address in this short discourse. Although I can certainly argue the rationale behind the arguments for God, many others have already done so—and perhaps better than I.[19]

I can best provide a logical syllogism for God's existence. Here is a summary of Norman Geisler's[20] position on *being* and "Being" (God):[21]

1. Something exists (e.g., I do).

2. Nothing cannot produce something.

3. Therefore, something exists eternally and necessarily.

4. It exists eternally because if ever there was absolutely nothing, then there would always be absolutely nothing because nothing cannot produce something.

17. David Bentley Hart (b. 1965) is an American Orthodox philosopher, theologian, and writer.

18. Hart, *Experience of God*, 88.

19. See authors such as Thomas Aquinas, Norman Geisler, Peter Kreeft, David Bentley Hart, William Lane Craig, Alvin Plantinga, Richard Swinburne, Peter van Inwagen, as examples.

20. Norman Geisler (1932–2019) was an evangelical Thomistic philosopher, theologian, and writer.

21. Geisler, *God*, 10.

5. It exists necessarily because everything cannot be a contingent being because all contingent beings need a cause of their existence.

6. I am not a necessary and eternal being (since I change).

7. Therefore, both God (a Necessary Being) and I (a contingent being) exists (= theism).

A question arises: How does *being* relate to beauty? For Aquinas, "All things participate in beauty, just as they participate in being."[22] Alice Ramos[23] notes, "Beauty is inseparable from actuality; the first sense of actuality for Aquinas is being."[24] Geisler would probably agree. To show a correlation between *being* and beauty, here's my follow-up syllogism connecting beauty, *being*, and God.[25]

1. If beauty exists, it must be conjoined in a Necessary Being which cannot not exist.

2. Consequently, beauty, as an attribute of a Necessary Being, cannot not exist; it is actual.

3. Beauty exists; therefore, we must conceive of beauty as real, rooted in reality as an attribute of a Necessary Being as conveyed through creation.

4. Beauty is; therefore, God exists.

Only time will tell whether or not the syllogism holds up to further scrutiny.[26] Quite frankly, it's not about a syllogism for beauty—it's the reality of beauty's existence that matters. For the purposes of this book, *being* will represent reality, both physical and metaphysical, a correspondence to both what is real and also the actions of what is real.

Here's something hinted at in the above paragraph: there are physical and metaphysical aspects to beauty. Brendan Thomas Sammon writes,[27] "beauty is understood as both spiritual and material, as that mode of being that gives form, as the power of being to entice the intellect through formal

22. Ramos, *Dynamic Transcendentals*, 72.

23. Alice Ramos is a philosopher and writer.

24. Ramos, *Dynamic Transcendentals*, 73.

25. Nixon, *Tilt*, 171.

26. Others have created similar syllogisms, including Tim Stratton:

 1-If God does not exist, objective beauty does not exist.

 2- Some things are objectively beautiful.

 3- Therefore, God exists.

27. Brendan Thomas Sammon is a professor and philosopher.

proportion and symmetry into being's own ontological depths."[28] Through *being*, we experience beauty, materially and spiritually, "a participation in the divine brilliance."[29] Beauty is the brilliance of *being*, having physical manifestations (i.e., a tree) and metaphysical manifestations (i.e., numbers, imagination, ideas, etc.).

Another thing to note: the transcendentals (the things we discussed in the introduction—truth, beauty, goodness and unity) "add nothing to being."[30] Instead, "They inhere in being coextensively and can be discerned in every being, and they determine the character of beings . . . they are convertible into one another."[31] I know: a lot of jargon. Perhaps W. Norris Clarke simplified it for us:[32] "The concepts themselves are distinct from each other in what they explicitly affirm about being, but they refer to the identical reality as it exists in itself."[33] Philosopher D. C Schindler affirms the "properties [truth, beauty, and goodness] are unlimited, they are found absolutely everywhere. . . . Insofar as something exists it is good, and true, and beautiful in some respect. To be entirely without those properties is not to be at all."[34]

So *being* has beauty, truth, unity, and goodness manifest within itself.

Think of it this way. If something is true, it is also beautiful and good.[35] So, if a mathematical formula is really true (as opposed to a theory) it is both beautiful and good, and therefore unified. The transcendentals are related. They are convertible and correlative.

Being, Art, and Beauty

How does beauty relate to art? Well, art is beauty's kissing cousin.

Martin Heidegger's[36] concept of the idea of *Alethia* is helpful here.[37] *Alethia* is defined as "unveiling." For Heidegger, "Beauty—especially the

28. Sammon, *God Who Is Beauty*, 176.

29. Aquinas, *In De Div. Nom*, as quoted in *Pocket Aquinas*, 272.

30. Eco, *Aesthetics of Thomas Aquinas*, 21.

31. Eco, *Aesthetics of Thomas Aquinas*, 21.

32. W. Norris Clarke (1915–2008) was an American philosopher, author, and Thomas Aquinas scholar.

33. Clarke, *One and the Many*, 291.

34. Schindler, "On the Classical and Christian Understanding," 40:48.

35. Beauty is commonly associated with good.

36. Martin Heidegger (1889–1976) was a German philosopher, specializing in phenomenology and hermeneutics.

37. As noted in Carpenter, *Theo-poetics*, 87. Quoting Heidegger, "On the Origin of

work of art—is suited to the unveiling of truth. A work of art is created in order to 'shine-out' or illuminate being, and this illumination is the unveiling or concealment of being and thus of truth. . . . *Beauty is one way in which truth essentially occurs as unconcealedness.*"[38] Put another way, art helps highlight the loveliness of being, as expressed through various artistic medium, a means of pointing a person to the certainty of the concrete object or form.

Anne Carpenter writes,[39] "Yet it is not the illumination of being alone that orients art to truth; it is also art's concrete particularity, its 'thing-ness'. . . . Thing-ness, or particularity, and historicity means that art's unveiling of being takes place not in the abstract, but in time through concrete beings."[40]

"Thing-ness," "particularity," "illumination," and "shine-out" are all important features found in art, representing the art's form and the beauty it exudes.

This is similar to Aquinas' notion that beauty is the brilliance of being.

So, art, as a concrete thing, its "thing-ness," *shines-out* being, and this *shining-out* is beauty. And remember, beauty is its own value, it has unique significance. Dietrich von Hildebrand states:[41] "It is important to see that the importance-in-itself of beauty, its genuine character as value. . . .The beautiful calls us to apprehend it. . . . a type of fragrance."[42]

I like that. Beauty is the pleasant smell of an object, and art is just one means of exuding the fragrance.

If nothing else, let's remember that *being* is the basis for reality, of real things. Beauty is found in being—it *shines-out* being. And art is one way that helps illuminate beauty, but not the only way.[43] Metaphorically, beauty is perfume among people and things.

We'll get to art more below, but that's it for now. Aside from *being*, let's look into how some others interpret beauty.[44]

the Work of Art," 178.

38. Carpenter, *Theo-poetics*, 87.

39. Anne Carpenter is a philosopher, poet, and Hans Urs von Balthasar scholar.

40. Carpenter, *Theo-poetics*, 87. Carpenter points out that Balthasar would incorporate Heidegger's idea as truth unveiling being, a type of "Heideggerian Thomism," an expression of being.

41. Dietrich von Hildebrand (1889–1977) was a German philosopher and author.

42. Hildebrand, *Aesthetics*, 85 and 89.

43. Nature, virtue, love, community, and a host of other ways shines-out beauty as well.

44. Dietrich von Hildebrand does not see beauty, per-se, as an aesthetic value because to him there is "no hierarchy, no 'more' or 'less', within ontological value." Von Hildebrand

Beauty

"It's so beautiful, I could cry!" We've all heard this before. Maybe while looking at a beautiful mountain range or a pond in the rain. Some artists truly weep in the presence of beauty, such as hard-edge painter Frederick Hammersley.[45]

What brings about the tears? Is it beauty? The experience of the beauty? Both beauty *and* the experience? If it is beauty, what about it makes us weep?

Author and artist, Dave Beech,[46] wrote that beauty is said to be impossible to define on account of the subjective nature of judgments of pleasure and taste.[47] He noted: "There are two contradictory conceptions of beauty: one is the conviction that it is a purely private, subjective experience; and the other is the notion that it is always, inevitably socially inscribed."[48] In other words, one's understanding of beauty is personal (subjective) and public (how a society interprets and understands beauty).

American philosopher D. C. Schindler summarizes beauty as "the manifestation of reality,"[49] proposing a correlation between appearance and perception: "beauty offers a kind of paradigm of appearance and so perception, which is to say that it represents appearance as perfected, isolate in its purity. . . . To put it another way, beauty captures the essence of both appearance and perception."[50] Schindler argues that "beauty is an encounter between the human soul and reality, which takes place in the 'meeting ground'. . . . of appearance."[51]

Connecting reality and perception, British art critic Martin Gayford notes, while standing in front of sculptor Constantin Brancusi's Endless Column in a remote region of Romania, "that when it comes to works of art there is often no substitute for being there right in front of it."[52] Implication: one must experience the reality of the beauty the object offers to fully appreciate its impact.

likens beauty to a "quantitative value," following a different "theme." Yet, he recognizes the complexity of the issue. For von Hildebrand, moral values can only apply to people, whereas beauty is applicable in "diverse domains." See *Aesthetics*, 76–83.

45. Noted at a conference dedicated to the work of Hammersley, sponsored by the University of New Mexico.

46. David Beech (b. 1960s) is a British writer and artist.

47. Beech, *Beauty*, 12.

48. Beech, *Beauty*, 14.

49. Schindler, *Love and the Postmodern Predicament*, 31.

50. Schindler, *Love and the Postmodern Predicament*, 35.

51. Schindler, *Love and the Postmodern Predicament*, 39.

52. Gayford, *Pursuit of Art*, 18.

Offering a divergent view, American art critic, Saul Ostrow,[53] notes, "Beauty, which had once been considered the supreme good, has come to be identified as a source of oppression and discrimination."[54]

What makes the inherence of beauty so difficult to pinpoint? What is the elusive attribute that makes people joyously exclaim or helplessly cry out? Why do some people—like Gayford jaunt off to remote parts of the globe to bask in beauties presence?

So, again, I ask, what is beauty?

Merriam-Webster defines beauty as "the quality or aggregate of qualities in a person or thing that gives pleasure to the senses or pleasurably exalts the mind or spirit." In addition, beauty is "a particularly graceful, ornamental, or excellent quality" and "a brilliant, extreme, or egregious example or instance."[55] In total, Merriam-Webster lists five separate definitions of beauty.

So, a contemporary understanding of beauty relates to "qualities" that give "pleasure" to the "mind or spirit."

It's not a bad definition. This is how beauty affects people. And, throughout history, people have used elements of Merriam-Webster's definitions in his or her understanding of beauty. Yet even as the definition works, it also seems to distance itself from an objective sense (real, tangible). Instead, beauty is relegated to more emotional characteristics, like "pleasure." And it doesn't define "qualities." So even though it's not a bad definition, it's not a particularly good definition. It has more to say about the consequences of beauty than the content of beauty.

As we learned in the introduction, decorating our houses is pleasurable (the consequence of your curatorial skill), but it doesn't necessarily tell us the why, the actual content, of what makes our decorating beautiful.

It's interesting to note that many contemporary thinkers are hesitant to define beauty. For example, philosopher Sir Roger Scruton.[56] He doesn't think beauty—per-se—conforms to logical statements.[57] Rather than a definition, he provides "platitudes":

- Beauty pleases us.

- One thing can be more beautiful than another.

53. Saul Ostrow (b. 1948) is an editor, art critic, and curator.

54. Beech, *Beauty*, 59.

55. https://www.merriam-webster.com/dictionary/beauty.

56. Sir Roger Scruton (1944–2020) was a British philosopher and author. Scruton stated, "I have implicitly rejected the Neo-Platonist view of beauty, as a feature of Being itself. God is beautiful; not for this reason," *Beauty*, 162.

57. Scruton, *Beauty*, 4.

- Beauty is always a reason for attending to the thing that possesses it.

- Beauty is the subject-matter of judgment; the judgment of taste.

- The rudiment of taste is about the beautiful object, not about the subject's state of mind.

- Nevertheless, there are no second-hand judgments of beauty.[58]

Scruton's six "platitudes" lead to the paradox of beauty: "The judgement of beauty makes a claim about its object, and can be supported by reasons for its claim. But the reasons do not compel the judgment, and can be rejected without contradiction."[59]

That's a lot to think about. At the heart of his idea is that beauty is based upon "judgment."[60] Scruton corresponds this judgment to "the subjects state of mind." The judgments are "the final verdict," which is "an act of attention."[61] The "final verdict," the "acts of attention," is the "attempt to show what is right, fitting, worthwhile, attractive or expressive in the object."[62] And this "state of mind" is a "judgment that seems to be implicit in it."[63] In Scruton's view of beauty, judgment (a personal assessment) is primary.[64]

Let's leave this to set in for a bit. We'll come back to judgment a little later in the book.

Perhaps Scruton's summary of how one finds something beautiful is easier to grasp. He says, "We call something beautiful when we gain pleasure from contemplating it as an individual object, for its own sake, and in its presented form."[65] So, for Scruton, beauty is connected to an object, form, and pleasure.[66] But Scruton is not the only person hesitant to define beauty. Theologian and philosopher, David Bentley Hart, is another. But, unlike Scruton—who doesn't clearly define beauty as objective within his "platitudes"—Hart

58. Scruton, *Beauty*, 5.

59. Scruton, *Beauty*, 7.

60. As we'll read later, beauty being based on judgment was also proposed by Kant.

61. Scruton, *Beauty*, 13.

62. Scruton, *Beauty*, 13.

63. Scruton, *Beauty*, 29.

64. This view is the predominant thought in Western culture, which does not always account for non-Western ideals, as relating to emotions, perception, and social engagement. See Bence Nanay's *Aesthetics*, 50–53.

65. Scruton, *Beauty*, 22.

66. There are some interesting elements found in Scruton's sentence, that relate back to *being*. Notice the words "object" and "form." These are words we'll find in the thoughts of others as we see in later sections.

recognizes the objectivity of beauty. Furthermore, Hart argues that beauty is "a category indispensable to Christian thought."[67] Why?

According to Hart, and a host of other Christian thinkers, beauty is an attribute of God—it's objective—based on factual reality.[68] And though Hart is reluctant to define beauty, he does describe a general "'thematics' of the beautiful."[69]

In his book *The Beauty of the Infinite*, Hart's "thematics" are as follows:

1. Beauty is objective.

2. Beauty is the true form of distance.[70]

3. Beauty evokes desire.

4. Beauty crosses boundaries.

5. Beauty's authority, within theology, guards against any tendency towards Gnosticism

6. Beauty resists reduction to the "symbolic."[71]

Beginning with his concept of beauty being "analogical," Hart provides two "senses" of beauty. One: "In the simple analytic sense, that whatever 'beauty' means is grasped only by analogy, by constant exposure to countless instances of its advent." Two: "The more radically ontological sense. . . . [that] dwells the anagogical relationship of all things. . . . the dynamism of their involvement with one another."[72]

We don't have time to truly unpack Hart's thoughts, which are easily some of the most astute reflections on beauty written in the contemporary age. To say the least, Hart does argue that beauty—as one of the transcendental characteristics of God—is essential in our understanding of God, and thereby, all of existence; beauty is objective and necessary because it exists.

Theologian and philosopher Norman Geisler would concur. Geisler likens God's beauty to God's majesty manifest in being as articulated via

67. Hart, *Beauty of the Infinite*, 16.

68. Some thinkers, such as Hans Urs von Balthasar, believe the objectivity of beauty is found in the person of Jesus Christ.

69. Hart, *Beauty of the Infinite*, 17.

70. On *distance*, Hart states: "Beauty inhabits, belongs to, and possesses distance, but more than that, it gives distance. . . the distance of delight. . . and leads to reflection." See *Beauty of the Infinite*, 18–19.

71. Hart, *Beauty of the Infinite*, 17–28.

72. Hart, *Beauty of the Infinite*, 18: Beauty "is not some property discretely inherent in particular objects."

creation.[73] In relation to beauty and being, Geisler writes, "Being (reality), insofar as it is knowable, is true. Being, insofar as it is desirable, is good. And Being, in so far as it is pleasurable, is beauty. So . . . beauty in God is that aspect of His Being, when perceived by His creatures, provides a sense of overwhelming pleasure and delight."[74]

To Geiser, it's implicative that "All beauty comes from God; hence, all beauty is like God. All who create beauty imitate God . . . all effects preexist in their Cause."[75] Like Hart then, Geisler views beauty as objective, a result of God's beauty found within himself as transposed within creation.

Returning to the thoughts of Aquinas concerning beauty and being, "Nothing exists which does not participate in beauty and goodness, since each thing is beautiful and good according to its proper form. . . . Created beauty is nothing other than a likeness of the divine beauty participated in things."[76] For Aquinas, all things have a semblance of beauty, a marker of the Maker.

Simply, God is beautiful. His likeness is found in things he creates; beauty is an extension of his reality. Therefore, beauty is real.[77]

Even agnostic thinkers, like Umberto Eco,[78] point out two ramifications of beauty *if* it is an objective transcendental:

"First, the various determinations of being are affected: the universe acquires a further perfection, and God. . . . [an] attribute."

Two, "Beauty, for its part, acquires concreteness and a quality of necessity, an objectivity and dignity."[79]

It's clear that most theologians see beauty as objective.

Here's a couple of final thoughts.

One, as inferred, beauty carries a transcendental character, connecting it to God. According to W. Norris Clarke, beauty should be considered a transcendental truth of God for two reasons. First, "Every being, insofar as it exists in act, must have a certain inner coherence of unity and harmony—creatures through their intelligible forms—and shine forth with a certain splendor, radiance, light emanating from its act of existence, whose

73. Geisler, *Systematic Theology*, 239.

74. Geisler, *Systematic Theology*, 239.

75. Geisler, *Systematic Theology*, 240.

76. See Aquinas, *Introduction to the Metaphysics*, 88.

77. I understand beauty as an emanation from God: the parts-to-whole, the beauty-to-Beauty, the microcosm to macrocosm. Later, I'll touch on a different type of beauty: God revealing his beauty to a person through a *within* experience, unilaterally (an exchange with a divine agency).

78. Umberto Eco (1932–2016) was an Italian philosopher, novelist, and semiotician.

79. Eco, *Aesthetics of Thomas Aquinas*, 22.

contemplation should give delight to any intellect and will apt and attuned to receiving it . . . as a participation in being from God."[80] Second, "Since beauty is distinguished from all the others in that it signifies being as related to both intellect and will at once . . . the synthesis of all the transcendentals."[81] In this way, beauty harmonizes the other transcendentals: it *shines-out*, allowing one to see the splendor and sublimity of unity, goodness, and truth.

Two, for the Christian, beauty is concretely connected to Jesus Christ, God's Son. In defining beauty, an objectivist position argues that beauty's "definition must begin from God."[82] And the supreme way to get a concrete understanding of God's beauty is from God himself, via his incarnation, Jesus Christ, as outlined in Scripture.

According to Hans Urs von Balthasar, "Hence we should never speak of God's beauty without reference to the 'form and manner of appearing which he exhibits in salvation history.'"[83] For Balthasar, God's beauty is summarized in his Son. "This means that God does not come primarily as a teacher for us ('true'), as a useful 'redeemer' for us ('good'), but . . . to display and to radiate the splendor of his eternal triune love . . . which true love has in common with true beauty. . . . And only the person who is touched by a ray of this glory . . .[is] the divine life in Jesus Christ."[84] Vildesau said: "The center of Balthasar's theological aesthetics, therefore, is the contemplation and grasp of the 'form' of God's revelation in Christ and the scriptures."[85]

For Balthasar—and most Christians, Jesus is the objective Beauty of God.[86]

Summary

To sum up a bit, an objectivist view of beauty believes beauty corresponds to an external reality, namely God. Beauty is found and bound in things but is beyond things—it "leaps over" them, found ultimately in a metaphysical reality. And in the decisive sense for the Christian, beauty is found in the form of God in Christ.

At the center of aesthetical thought for many Christian thinkers lies the view that beauty is objective; it as real as real gets. Because God is beautiful,

80. Clarke, *One and the Many*, 300.

81. Clarke, *One and the Many*, 300.

82. Viladesau, *Theological Aesthetics*, 32.

83. Balthasar, "Another Ten Years," as quoted in Viladesau, *Theological Aesthetics*, 33.

84. Balthasar, "Another Ten Years," as quoted in Viladesau, *Theological Aesthetics*, 33.

85. Viladesau, *Theological Aesthetics*, 34.

86. For a more detailed discussion, see Carpenter's *Theo-Poetics*, 107–16.

beauty is, even if it has "its own distinctive logic."[87] And because beauty is real, we can study and appreciate it and weigh its worth in tangible ways (cognitive, linguistic, emotional, etc.). We can, and should, enjoy beauty with wonder, pleasure, surprise, interest, and awe.

Maybe it's as sublime as Aquinas said: "There is nothing that does not participate in beauty."[88] Or as simple as Eco thought: "A beautiful thing is something that would make us happy if it were ours, but remains beautiful even it belongs to someone else."[89]

At the bottom of all is a simple theme—beauty is, our minds know it and our hearts go for it.

Art and Beauty

A woman stands in a gallery with friends. As they move on, she stops to stare at "Three Studies of George Dyer" (1966). "That's so ugly," she retorts! But is it? She sees three contorted heads, grotesque, with hues of black, brown, and splashes of white. The eyes are in the wrong place, the forehead is twisted, the nose is a wreck, and the mouth almost vertical to the face. The artwork is by British artist Francis Bacon (1909–92). "It's gross and scary," she tells her friends. "That's not art at all." And to her, the painting isn't.[90]

So, what is art? And how does it relate to beauty beyond the brilliance of being described above?

To be sure, art is not necessarily beauty. Art may contain beauty, but it is not beauty as a transcendent form of reality. Art and beauty are not identical. But art is one of the means by which people try to grasp beauty. How do we distinguish between art and beauty?

To help differentiate between art and beauty, Eco said, "Beauty was a quality that could be possessed by natural things . . . while the task of art was solely to do things *well* . . . for which they were intended."[91] In other words, beauty is a quality, an eternal attribute. Art, however, is akin to a quota,

87. Eco, *Aesthetics of Thomas Aquinas*, 32.

88. Aquinas, *Introduction to the Metaphysics of St. Thomas Aquinas*, 88.

89. Eco, *History of Beauty*, 10. Eco does not believe in immutable beauty, but often slips in tantalizing clues that he once did.

90. Scruton believes that many modern artists were not trying to leave beauty, but recapture it in new settings, not a "transgression but as a recuperation: an arduous path back to a hard-won inheritance of meaning, in which beauty would again be honored, as the present symbol of transcendent values . . . a desire to recover it." *Beauty*, 143.

91. Eco, *History of Beauty*, 10. Though Eco took a very relativistic view of beauty, it is not absolute or immutable. He did understand there are certain qualities in an object that make it beautiful.

something that can be produced, an object created for an end. Beauty is a value, something beyond the object. Art is vested in an object or idea as a creative outlet, eliciting attention.

Definition of Art

Clive Bell,[92] a leading thinker in aesthetics, tried to close in on a basic definition of art. He asked a series of questions concerning how to define art: "What is the quality. . . . What is shared by all objects that provoke our aesthetic emotions?"[93]

Bell thought a definition of art was necessary to understand art.

Gordon Graham,[94] a theologian and philosopher who studied Bell, said that "Bell's answer to his own question is that what is shared by all works of art is 'significant form.'"[95] Bell understood *form* in "relations of line, colors, and shapes."[96] And *form* implies being, something rather than nothing.

Expanding on the thought, Suzanne K. Langer, another aesthetics theorist, defined art as the "creation of forms symbolic of the human feeling."[97] Langer combined the ideas of creation, form, and feeling. For her, the form of an object (it's being) and the reaction to the object (human feelings), can point to something more meaningful—symbolism, intelligence, and understanding.[98]

Jaroslav Pelikan[99] points out that an early proponent of *kalilagathia* ideals (good and beautiful)—Friedrich Schleiermacher—who "grasped the balance of the ancients,"[100] categorized art as "emotion controlled by form."[101]

Art educator and historian, Terry Barrett, clarified the idea of form as it relates to feeling or interest. He saw the understanding of art as an equation: "subject matter + medium + form + context = meaning."[102]

92. Clive Bell (1881–1964) was an English art critic and author.

93. Graham, *Philosophy of the Arts*, 222.

94. Gordon Graham is a Scottish Episcopal priest, philosopher, and professor at Princeton Theological Seminary.

95. Graham, *Philosophy of the Arts*, 222.

96. Giovannelli, *Aesthetics: Key Ideas*, 119.

97. Graham, *Philosophy of the Arts*, 222.

98. Langer's idea, interestingly, is very similar to Saint Augustine's, discussed later.

99. Jaroslav Pelikan (1923–2006) was an American, Lutheran-Orthodox theologian and historian.

100. Pelikan, *Fools for Christ*, 123.

101. Pelikan, *Fools for Christ*, 123.

102. Barrett, *Interpreting Art*, 199.

In the end, I think all definitions of art come up short. Something important is unstated—being. I would add that we render art as *being engaged with form as enclosed in implication*.[103] With a caveat: I'd put beauty, as an attribute of God, before being. God is beautiful, and his beauty emanates and encompasses his creation. With this understanding, beauty is echoed in art as a reality of being and moves towards form (the organization of being),[104] progressing towards a response, an implication, a meaning of something more transcendent, a sense of wonder or intellectual appetite.[105]

An equation would look something like this:

God/Beauty → being + form[106] + implication = a response, leading towards meaning, a type of wonder or interest.[107]

Later, I'll frame this equation using the words *innate* (being), *intelligence* (teleology), and *immutability* (theology)—three "I's."

An Art Circle

For now, here's a final thought on the relationship between beauty and art. Since an objectivist understanding of art is more circular than linear, with beauty as both the beginning and the end, encompassing all the other qualities, I use what I call an *art circle*.

The art circle would look something like this:

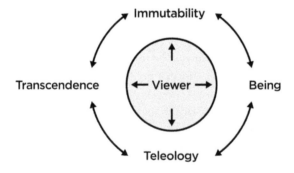

103. By being, I mean both corporeal and incorporeal. By implication, I mean something that is transcendent and can convey immutability.

104. An ordering of being in any medium: visual, musical, movement, ideas, etc.

105. Such as an idea, understanding, interest, or possibly, God.

106. The medium or organization.

107. I.e., ideas, emotions, a spark of imaginative insight.

Notice that the arrows are pointing both ways, conjoining the qualities into a cohesive whole. Being has beauty and teleology invoking transcendence. Teleology has being and transcendence, invoking immutability. And transcendence has immutability, enveloped in being and teleology. In the middle of the circle is the viewer, us, eliciting a reaction to each area, any response from delight to disapproval. Though the response or interpretation of art may change over time, beauty remains—it "leaps over." In the end, it's not how one defines beauty, but simply that beauty is.

Von Balthasar's understanding of Heidegger may work best in connecting beauty and art: art, the concrete thing, *shines-out* being, and this *shining-out* is beauty.

No matter the definition, it's important to note that from a theological perspective, beauty relates to art in that it exists and subsists in the being and form, teleology, context, and meaning. Yet beauty surpasses all aspects of the art, it "leaps over" the art itself, invoking a broader communitive realm. Beauty is an objective reality within art that transcends any particular structure of form. Art is just one vehicle for beauty's luminance. Beauty is everywhere, because God, in his beautiful omnipresence, is everywhere.

How do we understand this ever-presence of beauty? Author Marcel Proust, while at home, began noticing ordinary objects around his house: a napkin, glasses, bottles, colors, chairs, an oyster shell. Proust said, "I tried to find beauty there where I hadn't ever imagined before that it could exist, in the most ordinary things."[108] The point? Proust concluded that beauty is always present; it permeates everything. From the way light hits a wall, to the way branches blow in the wind, to the assemblage of silverware at a dinner table—all the way to abstract qualities of color, shapes, and form splashed on a canvas. Beauty is there.[109]

But this raises two questions.

First, does the art circle mean beauty is present in art only when there is a viewer? No. And this is the main point of an objectivist position regarding beauty. As just pointed out, beauty is inherent in things regardless of a response or time; beauty is transcendently there. Dietrich von Hildebrand puts it this way: "It is extremely important to see that the objectivity of beauty as a value, it importance-in-itself, has nothing to do with the question whether the so-called secondary qualities exist independently of a human spirit."[110] For in the end, at least for the theist, there is Someone attending to beauties realm, knowing every detail and nuance, the flickering

108. Nanay, *Aesthetics*, 85.

109. Nanay, *Aesthetics*, 85.

110. Hildebrand, *Aesthetics*, 56.

of a candle, the song never heard, a flower never beheld, the poem only recited, but by One. God attends to beauty. And if there is any wavering in the contemporary understanding of beauty it is because "our understanding . . . has degenerated because we have forgotten God."[111]

Second, a friend of mine, Quentin Guy, asked: "What about things that might be called ugly (based on what they are or represent): The iridescent green of a fly's carapace as it alights on a pile of dung. Or sparkling bits of glass at the site of a fatal car crash. Do we pick and choose those things we call beautiful, or are they beautiful despite the broken environs in which we may find them? If beauty depends on its connection to God, that makes sense. Are the things that God hates—death and disease, sin and putrescence—capable of conveying beauty?" Later, we'll briefly touch on ugliness. For now, let's just say that ugliness is the distortion of beauty, but ugliness still contains factors of beauty in its being. So even car crash—though horrific—has elements of beauty within its realm: the car, the person, the form, the shape.[112] This is similar to Baudelaire's understanding: "Sometimes, too—and this is one of the most interesting characteristics of beauty—it will have mystery; and lastly. . . . It will have unhappiness."[113] Beauty—in a fallen world—has the potential to both delight and cause despair. Or as poet Charles Bukowski noted in a letter to an editor,[114] "There's music in everything, even defeat."[115] In the end, a recognition of distorted beauty dimly conceals a hunger for divine beauty.

Summary

Let's recap. According to most theologians, beauty has *being*. It is objective and it is real, in a factual sense. By *being* we don't exclusively mean material. We also understand beauty as an ontological reality, a participated being as experienced through a host of factors (creation, imagination, ideas, etc.). Beauty is real both physically and metaphysically (as Clarke said: "real

111. Carpenter, *Theo-Poetics*, 79. Carpenter made this point in relationship to von Balthasar's view. Scruton positions a similar sentiment: Our postmodern culture "is a loveless culture, which is afraid of beauty because it is disturbed by love." *Beauty*, 148.

112. Andy Warhol picked up on this in various of his works, from his *Electric Chair* works to his *Car Crash* works.

113. As quoted in Miller, *Hells and Holy Ghosts*, 85.

114. Poet and novelist, Charles Bukowski (1920–44), was a great example of this sentiment. As an agnostic writer with a proclivity for drink and promiscuity, he often wrote beautiful, if unorthodox, poetry.

115. Bukowski, *On Writing*, 18.

being" and "mental being"[116]). Furthermore, all beauty (being, teleology, and immutably) is a consequence of a Pure Act, of God.[117]

As Joseph Owen[118] states, "Nothing in its nature (God), therefore could necessitate it to produce something other than itself."[119] But this does not mean all being, when distorted, is fully beautiful. There is ugliness in the world, a distortion of being or teleology—as just mentioned above. Yet, even in ugliness there is a hint, or an echo, of beauty. A woman with her friends may truly think that Bacon's "Three Studies of George Dyer" is ugly—but that does not take away from the fact that it has being and teleology (form, color, organization, etc.).

Scruton's understanding of Kant (who, we'll soon discover is one of the key thinkers on the relationship between and object and judgement) may help iron out the relation between beauty and being: "Kant was naturally inclined to describe [beauty's] characteristic object as something not made but found."[120] In other words, we don't ultimately determine beauty's reality. We discern and discover it. Beauty was in the beginning, an attribute of God, yet we find it in an object or idea's being as manifest in various forms.

I find it interesting how, in the Old Testament of the Bible, God's name is denoted as *Yahweh*. *Yahweh* was a tetragrammaton of YWHY, meaning "the one who is, the existing." God's name, then, is connected to the infinitive "to be."[121] God is. God exists. And because God exists, beauty exists. Therefore, the converse should be true: because beauty exists, God exists. Being begets beauty; and beauty points to Being: God.[122]

And how God's Being relates to beauty—be it physical or metaphysical—matters.[123] Even from a non-theist perspective, beauty is important since it points to existence and human's participation within existence. Beauty affords humanity a common quest, a means to place value on that

116. Clarke, *One and the Many*, 30.

117. Geisler, *Systematic Theology*, 238–40.

118. Owens is a Thomistic philosopher and theologian.

119. Owens, *Elementary Christian Metaphysics*, 99.

120. Scruton, *Beauty*, 54.

121. Etymology Dictionary, "Yahweh."

122. YHWH is a name likened to breathing. Many have pointed out that its correct pronunciation of YHWH is an attempt to imitate the very sound of inhalation and exhalation. "Be still and know that I am God," the Lord declares in Psalm 46:10.

123. For more insight, read *Tilt*, 108.

which delights or interests.[124] Being and beauty go hand-in-hand.[125] And how humans react to beauty is part of the broader confluence of beauty's influence within and upon the cosmos. In the end, beauty is unquestionably real. We humans know it, and history shows it.

If history shows beauty, then how has history shaped our understanding of beauty? Let's move on to the next chapter.

124. Concerning art and beauty, Scruton stated: "Our favorite works of art seem to guide us to the truth of the human condition and, by presenting completed instances of human actions and passions . . . show the worthwhileness of being human." *Beauty*, 108.

125. As an objectivist, I put beauty—as a real value—before anything else (or as echoed in everything else), found in God.

Chapter 2

Historical

How Has Beauty Been Understood?

With the earliest human presence on planet earth, one finds beauty. Beauty can be found within art (early cave paintings), music (the presence of flutes in many cultures), writing, or applied arts (pots, chairs, garments, blankets, etc.)—all used for living and understanding. Beauty is found in nature as well. From the mountain peaks of the Himalaya's to the ocean reef of Australia, beauty is. Because of the ever-present presence of beauty, people throughout the ages have grappled with its meaning, trying to measure it and come to terms with its reality. People respond to beauty. And just as important, they've created beautiful objects to facilitate beauty.

To help answer the question of how beauty is understood within human culture, I've summarized history into four large epochs—four "C's": Classical, Christian, Cartesian, and Contemporary. Most historian would be quick to point out that there are many variant subcategories and nuances found within each suggested epoch (not all cultures were Christian, as an example); he or she would be right. And in two cases (Plotinus and Paul), I've reversed their chronological order to stress his particular influence within a school of thought. I've summarized the epochs for clarity and to be concise. Furthermore, I'll only highlight key representatives of each era, not a comprehensive analysis of all the main personages.

CLASSICAL (800 BC–70 AD): THE ANCIENT WORLD

The classical world is not only a Western phenomenon, taking root in ancient Greece, but a worldwide phenomenon. From the paleolithic to chalcolithic eras, through the Bronze and Iron Ages, ancient Mesopotamia, China, India, Japan, the Mayans of South America, Europeans, the Aboriginals of Australia, and African civilizations left the world artifacts and works of stunning beauty and originality. History shows us that all cultures integrate objects of beauty at some level. In most cases, though, little was written concerning a specific understanding of beauty, a philosophy, if you will; instead, the various people groups created beauty, "cryptically encoded in their works."[1]

We do, however, find facets of beauty sprinkled in writings. As an example, the ancient Indian philosophers incorporated physical and metaphysical pursuits in their tomes, touching on harmony, balance, and form, all aspects of beauty.[2] The Chinese incorporated the *Three Perfections* (poetry, painting, and calligraphy), valuing "transcendence of objective representation and emotional expression."[3] The Japanese aesthetic included concepts such as *mono no aware* (pathos), *wabi* (simple beauty), *sabi* (rustic, solitary beauty), *yugen* (mysterious or hidden beauty), and *ike* (refinement).[4] And the Navajo (Dine') people of North America (whose ancestors arrived from ancient Mongolia) integrate a blessing in their ethos, calling a person to "Walk in Beauty" (*Hozho*). For the Navajo, *Hozho* means to "live in beauty, harmony, balance, happiness, [and] good health,"[5] walking in integrity with the world. According to Robert Drake (University of Arizona), "[*Hozho* is the] consideration of the nature of the universe, the world, and man, and the nature of time and space, creation, growth, motion, order, control, and the life cycle."[6]

So, beauty—in concept and practice—was part of the ancient world.[7]

But it was the ancient Greek civilization that brought together a particular culture's understanding of beauty and gave it great thought culminating

1. Bredin and Santoro-Brienza, *Philosophies of Art and Beauty*, 20. Hugh Bredin is a philosophy professor based in Belfast, Ireland. Liberato Santoro-Brienza is a philosophy professor based in Ireland and Italy.

2. Eco, *History of Beauty*, 12.

3. Jiang and Cai, "Aesthetics," para. 1.

4. Loughnane, *Japanese Aesthetics*, Stanford Encyclopedia of Philosophy.

5. Braude-Spragg, *To Walk in Beauty*, 16.

6. Drake, "Walk in Beauty: Prayer From the Navajo People."

7. Many of these ideas discussed here, such as the Japanese, were present in ancient culture but were formalized later in history.

in the written word. And though beauty wasn't formally solidified as one of the transcendentals until the time of Aquinas, beauty still played an important role within ancient world.[8] Umberto Eco uses the ancient philosopher Xenophon's summary of Socrates to show how Greeks categorized beauty:[9] *ideal beauty* (nature and her parts), *spiritual beauty* (that which concerns the soul), and *functional beauty* (useful objects). Summarizing classical ideas, Eco states that beauty "begins to appear in the world when matter created becomes differentiated in terms of weight and number, circumscribed by its outlines, and takes on shape and color; in other words, beauty is based on the form that things assume in the creative process."[10]

In this short assessment of the classical world, I won't get into the categories of history as much as I will try to mine history for the basic content of how a person understood beauty and the arts.

This said, it's upon the ancient Greek ideals we'll focus, highlighting three Greek thinkers and one Roman.

Pythagoras (c. 570–495 BC)

Pythagoras, according to Aristotle, was about *harmony*. But the harmony Pythagoras sought was not necessarily found in visual art, but in mathematics, and consequently, music. Pythagoras and his students dedicated themselves to study mathematic principles. Here's how Aristotle summarized it:

> At the same time, however, and even earlier the so-called Pythagoreans applied themselves to mathematics and were the first to develop this science; and through studying it they came to believe that its principles are the principles of everything. And since numbers are by nature first among these principles, and they fancied that they could detect in numbers, to a greater extent than in fire and earth and water, many analogues of what is and comes into being—such and such a property of number being justice , and such and such soul or mind , another opportunity, and similarly, more or less, with all the rest—and since they saw further that the properties and ratios of the musical scales are based on numbers, and since it seemed clear that all other things have their whole nature modeled upon numbers,

8. See Clarke, *One and the Many*, 298.

9. Eco, *History of Beauty*, 48.

10. Eco, *History of Beauty*, 85.

and that numbers are the ultimate things in the whole physical universe.[11]

According to Bredin and Santoro-Brienza, "The Pythagoreans were not primary and explicitly concerned with aesthetic properties or with art, but we owe to them the axiom that physical beauty consists in order, measure, proportion, harmony."[12]

Here are a few Pythagorean principles to know.

- **Math and Harmony.** Harmony, as understood by Pythagoras and his followers, "is not the absence of but the equilibrium between opposites. . . . And, once these aspects are transported to the level of visual relationship, the result is symmetry."[13] Symmetry, harmony, and equilibrium are all terms found within Pythagorean thought, and later relate to beauty within the Greek mind.

- **Music.** In their study of mathematics, Pythagoreans "happened upon the mathematical laws of music."[14] And with music, "The harmony and order of musical sounds were . . . an expression of the universal order of reality itself."[15] For Pythagoreans, it would seem, beauty was found in math and music, structuring and constructing the entire cosmos, "the whole world depends on music, whose object is unity and harmony."[16]

Joseph Ratzinger[17] seems to agree with the above sentiment, combining this harmonious order and beauty: "For the Pythagoreans, this mathematic order of the universe was identical with the essence of beauty itself; Beauty comes from meaningful inner order."[18]

Broadcaster and author Ken Myers, in his foreword to *Beauty for Truth's Sake,* picks up on the Pythagorean ethos when he writes, "Proportionate and harmonious aspects of creation . . . first recognized by the Pythagoreans . . . [is found when] wonder is awakened and sustained not just

11. Aristotle, *Metaph.* 985b–86a.

12. Bredin and Santoro-Brienza, *Philosophies of Art and Beauty*, 22.

13. Eco, *History of Beauty*, 72.

14. Bredin and Santoro-Brienza, *Philosophies of Art and Beauty*, 22.

15. Bredin and Santoro-Brienza, *Philosophies of Art and Beauty*, 22.

16. Bredin and Santoro-Brienza, *Philosophies of Art and Beauty*, 22–23.

17. Pope Benedict XVI is a retired German priest and author.

18. Ratzinger, as quoted in Caldecott, *Beauty for Truth's Sake*, 14.

through enchanting stories but by the perception of the numberliness of the world we know through the senses."[19]

Pythagaoran impact on beauty is clearly found in two areas: math and music. And both areas have order, harmony, and metaphysical dynamics, transcending the physical world, but clearly rooted and found in the world.

Plato (c. 427–347 BC)

Regarding the arts, Plato has a mixed reputation. Some felt he tried to ban the arts, citing Plato's exclusion types of poetry as an example.[20] Others felt he limited the arts to just the education of its citizens, a sort of civic propaganda. There's a tad of truth to both views, but don't supply the complete answer.[21] Bredin and Santoro-Brienza point out that "Plato was inclined not so much to banish artists completely as to compel them to produce only edifying and morally improving works."[22]

Plato's insight on the arts are described best in the *Republic*, with books II, III, and X offering the most insight. *Stanford's Encyclopedia of Philosophy* points out that Plato addresses both art and beauty, "yet treats them oppositely."[23] Stanford's post summarizes the opposites as thus: "Art, mostly as represented by poetry, is closer to a greatest danger . . . while beauty is closest to a greatest good."[24]

Art aside, what is Plato's greatest contribution to beauty? The answer: his understanding of forms.[25] Forms are immaterial, non-physical, but are embodied in nature and things. Beauty is one of Plato's forms. But so is "radiance, splendor, and brilliance."[26] Plato's views are similar to Pythagorean ideals, which included harmony and order. For Plato, a form is true reality, an unchanging truth.[27] And beauty as a form is worth pursuing. Plato sum-

19. Caldecott, *Beauty for Truths' Sake*, 7.

20. See Stecker, "Plato," 8.

21. Stecker, "Plato," 8–10.

22. Bredin and Santoro-Brienza, *Philosophies of Art and Beauty*, 31.

23. Pappas, *Plato's Aesthetics*, para 1.

24. Pappas, *Plato's Aesthetics*, para 1.

25. Plato's forms are the immaterial part of existence. They are perfect and unchanging, transcending the physical world. The physical is only a shadow of non-physical reality. Forms are similar to values such as truth, beauty, and goodness.

26. As quoted by Sevier, *Aquinas on Beauty*, 103.

27. Silvermann, "Plato's Middle Period Metaphysics and Epistemology"; Giovannelli, *Aesthetics: Key Thinkers*, 14.

marized the pursuit of beauty as thus: "If there is anything worth living for, it is to contemplate beauty."[28]

Concerning nature, Plato saw the physical world as *memesis*, copies or images, of the immaterial, eternal world.[29] *Memesis* includes art, though twice removed from nature and forms. Art can embody beauty but is not beauty itself. Beauty is its own reality.

Bredin and Santoro-Brienza condense Plato's central point's regarding beauty and art as follows.

- Plato incorporates "two conceptions of art": mimesis and inspiration.
- Plato's "radical dependence of art upon pedagogical and moral concerns."
- The "dualistic separate of art and beauty."
- Plato's "preoccupation with the idea of beauty."[30]

Because Plato's understanding of beauty is fairly involved, connecting it with other transcendentals, I'll abridge his thought using five "E's."

- **Excellence**. Plato used the Greek word *to' kalon* for beauty. It implies all types of excellence, from moral to craft, not just artistic excellence.[31]
- **Eternal**. Beauty is autonomous of utility.[32] Meaning, beauty is not dependent on an object or the purpose of the object. Beauty is eternal, changeless; a form that embodies an object.
- **Enjoyment**. People can enjoy art, but enjoyment doesn't make something beautiful. Beauty is pleasing, but independent of the object. Something is not beautiful because we enjoy it (subjective), but it is beautiful because it embodies an eternal from (objective).[33]
- **Effects**. The effects of beauty had specific characteristics. These characteristics consist of several factors—order, harmony, and proportion, as examples.[34]

28. Plato, *Symp.* 211d. Quoted in Bredin and Santoro-Brienza, *Philosophies of Art and Beauty*, 26.

29. Bredin and Santoro-Brienza, *Philosophies of Art and Beauty*, 27.

30. Bredin and Santoro-Brienza, *Philosophies of Art and Beauty*, 33.

31. Bredin and Santoro-Brienza, *Philosophies of Art and Beauty*, 27

32. Bredin and Santoro-Brienza, *Philosophies of Art and Beauty*, 27.

33. Bredin and Santoro-Brienza, *Philosophies of Art and Beauty*, 27.

34. Bredin and Santoro-Brienza, *Philosophies of Art and Beauty*, 27.

- **Exceeds**. Beauty comes before, exceeds, physical being; it is transcendent. Beauty is unaltered by the physical object, be it nature or art.[35]

Aristotle (ca. 384–322 BC)

Philosopher Angela Curran reminds us that Aristotle's *Poetics* is "the first and most important work of a philosophical account of an art form every written."[36] Largely about drama, *Poetics* advances *techne*, art or craft, in a philosophical manner, an aim to underscore art's intended purpose or goal.[37] If Plato stresses the form of beauty, Aristotle is likened to emphasize art, it's purpose and *telos*, wherein beauty can be found.[38] Furthermore, Umberto Eco points out that the transcendentals had their origins in Aristotle.[39]

Here's how Aristotle understood art, and consequently, a foundational understanding of beauty:

> All Art deals with bringing something into existence; and to pursue an art means to study how to bring into existence a thing which may either exist or not, and the efficient cause of which lies in the maker and not in the thing made; for Art does not deal with things that exist or come into existence of necessity, or according to nature, since these have their efficient cause in themselves. But as doing and making are distinct, it follows that Art, being concerned with making, is not concerned with doing.[40]

Here's a few key takeaways from his paragraph about art:

- Art is "bringing something into existence," an object that is not necessary or created via nature is brought into existence by a human being.
- Studying art is to learn how to "bring into existence a thing," acquiring the skill and knowledge to create something new.
- The "efficient cause" is the artist, the person bringing the object into being.

35. Bredin and Santoro-Brienza, *Philosophies of Art and Beauty*, 28.

36. Curran, "Aristotle," 21.

37. Curran, "Aristotle," 22.

38. Brendan Thomas Sammon writes, "Where Plato's ambiguity can be cast within a trajectory toward transcendence, Aristotle's ambiguity can be seen within his trajectory toward the immanence of form."

39. Eco, *Aesthetics of Thomas Aquinas*, 21.

40. Aristotle, *Eth. nic.* 1140a.

- Aristotle separates "making" and "doing." This seems to indicate that "making" is creating something new and original, whereby "doing" may be the act—or intended goal—for the making, the purpose the object serves.

Concerning this last point, one of Aristotle's key points regarding art is that it is teleological.[41] Meaning art serves a purpose, it has a function towards an end goal.[42]

And regarding how an artist is to produce an object, Aristotle recognized that this requires knowledge, an ability to create art.[43] Art requires *eidos*, "a true course of reasoning."[44] In other words, art requires a comprehension of the craft, an ability and know-how to bring something into existence.[45]

Within Aristotle's metaphysics, three words are emphasized: *mimesis*, *katharis*, and *entelechy*.

Mimesis means imitation, representation, reproduction, or depiction. *Mimesis* is "a likeness of some object or set of events."[46] Though there are differing theories concerning how Aristotle understood and used the word *katharis* in his works, the root meaning of the word is clear: "purification" and "cleansing."[47] "Aristotle discusses *katharis* in the context of ritual purification ceremonies,"[48] eliciting a feeling. A couple of the feelings Aristotle addressed within *katharias* is pity and fear, an emotional response from people. *Enteloecy* is the structural principal of things.[49] "Entelechy does not signify an object which has structure, but is rather what combines with matter to produce and object."[50] In other words, it's similar to an object's form. And "*form* in this sense . . . means the actuality, perfection, or determinacy of a thing."[51]

Art aside, how did Aristotle view beauty? Though he may have some differing views from Plato, both would view beauty as objective, something

41. Curran, "Aristotle," 21–32.

42. Curran, "Aristotle," 22.

43. Bredin and Santoro-Brienza, *Philosophies of Art and Beauty*, 34–36.

44. Bredin and Santoro-Brienza, *Philosophies of Art and Beauty*, 36.

45. Bredin and Santoro-Brienza, *Philosophies of Art and Beauty*, 36.

46. Curran, "Aristotle," 23.

47. Beardsley, *Aesthetics*, 64–65.

48. Curran, "Aristotle," 26.

49. Eco, *Aesthetics of Thomas Aquinas*, 69.

50. Eco, *Aesthetics of Thomas Aquinas*, 69–70.

51. Eco, *Aesthetics of Thomas Aquinas*, 69–70.

independent of the viewer.[52] And like Plato, Aristotle would see beauty as proportionate to order and symmetry as exemplified in math. Aristotle writes, "The chief forms of beauty are order and symmetry and definiteness, which the mathematical sciences demonstrate in a special degree."[53] And in *Poetics*, Aristotle likens beauty to "a certain arrangements of parts," alluding to order, balance, and harmony.[54]

There's lots to chew on in Aristotle.[55] Like the summary of Plato's thought, one can summarize Aristotle's ideals of art and beauty into four broad areas, simplified with the acronym BELL.

- **Being**. There is a structural organization to the object; it has order, symmetry, and balance. It exists according to its form and intended purpose.[56] In an object's being is found objective beauty and telos.

- **Emotional response**. Art or beauty causes a response, as Aristotle's *katharias* implies.

- **Likeness**. Art is representation, a depiction, a replication, of something, an embodiment of an ideal.[57]

- **Learn**. Art, like ethics, can teach. Humans can learn from and enjoy artwork, inferring and understanding the work. And learning, according to Curran's understanding of Aristotle, is "the account of knowledge acquisition . . . all humans desire to know, and knowledge (*episteme*) and inquiry begin with the natural delight we take in sense perception."[58]

52. Sartwell, "Beauty."

53. Aristotle, *Metaph.* 2.1705.

54. Aristotle, *Poet.* 7.3: "to be beautiful, a living creature, and every whole made up of parts, must . . . present a certain order in its arrangement of parts."

55. Here's how Brendin and Santoro-Brienza summarize Aristotle. "Aristotle . . . did not hold a representationally realistic conception of art. He did not accept Plato's conception of art as the production of simulacra. Instead, he insisted that artists deal with probability, possibility and inner necessity: in a word, with verisimilitude, that is, with the imaginative, creative, fictional constructions of symbolic and ideal worlds. . . . Art does not consist in the copying or reproducing of a pre-existing state of affairs, but rather in forming and producing an ideal state of affairs. Through art we encounter metaphors and epiphanies of probable and possible worlds" (*Philosophies of Art and Beauty*, 41).

56. Bredin and Santoro-Brienza, *Philosophies of Art and Beauty*, 41.

57. Bredin and Santoro-Brienza, *Philosophies of Art and Beauty*, 42.

58. Curran, *Aesthetics*, 24.

Plotinus (204–7 AD)

Though Plotinus lived after the apostle Paul (discussed below), I've placed him within the classical area for his alignment with classical ideals, neo-Platonic in influence.[59] Plotinus was not a Christian, though he lived after the life, death, and resurrection of Jesus. And he wasn't Greek, but a Roman citizen living in Egypt. Yet as a Roman, he was influenced by Greek principles, falling within a Platonic tradition.

His impact was heavy upon early Christian thinkers, "influence[ing] and inform[ing] the Christian sensibility of the early Middle Ages."[60] Plotinus' philosophical goal could be summarized as "a search for unity in all things . . . the One."[61]

In Plotinus' pursuit of "the One," he sought all ontological reality, yearning to understand existence. For Plotinus, the One was unified, transcendent, and unknowable, akin to God. In his pursuit of "The One," "Art and beauty . . . occupied a central position on Plotinus' thought . . . placing a "high value on sensuous beauty and considered it to be the most perfect property of this world."[62]

Plotinus contrasted with Pythagoras' understanding of beauty. Whereas Pythagoras valued order, measure, proportion and harmony, Plotinus sought something different, the "whole," a quality that was universal in scope, a divine mark—of sorts.[63]

For Plotinus, the soul was a conduit for beauty, making the other things (body, culture, etc.) beautiful. Plotinus states, the "Soul makes beautiful the bodies which are spoken of as beautiful; for since it is a divine thing and a kind of part of beauty, it makes everything it grasps and masters beautiful."[64] In a way, Plotinus' view of beauty was that its universality is found in the soul—as given from the One—but expressed in the physical.

Concerning art, Plotinus divided the arts into two categories: "those that make and employ their own specific tools, and those that exploit the forces and powers of nature."[65] Later, Plotinus defined five types of arts and

59. Those philosophers, beginning with Plotinus, whose work were in dialogue with Plato's writings, had divergent streams. Neo-platonic thought was largely mystical.

60. Bredin and Santoro-Brienza, *Philosophies of Art and Beauty*, 46.

61. Bredin and Santoro-Brienza, *Philosophies of Art and Beauty*, 46.

62. Bredin and Santoro-Brienza, *Philosophies of Art and Beauty*, 48.

63. See Bredin and Santoro-Brienza, *Philosophies of Art and Beauty*, 47–49.

64. Plotinus, *Enn.* 1.6.6, quoted in Bredin and Santoro-Brienza, 49.

65. Bredin and Santoro-Brienza, *Philosophies of Art and Beauty*, 49.

crafts. I summarize them as architecture, medicine, music (and dance), poetry, geometry.[66]

Furthermore, Plotinus "rejected the Platonic assumption that fine art is fundamentally mimetic and imitative of pre-existing reality. . . . he believed that the defining role of the fine arts is that they produce or manifest beauty in the material world,"[67] a concept closer to Aristotle than Plato.[68] In short, art is a repository and reflection of beauty, not just an imitation of the natural world.

Concerning beauty and art, Plotinus thought of beauty as an objective reality that embodies things, brought into being via an artist's imagination.[69] Basic beauty (art, nature, etc.) connects one to the supreme beauty, the One. In his work the *Sixth Tractate of Enneads*, Plotinus provides the following qualities related to beauty: the one, the intellect, and the soul.

I've summarized them using the acronym *SEE*, going from lower to higher beauties.

- **S—Senses**. The beautiful is located by the senses. Both sight and sound are addressed in his work.[70] This is largely an intellectual pursuit, and concerns with lower beauties—things found in the world—nature, music, etc.

- **E—Essence**. The soul—a person's essence, its being—is a conduit for beauty and helps comprehend beauty. The soul's pursuit of "The One" is a quest from lower beauties to the higher beauty of the Beautiful One. Plotinus writes, "Our interpretation is that the Soul—by the very truth of its nature, by its affiliation to the noblest Existences in the hierarchy of Being—when it sees anything of that kin, or any trace of that kinship, thrills with an immediate delight, takes its own to itself, and thus stirs anew to the sense of its nature and of all its affinity."[71]

- **E—Eternal**. Though beauty is found in material objects, there is greater beauty to be discovered in the metaphysical, eternal world: virtue, knowledge, and particularly, the good. Plotinus states, "Find in yourself, or admire in another, loftiness of spirt; righteousness of life; disciplined purity; courage of the majestic face; gravity, modesty that

66. Bredin and Santoro-Brienza, *Philosophies of Art and Beauty*, 49.

67. Bredin and Santoro-Brienza, *Philosophies of Art and Beauty*, 49.

68. Bredin and Santoro-Brienza, *Philosophies of Art and Beauty*, 49.

69. Bredin and Santoro-Brienza, *Philosophies of Art and Beauty*, 49–50.

70. Plotinus, *Enn.* 1.6.1.

71. Plotinus, *Enn.* 1.6.2.

goes fearless and tranquil and passionless; and shining down upon all, the light of godlike Intellection."[72]

CHRISTIAN (70–1500 AD): BYZANTIUM RENAISSANCE

After the birth of Christ (ca. 4 BCE) and Rome's eventual assimilation within the Church (ca. 325 BCE), Western culture changed. The growth and influence of Christianity dominated the landscape, both in the East (Orthodoxy) and West (Roman Catholic). The defining worldview was a Christ-centered orientation. Inheriting much of Greek and Roman thought concerning beauty, early Christian writers assimilated the thought into a uniquely Christian way, seeing Christ as divine, implying he has all divine attributes, including beauty, adding beauty as a name of God.[73]

Early Christians had a split view of the arts (literature, poetry, music, drama, and visual arts). Some were for them, such as Clement of Alexandria and Basil the Great. Others were against them, such as Tertullian and Boethius. Others had a love-hate relationship with the arts, such as Jerome and Augustine. If there was one medium that received the brunt of the animosity it was drama.[74] And one that was esteemed was poetry.[75] Early on, the visual arts were frowned upon because of the Roman emphasis on representing gods and emperors.[76] But by the time of Nicaean Council in 787 the visual arts were largely accepted, as "honorable reverence,"[77] though debate continue for years.[78]

Key thinkers and ideas of the Christian era included.

Paul of Tarsus (ca. 5–55 AD)[79]

The apostle Paul wrote no known discourse on beauty. Yet throughout his letters we discover that he was familiar with poets (Acts 17:28), music (Eph 5:19), and athletic events—beauty in motion (2 Tim 2:5), things

72. Plotinus, *Enne.* 1.6.5.
73. See Sammon, *God Who Is Beauty*, for more information.
74. Beardsley, *Aesthetics*, 91.
75. Beardsley, *Aesthetics*, 91.
76. Beardsley, *Aesthetics*, 91.
77. Beardsley, *Aesthetics*, 91.
78. See Viladesau, *Theological Aesthetics*, 52–55.
79. The apostle Paul, chronologically speaking, was part of the Classical world. However, because of his influence, I've place him within a Christian context.

that incorporate beauty. Paul was also familiar with community and the beautiful interactions among people, *koinonia*, a type of communion and idealized fellowship. Ultimately, Paul was not inspired by the philosophical transcendentals. His inspiration was the life, death, and resurrection of Jesus Christ. For Paul, Jesus is the fulfillment of God's rescue plan, the prophesied Messiah.

Paul probably saw earthly beauty as a reflection of heavenly beauty, a likeness of the magnificence instilled at creation. He was certainly familiar with the ancient Jewish texts and concepts surrounding beauty (such as Bezalel, who was called to make beautiful objects for the Ark of the Covenant).[80] Since Paul was a first-century educated man and a Roman citizen,[81] he would have been exposed to broader concepts of beauty. This is clear in his letter to the Philippians:

> Whatever things are true, whatever things are noble, whatever things are just, whatever things are pure, whatever things are lovely, whatever things are of good report, if there is any virtue and if there is anything praiseworthy—meditate on these things. (Phil 4:8)

Here, Paul offers a prism of colors, gorgeous qualities inferred from the true, good, and beautiful. Like light hitting a glass prism, the qualities described in Philippians 4:8 are found in God, in Christ, but reflected throughout the cosmos.

Paul's implication is that each value in the Philippians list consists of the beautiful, the spiritually attractive. All values are objective, outside of a purely internal subjectivity. For Paul, internal, spiritual beauty was informed by external objective beauty; all truth, beauty, and goodness begin with God and is echoed throughout eternity. In other words, one had to see or experience these qualities, objectively, in the world in order to internalize them and think about them, subjectively. The objectivity of the values is independent of the internal, subjective, nature. The characteristics Paul listed were meant to be objective values, something from God. For example, someone needed to experience truth or justice objectively in the world in order to adopt such as a rule of life. For Paul, external, objective values—rightly filtered—influence internal, spiritual implementation. And properly applied, there is harmony between the objectivity and subjectivity. Furthermore, Paul called on his readers to "meditate" on the qualities, meditation being another form of internalization.

80. See Exod 31–39.

81. See Acts 16:37–38; 22:25–28.

Paul's approach to the transcendentals (truth, beauty, and goodness) was one of harmonic unity, a symphony and confluence of spiritual qualities organized under the orchestration of God in Christ. In the end, Jesus is the beauty (the icon[82]) of God, and Christians are called to imitate him.[83] Paul's theology resounded Jesus' own statement: "I and my Father are one."[84] This is a proclamation of unity, a confluence of traits and will.

Paul's ideas (and biblical thought, in general) influenced countless Christians after him. One such thinker was Basil of Caesarea (329–79 AD). Philosopher Gian Garfagnini provides a good summary of Basil's thoughts on beauty:[85]

- Basil used the Greek word *pankalia* to define beauty.

- Basil stressed unity: "Parts comprises a harmonic whole."

- Basil emphasized light: "Light, propagating directly and making everything it reaches shine."

- Basil centered on teleology: "A relation [between] the subject and the correspondence between the object and its intrinsic goal."[86]

- Basil highlighted how "the world is beautiful because of the harmony between its part, of humans' capacity to enjoy its overall arrangement as a way to get to the Creator, and finally, of its perfect correspondence to the goal for which God created it."

Basil, inspired by Paul, based his idea of unity and harmony, of various qualities held together and working in unison, in Jesus Christ.[87] For Paul, Christ holds all qualities of divinity; Jesus is the fullness of the Godhead.[88] Christians, after Paul, followed a similar trajectory. In Jesus Christ is all truth, all beauty, and all goodness; he is all in all.[89] All of this reflected Jesus' own words: "I am the way, the truth, and the life."[90]

Since the transcendentals are dependent upon one another, the unified approach of Paul and other Christians continues to influence modern Christianity, which maintains that Christ is the center of life and action.

82. Paul used this term in Col 1:15.

83. 1 Cor 11:1.

84. John 10:30.

85. Garfagnini, "Medieval Aesthetics," 35.

86. Garfagnini, "Medieval Aesthetics," 35.

87. See Rom 8 and Col 1:17.

88. Col 2:19.

89. See 1 Cor 15:28; Col 3:11.

90. John 14:6.

Historian and theologian, Jaroslav Pelikan, summarized this unified truth: "Christ was the . . . personal revelation of God Himself. . . . In Him God was revealed, in Him God was concealed."[91] In Jesus, we discover truth, beauty, and goodness incarnate, previously concealed, but now revealed through his birth, life, death, and resurrection.

Pelikan further articulated the incarnation and beauty as the "Creativity of God. God as the supreme Artist of the universe who . . . fashioned it into beautiful forms that could provide human life with meaning, value, and beauty. We could participate in the creativity of God if we learned sensitively to appreciate the gentle beauties He fashioned. . . . We are united in one all-embracing affirmation of the creativity and the beauty that is God."[92] In other words, Christians participate *within* God's beauty and the totality of his benefits. Christians are members of God's eternal Being.

Joseph Ratzinger stated: "In virtue of his works in creation, the Logos [Jesus] is, therefore, called the 'art of God.' The Logos himself is the great artist, in whom all works of art—the beauty of the universe—have their origin."[93]

Augustine (354–430 AD)

Augustine penned a book on beauty titled *On the Beautiful and the Fitting*. The work is lost to history. But it's notable that Augustine put deep thought into the topic of beauty. In his autobiography and testimony *Confessions*—where Augustine stated he wrote the book—Augustine asks a couple of questions concerning the aim for *On the Beautiful and the Fitting*: "What is beauty?" and "What is it that allures and unites us to the things we love?"[94] It was a love of beauty—and a desire to discover it—that "inflamed him with desire to know [beauty] truly and fully."[95] And this vision led "him to find God."[96]

What is Augustine's concept of beauty? In *Confessions*, Augustine said that "in bodies . . . there [is] a beauty from their forming a kind of whole . . . [and a] . . . mutual fitness."[97] The terms *form*, *wholeness*, and *fitness* encompassed Augustine's early understanding of beauty, with *fitness* probably

91. Pelikan, *Fools For Christ*, 127.

92. Pelikan, *Fools For Christ*, 132.

93. Ratzinger, quoted in Caldecott, *Beauty for Truth's Sake*, 15.

94. See Augustine, *Conf.* 10.27.38.

95. McGrath, *Open Secret*, 263.

96. McGrath, *Open Secret*, 263.

97. Augustine, *Conf.* 4.13, as rendered in Beardsley, *Aesthetics*, 92.

meaning a part of semblance of beauty relating to the broader whole.[98] Broadly, the focus of Augustine's understanding of beauty revolved around five major characterizes: unity, number, equality, proportion, and order.[99]

Augustine's influence upon Christendom was great. It is Augustine's cumulative thoughts (on beauty and many other topics) and writings that "set the stage for medieval Christian philosophers."[100] Bredin and Santoro-Brienza state that Augustine was "a primary figure in the shaping of medieval thought."[101]

At the core of Augustine's thought regarding beauty is that beauty is based in God. Because there is a God, there is beauty. Therefore, beauty is objective and necessary. All beauty is a reflection of God's being. Philosopher Michael Spicher of Boston University puts it this way, "God's beauty emanates out to natural things through His act of creation."[102]

W. Norris Clarke reveals that Augustine's major contributions to beauty is how it relates to form, the splendor of being. Concerning Augustine's understanding of the word *splendor*, Clarke writes, "St. Augustine, drawing from his metaphysics of form as the central metaphysical perfection spoke of it as 'the splendor of the form (*splendor formae*) shining forth.'"[103]

Furthermore, Augustine likened beauty to "a harmony of parts with a certain pleasing color"[104] and "geometric regularity."[105] Augustine also comparted beauty to other transcendent attributes and defined them (virtues) as "intelligible beauty."[106] For Augustine, beauty had both physical and metaphysical channels.

Like Pythagoreans, numbers also played a primary role in Augustine's thought—they elicited harmony. Augustine "regarded number as the fundamental principle in God's creation of the world. Everything depends on number. Objects are what they are—participate in the Forms that exist in the mind of God—through their numerical properties."[107] According to Beardsley, Augustine saw how "Beauty . . . proceeds from unity, proportion, order—and shares their admirable immutability." In other words, it's

98. Beardsley, *Aesthetics*, 92.

99. Beardsley, *Aesthetics*, 93.

100. Spicher, "Medieval Theories of Aesthetics," section 3a.

101. Bredin and Santoro-Brienza, *Philosophies of Art and Beauty*, 53.

102. Spicher, "Medieval Theories of Aesthetics," section 3a.

103. Clarke, *One and the Many*, 300.

104. Eco, *Aesthetics of Thomas Aquinas*, 72.

105. Eco, *Aesthetics of Thomas Aquinas*, 107.

106. Eco, *Aesthetics of Thomas Aquinas*, 43.

107. Beardsley, *Aesthetics*, 54.

the immutability—its transcendent nature—that connects beauty back to the universe and God,[108] and numbers, harmony, and other eternal values demonstrate a connection.

Bredin and Santoro-Brienza show how Augustine's ideas of beauty "combined and consolidates all of the philosophies that preceded him. It synthesized four main ideas: objectivity, transcendence, harmony, and pleasure."[109] In framing the synopsis of Augustine's thought, Bredin and Santoro-Brienza summarized four parts. It may be easiest to use the acronym, TOhP (or TOP).

- **T—*Transcendence***: "The ground of beauty was identified with God. God's perfect beauty was the source of beauty in everything else."[110] Hence, beauty is immutable and transcendent.

- **O—*Objective***: Augustine understood the concept objectivity in being as "things." And "things give pleasure."[111] Augustine stated, "The eyes delight in beautiful shapes of different sort and bright and attractive colors."[112] In the end, Augustine saw beauty as objective, real, confirmed through the senses ("pleasure")—there is something real one can enjoy.

- **H—*Harmony***: Augustine inherited the classical view of harmony as one of the attributes of beauty, and so saw beauty as a harmonious, measured, and orderly "fitting together of parts."[113] These parts unified into a cohesive whole.[114] Overall, harmony, unity, and order were key to Augustine's understanding of beauty.

- **P—*Pleasure***: As noted above, Augustine said beauty "delights," and delight is an intellectual response to a being's form. "For Augustine it was the intellect, the faculty that people share with God, that perceived beauty, the revelation of the divine in the physical world."[115] Therefore, the response to God's revelation should bring pleasure.

108. Beardsley, *Aesthetics*, 54.

109. Beardsley, *Aesthetics*, 54.

110. Beardsley, *Aesthetics*, 54.

111. Beardsley, *Aesthetics*, 54.

112. Augustine, *Conf.* 10.34, as quoted in Bredin and Santoro-Brienza, *Philosophies of Art and Beauty*, 54–55.

113. Beardsley, *Aesthetics*, 55.

114. Beardsley, *Aesthetics*, 55.

115. Beardsley, *Aesthetics*, 56.

Pseudo-Dionysius the Areopagite (ca. Fifth Century, 400s AD)

Dionysius the Areopagite was an early Christian who wrote much on beauty.[116] Little is known about the life of Dionysius the Areopagite. We have his works, such as *The Divine Names*, which influenced a host of medieval Christian philosophers, Aquinas being one.[117] Many point out that *The Divine Names* is largely Neoplatonic thought mixed with Christian theology.[118] According to Bredin and Santoro-Brienza, "Pseudo-Dionysius. . . . left a series of treaties containing important metaphysical and theological reflections on art and, especially, beauty . . . [and] from these writings a transcendental conception of beauty . . . as an attribute of all being" arose.[119] Dionysius the Areopagite incorporated some of Plotinus' imagery, and has often been categorized as a Christian mystic.[120]

Dionysius the Areopagite was one of the first Christians to import beauty as an attribute of God, a "divine name."[121] Philosopher, Gian Carlos Garfagnini pointed out that Pseudo-Dionysius promoted an idea called *emanation*, which "identifies the beautiful with the light that propagates from the One and that, shining on all things, brings them into existence."[122]

Dionysius the Areopagite inherited his understanding of beauty—with its stress on harmony—from the classical world.[123] Bredin and Santoro-Brienza found two overarching themes in the thoughts of Dionysius the Areopagite.

The first theme is transcendental beauty: beauty is identified with God, the origin of being. Dionysius the Areopagite spoke of "super-substantial beauty, universal beauty and super-beauty."[124]

In *Divine Names* 704A, this theological framework is rendered as:

> Beauty . . . is the superabundant source in itself of the beauty of
> every beautiful thing. . . . From this beauty comes the existence
> of everything; each being exhibiting its own way of beauty. For

116. Though there was an earlier Dionysius, mentioned in the book of Acts, most scholars think this is a different Dionysius, hence the "Pseudo" rendered before his name.

117. Dionysius the Areopagite's other books include *Ecclesiastical Hierarchy, Celestial Hierarch, and Theology*.

118. Bredin and Santoro-Brienza, *Philosophies of Art and Beauty*, 51.

119. Bredin and Santoro-Brienza, *Philosophies of Art and Beauty*, 51.

120. *Corrigan and Harrington*, "Pseudo-Dionysius the Areopagite."*Stanford Encyclopedia of Philosophy*.

121. Bredin and Santoro-Brienza, *Philosophies of Art and Beauty*, 51.

122. Garfagnini, *Aesthetics: Key Thinkers*, 36.

123. Garfagnini, *Aesthetics: Key Thinkers*, 52.

124. Bredin and Santoro-Brienza, *Philosophies of Art and Beauty*, 51.

beauty is the cause of harmony, of sympathy, of community. Beauty unites all things and is the source of all things.[125]

The second overarching theme of Dionysius is art and the physical world as a symbol of the beautiful.[126] Bredin and Santoro-Brienza stated that Dionysius the Areopagite believed "beauty originates in God, emanates from God, and returns to God . . . [and that] Divine beauty, for all its transcendence, resonates throughout the physical world."[127] Art and nature were viewed as one of the means in which beauty "resonates" in the world. In essence, "Visible things . . . are images of invisible things. . . . everything is the symbol and sign of something else, and ultimately of God."[128]

Bredin and Santoro-Brienza concluded that, for Dionysius, the "task of art was to produce images and symbols of spiritual reality, or of God, so that people's minds might be edified and elevated from their worldly concerns to the contemplation of theological and religious truths."[129]

Aquinas (1225–74 AD)

Aquinas based much of his conceptual ideas regarding beauty on Plato, Aristotle, Dionysius the Areopagite, and Augustine. Bredin and Santoro-Brienza related Aquinas' understanding of beauty back to Pythagorean thought, "proportion primarily in quantitative and mathematical terms."[130]

In keeping within a formal criterion set by his predecessors, Aquinas placed an emphasis on harmony, spatial proportion, and light,[131] Aquinas, like Augustine, related beauty to the intellect and to sight: "Beauty . . . has to do with the cognitive powers, for we ascribe beauty to things which give us pleasure when they are seen."[132] Aquinas clarified his idea of beauty as based within three formal criteria: proportion, integrity, and clarity.[133]

125. Dionysius the Areopagite, as quoted in Bredin and Santoro-Brienza, *Philosophies of Art and Beauty*, 52.

126. Bredin and Santoro-Brienza, *Philosophies of Art and Beauty*, 52.

127. Bredin and Santoro-Brienza, *Philosophies of Art and Beauty*, 52.

128. Bredin and Santoro-Brienza, *Philosophies of Art and Beauty*, 53.

129. Bredin and Santoro-Brienza, *Philosophies of Art and Beauty*, 53.

130. Bredin and Santoro-Brienza, *Philosophies of Art and Beauty*, 64.

131. See Sevier, *Aquinas on Beauty*, 103.

132. Aquinas, *Summa Theologia* 1.5.4.

133. The best book exploring how Aquinas used and understood the criteria is found in Umberto Eco's *Aesthetics of Thomas Aquinas*.

Understanding beauty involved not only the intellect, but also the emotions; a response of pleasure, delight.[134]

Umberto Eco suggested how the three formal criteria "points, either explicitly or by implication, to the concept of form. . . . Form, in fact, is a key concept in Aquinas' aesthetics: everything that he says about beauty indicates that it is grounded in form."[135] This said, Aquinas' understanding of form returned to that of Augustine: measure, dimension, and order.[136] The three formal criteria, plus form, connect beauty to the perfection of an object, the reality of its existence, its being according to its form.

We may structure Aquinas' thoughts regarding beauty as an equation: being + form + intellect (recognizing harmony, light, proportion, integrity, and clarity) = response, eliciting pleasure.

Aquinas understood the three formal criteria as a "PIC" of beauty.

- *P—Proportion.* Aquinas had four overarching understandings of proportion.[137] First, "The suitability of matter for receiving a form . . . form that gives it order and actuality."[138] In essence, the object is; it has being. Second, there is a "proportion between essence and existence."[139] Aquinas may have been making a connection between the material matter of an object and the energy extended via the object. Third, the proportion is "sensible and basically quantitative."[140] This seems to include the measurement of the form, or the concrete experience through the senses and science. Last, there was a "purely rational fit between things: logical relations."[141] This was both moral and metaphysical. Eco stressed that proportion is connected to form: "proportion is based upon the vital reality of form."[142]

134. See Eco, *Aesthetics of Thomas Aquinas.* It's important to note, however, Günther Pöltner points out that "Thomas rarely spoke about the beautiful. We have no *quaestio disputant,* not even an *articulus* devoted to the beautiful. He touches on the question only rarely, though these several remarks are heavy with implications." Yet it's with Aquinas' three formal criteria we find "heavy . . . implications" regarding beauty, carrying great weight throughout history."

135. Eco, *Aesthetics of Thomas Aquinas,* 66.

136. Eco, *Aesthetics of Thomas Aquinas,* 66–67.

137. Eco, *Aesthetics of Thomas Aquinas,* 83–85.

138. Eco, *Aesthetics of Thomas Aquinas,* 83.

139. Eco, *Aesthetics of Thomas Aquinas,* 84.

140. Eco, *Aesthetics of Thomas Aquinas,* 85.

141. Eco, *Aesthetics of Thomas Aquinas,* 85.

142. Eco, *Aesthetics of Thomas Aquinas,* 95.

- *I—Integrity.* According to Eco, Aquinas' understanding of integrity is connected to an object's "wholeness or perfection . . . and perfection means the complete realization of whatever it is that the thing is supposed to be."[143] Eco said: "Integrity, then, is a type of proportion."[144] Christopher Scott Sevier likened Aquinas' view of integrity to its "wholeness or perfection of an object . . . similitude to the ideal member of its species."[145] And Bredin and Santoro-Brienza stated that integrity "signifies the completeness of something . . . an object exhibits all the structural and organic elements that its specific nature of essence requires."[146] In final analysis, integrity deals with the ideas of perfected form, "a form which presides over [an object's] construction and regulates it in a law-governed way."[147]

- *C—Clarity.* Eco points out that Aquinas believed the term clarity had "a variety of meanings."[148] Some of the meanings revolve around the concepts of color, arrangement, and proportion.[149] But one of the most prominent usages is in relationship to light, clarity "as an effect of light."[150] Eco connects this concept to the Aristotelian idea of light and color, "a theory which explains the mechanics of luminous phenomena."[151] Sevier sees Aquinas' view of clarity related to Plotinus' understanding of the "Good": "The good that illumines intelligible reality . . . [and] a constituent of beauty."[152] Bredin and Santoro-Brienza point out that Aquinas often used the term "beauty" in relation to color, connecting clarity to virtue, the beauty of the soul.[153]

Like many of his Christian processors, Aquinas saw beauty as a unifying value, "the synthesis of the other three transcendentals:"[154] the "splendor of unity, truth, and goodness."[155] For Aquinas, beauty is a principle found

143. Eco, *Aesthetics of Thomas Aquinas*, 98–99.

144. Eco, *Aesthetics of Thomas Aquinas*, 99.

145. Sevier, *Aquinas on Beauty*, 112.

146. Bredin and Santoro-Brienza, *Philosophies of Art and Beauty*, 64.

147. Eco, *Aesthetics of Thomas Aquinas*, 101.

148. Eco, *Aesthetics of Thomas Aquinas*, 102.

149. Eco, *Aesthetics of Thomas Aquinas*, 103.

150. Eco, *Aesthetics of Thomas Aquinas*, 103.

151. Eco, *Aesthetics of Thomas Aquinas*, 103.

152. Sevier, *Aquinas on Beauty*, 112.

153. Bredin and Santoro-Brienza, *Philosophies of Art and Beauty*, 64.

154. Bredin and Santoro-Brienza, *Philosophies of Art and Beauty*, 62.

155. Bredin and Santoro-Brienza, *Philosophies of Art and Beauty*, 65.

in all being and is the end of all being (all being goes back to God), the splendor of being and form.[156]

CARTESIAN (1600–1945)

The culmination of the Renaissance and Reformation (ca. 1400–1600 AD) saw the last major vestiges of the church's organized influence on Western culture. The West took a sharp turn towards empiricism (knowledge arising from the senses as tested through experiment) and ended with the Enlightenment and the rise of modern science. I have followed Beardsley's categorization of the era as Cartesian Rationalism,[157] named for René Descartes, whose ideas "spread across Europe"[158] and influenced many prominent thinkers. Cartesian rationalism is based on the idea that scientific knowledge can be discovered through deductive reasoning. Though the three examples provided below may expand beyond a simple Cartesian expression (for example, Nietzsche), they are all rooted in the ideology established by Descartes.

Hume (1711–76)

The Scottish Enlightenment philosopher, David Hume, played a large role in developing the modern understanding of beauty. Hume derived much of his thought from his intellectual mentors, Francis Bacon and Francis Hutcheson. Hutcheson was one of the first to draw specific attention to aesthetics, writing the first modern essays on the topic in 1725.[159] Hume's influence on the thought of his day was remarkable. Bence Nanay stated that Hume's "influence on Anglo-American philosophical aesthetics is difficult to overstate."[160]

Hume emphasized sensory experience, maintaining the preeminence of the senses over intellectual arguments.[161] Regarding beauty, in his work, *Treatise of Human Nature*, Hume said: "Beauty is such an order and construction of parts, as either by the primary constitution of our nature, by custom, or by caprice, is fitted to give a pleasure and satisfaction to the

156. See Aquinas, *Introduction to the Metaphysics*, 93–95.
157. Beardsley, *Aesthetics*, 140.
158. Beardsley, *Aesthetics*, 141.
159. Beardsley, *Aesthetics*, 185.
160. Nanay, *Aesthetics*, 53.
161. Bredin and Santoro-Brienza, *Philosophies of Art and Beauty*, 78.

soul."[162] In other words, a person's understanding of beauty is based upon social conditioning—what culture deems beautiful—or personal preference.

For Hume, beauty could not be defined; it had to be experienced through taste or sensation.[163] For him, sensation led to a "sentiment."[164] Hume understood "sentiment" as a feeling that brings pleasure—with no "standard of taste."[165] For Hume, sentiments were always right because there was no outside reference point. In essence, sentiments are a matter of opinion; there is no objective way to valuate a judgment; one's opinion was as good as the next. This means someone's judgment can be wrong, for the same reason it is right for someone else. It's all a matter of taste. Hume did somewhat distinguish between sentiments (opinions) and judgments ("determinations of understanding"), but both were still based upon a subjective understanding, particular to a person's tastes and customs. In other words, there are no set criteria for beauty.

In *Of the Standard of Taste*, Hume wrote, "Beauty is no quality in things themselves: it exists merely in the mind which contemplates them; and each mind perceives a different beauty. One person may even perceive deformity, where another is sensible of beauty; and every individual ought to acquiesce in his own sentiment, without pretending to regulate those of others."[166] As stated, the individual "mind" of a person formulates the tastes and sentiments of what he or she considers beautiful, not, necessarily, the object.

Consequently, Hume felt that beauty was not found in a thing itself, but in a person's mind, flowing as judgment or sentiments. Because of this, Beardsley categorized Hume as a "Qualified Observer,"[167] someone that can give opinions or judgments but understands the judgments are largely the sentiments of a particular position of the person. There is no objective standard when it comes to beauty.

Philosopher Alan Goldman rendered Hume's understanding of beauty like this: "In the *Treatise* [*of Human Nature*], [Hume] also says that beauty is an order of parts fitted to give one pleasure because of one's nature or customs. Here, then, beauty is like a secondary quality in John Locke's sense. . . . beauty [is] a sentiment, the focus is on the object and its properties, which cause the response. A beautiful object is one that causes a pleasurable response

162. Hume, as quoted in Beardsley, *Aesthetics*, 187.

163. See Beardsley, *Aesthetics*, 187.

164. See Beardsley, *Aesthetics*, 188–89.

165. See Beardsley, *Aesthetics*, 189.

166. Quoted in Eco, *History of Beauty*, 247.

167. Beardsley, *Aesthetics*, 191.

in a viewer in favorable circumstances in virtue of its form."[168] Put simply, certain things ("the ordering of parts")—and how one perceives them ("fitted together to give one pleasure")—is what is beautiful to the person, not any universal standard of beauty; beauty is in the eye of the beholder.

In *The Standard of Taste*, Hume said that the important thing about art is its

> "agreeableness," the pleasure we derive from it, and that this is a matter of our sentiments, not its intrinsic nature (being). Judgments about good and bad in art, according to Hume, are not really judgments at all 'because sentiment has a reference to nothing beyond itself, and is always real, wherever a man is conscious of it. In other words, if I like a thing, I like it irrespective of any characteristic it possesses.[169]

Summarizing Hume's thought, theologian Gordon Graham writes that the "Subjective—a matter of likes and dislikes, rather than truth and falsehood . . . [and finds its] philosophic champion [in] David Hume. . . . If we take the idea of aesthetic taste seriously, Hume thinks, we have to allow that it 'has a reference to nothing beyond itself.'"[170] Plainly, we don't get a universal notion of beauty from anywhere else but ourselves.

What makes Hume different? Hume is unlike his predecessors, particularly the Christian thinkers, in that he did not think beauty was purely objective. (Other than the form of object, which necessarily did not embody beauty). For Hume, there was no outside standard or criteria to judge if something is beautiful—such as God or eternal forms. Though Alan Goldman stated that Hume "tried to steer a middle course between radical subjectivism or relativism and objectivism in regard to judgments of beauty or aesthetic value,"[171] it is clear that Hume began the move toward a fully subjective stance towards beauty. Contrasting with his mentor, Francis Hutcheson, who saw form as "unity amidst variety"[172] and endorsed the importance of the response to a form (an objective base), "Hume nowhere endorses this description of the objective side of the relation."[173] For Hume, beauty came down to taste or opinion, either influenced by "nature or customs."[174] And because Hume was critical and skeptical of the existence

168. Goldman, "David Hume," 49.

169. Graham, *Philosophy of the Arts*, 3–4.

170. Graham, *Philosophy of the Arts*, 200.

171. Goldman, "David Hume," 48.

172. Goldman, "David Hume," 49.

173. Goldman, "David Hume," 49.

174. Goldman, "David Hume," 49.

of God, his thoughts regarding God may have influenced his thoughts on beauty. In the end, for Hume, there was no "outside" criteria—in the object itself or in God. There was only a personal response, one's opinion and taste.

Immanuel Kant (1724–1804)

Monroe Beardsley, who deeply respected Immanuel Kant, stated that Kant's "aesthetic theory . . . would mark a turning point in the field."[175] So what was the "turning point" Beardsley referenced? He wrote that Kant "hoped to provide a theory of aesthetic judgment that would justify its apparent claim to intersubjective validity, and escape the temptations of skepticism and relativism. . . by giving a deeper interpretation of art and of its values."[176] In essence, Kant attempted to give beauty further intellectual rigor, and therefore tended toward a middle ground between a subjective (Hume) and an objective framework (ancient philosophers and theologians). This middle ground is what Philosopher Brent Kalar referred to as a "third way."[177] Kalar writes that Kant led to an "investigation of what we might call the 'subjective' and 'objective' poles of the beautiful. The subjective pole is Kant's theory of the psychological process involved in the pleasurable response to the beautiful. . . . The objective pole, on the other hand, which for Kant is centered around the notion of an object's 'form of purposiveness without a purpose.'"[178]

Bredin and Santoro-Brienza pointed out that Kant's aesthetic theories were "a synthesis and a development of ideas formulated early by the philosophers of the seventeenth and eighteenth centuries."[179] The philosophers Kant relied upon were Leibniz (an emphasis on harmony), Hutcheson (intellect versus desire), and Burke (beauty and perfection).[180]

Kant's understanding of philosophy appears in three monumental works. In *Critique of Pure Reason*, Kant addressed the nature of knowledge. In the *Critique of Practical Reason*, Kant wrote of will and desire. In *Critique of Judgment*, Kant contemplated aesthetics and beauty, or faculty and feeling.

One of the foci of Kant's *Critique of Judgment* was the differentiation between the subjective and objective nature of beauty. How can beauty be

175. Beardsley, *Aesthetics*, 210.
176. Beardsley, *Aesthetics*, 210.
177. See Kalar, *Demands of Taste*.
178. Kalar, *Demands of Taste*, 3.
179. Bredin and Santoro-Brienza, *Philosophies of Art and Beauty*, 80.
180. Bredin and Santoro-Brienza, *Philosophies of Art and Beauty*, 80.

both objective and subjective? In his early years Kant thought "aesthetic appreciation was purely subjective, simply a matter of pleasure."[181] But in *The Critique of Judgment*, Kant's views altered, paying attention to the rational aspects of beauty. In *The Critique of Judgment* Kant provided insight on why he felt aesthetics "transcends mere individual preference."[182] In the end, Kant believed that "appreciating the beautiful is an act of the mind as well as a matter of sensuous feeling,"[183] eliciting judgment, and placing "aesthetic judgment between logically necessary and the purely subjective."[184]

For Kant, there is a subjective sense in appreciating something beautiful (personal taste or judgment), but there also is an objective sense to what is beheld (the object). The subject-object interface is an area that Kant unpacks. And when the appreciation of the object leads the viewer to consider the object as beautiful, the end result is deep appreciation of the object, leading to sublimity. Sublimity is a type of transcendence or universal validity, deeming something as beautiful or lovely.[185] And this feeling of beauty had universal application; all people could (if rightly explained and experienced) appreciate the beauty found in the object. As an example, looking at the Grand Canyon should be universally accepted as beautiful and sublime. Scruton puts it this way, "Kant's position was that aesthetic judgments are universal but subjective; they are grounded in the immediate experience of the one who makes them, rather than in any rational argument."[186] We can understand universal validity as a quality that all humans share—we can experience something beautiful; therefore, the validity has a base in objective, common reality.

Kant's thought encompasses four broad areas: "disinterested pleasure," teleology, judgment, and the sublime.

- **Disinterested pleasure**. What is disinterested pleasure? Scruton, commenting on Kant, renders it as thus: "disinterested pleasure is a kind of pleasure *in*. But it is focused on its object and dependent on thought: it has a specific intentionality."[187]

- **Teleology**. Bredin and Santoro-Brienza defined teleology as "a universal principle governing all that there is and is the guarantor of an

181. Graham, *Philosophy of the Arts*, 17.

182. Graham, *Philosophy of the Arts*, 17.

183. Graham, *Philosophy of the Arts*, 17.

184. Graham, *Philosophy of the Arts*, 17.

185. See Kalar, *Demands of Taste*, 1–10.

186. Scruton, *Beauty*, 27.

187. Scruton, *Beauty*, 25.

ultimate harmony of all things."[188] Kant's understanding of teleology seems to be the glue that held all his thought together. Bredin and Santoro-Brienza said: "This principle [teleology] . . . is the ground and justification of aesthetic experience, which achieves a harmony between nature and mind, imagination and understanding, affectivity and the well, universality and particularly, subjectivity and objectivity."[189]

- Judgment. Beardsley, when studying Kant's judgment, "discovered that there remain on his hands two rather puzzling kinds of proposition whose cognitive status he had not yet cleared up [in his earlier books]: aesthetic judgments (especially of the sublime and the beautiful) and teleological judgments (judgments of purpose)."[190] In wrestling with the tension of these propositions, Kant closed the gap between subjective and objective: "Thus the form of the object is connected a priori with the feeling of the harmony of the two cognitive faculties; and the feeling of this harmony is precisely the disinterested pleasure itself,"[191] "judgment of taste," a "satisfaction it reports. . . . the satisfaction we get from an object is bound up with a desire that it exists, or a desire to possess it."[192] Put simply, an object exists (has being) and a person likes it, creating an objective-subjective relationship. And this relationship, according to Kant, leads to contemplation.[193]

- Sublime. Beardsley related the commonality between beauty and sublimity: "They can both be predicate of aesthetic judgements that are singular in logical form and claim universal validity, and they afford in themselves a pleasure that does not depend on a sense of on the definite concept of the understanding."[194] Beardsley defined Kant's understanding of sublimity in two ways: mathematical and aesthetical. Mathematical sublimity is "absolutely great";[195] whereas aesthetical sublimity is when the "imagination tries to comprehend or encompass

188. Bredin and Santoro-Brienza, *Philosophies of Art and Beauty*, 81.

189. Bredin and Santoro-Brienza, *Philosophies of Art and Beauty*, 81.

190. Beardsley, *Aesthetics*, 211.

191. Beardsley, *Aesthetics*, 216.

192. Beardsley, *Aesthetics*, 212.

193. Bredin and Santoro-Brienza summarized Kant's theories as "Subjective harmony . . . The aesthetic sentiment or feeling of pleasure depends upon and derives from the free, non-conceptual and harmonious interplay of the imagination and the understanding." And in light of teleology and art, Kant "understood art to be the conscious creation of objects that engender, in those who contemplate them, the impression that they have been created outshout intention" (*Philosophies of Art and Beauty*, 81).

194. Beardsley, *Aesthetics*, 218.

195. Beardsley, *Aesthetics*, 218.

the whole representation . . . [reaching] the felt limit and appears as if infinite."[196] There is joy, elevation, and pleasure in the aesthetic discovery, "surpassing every standard of sense";[197] sublimity sets in.

How would one summarize the complexity of Kant's thought? Beardsley positioned Kant's overarching contribution to aesthetics in four predominant principles:[198] First, the *imagination and understanding* of beautiful objects. Second, the *pleasure* we derive from beautiful objects. Third, the *relation or order* of the objects themselves. And fourth, the *modality* of the object. This last point describes the judgment we give an object, "a necessary reference to satisfaction." And "implicit in the judgment of taste presupposes a 'common sense'—the state of mind 'resulting from the free play of our cognitive power.'"[199]

In a similar manner, Philosopher Elisabeth Schellekens summarized Kant's key contributions:

1. "Freedom of the faculties . . . the way in which our mental faculties interact with aesthetic experience";[200]

2. Universality and necessity."[201] This idea holds that judgment making, and evidence for the judgment, are related and necessary;

3. "Pleasure and disinterestedness";[202]

4. "Purposiveness without purpose."[203] This means that "aesthetic judgments can neither be based on private sensations nor on the notation of perfection";

5. "Aesthetic ideas and genius," that is, "the artists seek to improve their taste by examining and engaging with example of beautiful form. In both nature and art . . . [and] pure and impure—beautiful and sublime."[204]

196. Beardsley, *Aesthetics*, 218–19.

197. Beardsley, *Aesthetics*, 219.

198. See Beardsley, *Aesthetics*, 214–20.

199. Beardsley, *Aesthetics*, 216–17.

200. Schellekens, *Aesthetics*, 63.

201. Schellekens, *Aesthetics*, 65.

202. Schellekens, *Aesthetics*, 66.

203. Schellekens, *Aesthetics*, 67.

204. Schellekens, *Aesthetics*, 69.

Nietzsche

At the time of Nietzsche, Romanticism took hold of the world. In the late eighteenth century, Romanticism's communitive ethos valued inspiration, imagination, feeling, and subjectivity. Romanticism was highly influential in literature and music. Emotion was key, valuing an authentic experience with art, nature, and humanity. Though borrowing from Hume, Hegel, and Kant, Romanticism ushered in a "change in basic values,"[205] epistemological re-orientation ("emotional intuitionism"[206]), and new ways to think about art.[207] Creatives such as Johann von Goethe, William Blake, Lord Byron, John Keats, Ludwig van Beethoven, Franz Liszt, Richard Wagner, and Frederic Chopin brought forth a Romantic spirit within the arts. In philosophy, Artur Schopenhauer and Jean-Jacques Rousseau were key thinkers.

In the middle of the Romantic movement, Nietzsche (1844–1900) rose to prominence as a key aesthetical thinker. Borrowing heavily from Schopenhauer and composer Richard Wagner, Nietzsche wrote his first book on aesthetics in 1872, *The Birth of Tragedy from the Spirit of Music*. Nietzsche valued truth—but truth without absolutes. Oddly enough, Nietzsche felt that people also needed illusion, "primordial energies of the 'will to power,'"[208] in emotion and creativity. And art (especially music and drama) was one of the illusions people needed, a symbolic rendering of reality. Nietzsche attempted to examine the depths of creative engagement to justify an aesthetic way of life, the "highest dignity lies in our significance as works of art."[209] In this way, Nietzsche was both existential in his thought, and the father of nihilism.[210]

According to Beardsley, "The main focus of all Nietzsche's thinking about art is on this previously neglected area [the impulse to create art]: he wanted to probe more deeply than had ever been done the deep sources of artistic creation, the nature of the impulse to make works of art."[211]

In *The Birth of Tragedy*, Nietzsche highlighted two key words: *Kunsttriebe* and *Mittelwelt*.

205. Beardsley, *Aesthetics*, 246.

206. Beardsley, *Aesthetics*, 246.

207. Beardsley, *Aesthetics*, 247.

208. Bredin and Santoro-Brienza, *Philosophies of Art and Beauty*, 97.

209. Nietzsche, as quoted in Jenkins, "Arthur Schopenhauer and Friedrich Nietzsche," 91.

210. Bredin and Santoro-Brienza, *Philosophies of Art and Beauty*, 96.

211. Beardsly, *Aesthetics*, 276.

- *Kunsttriebe* are the artistic impulses. Central to this inquiry was trag-
 edy, a dance between the Apollonian and Dionysian elements of the
 arts. Nietzsche references the two sons of Zeus, Apollo and Dionysus,
 and sets them in opposition to one another. Apollo represents order,
 logic, prudence, and rational thinking. Dionysus represents chaos,
 emotions, instinct, and irrational thinking. Both Apollyon and Diony-
 sian elements are found in the arts, and hence, beauty. Gordon Graham
 related the differing ideas as follows: "The Apollonian manufactures
 dream-like images . . . that intrigue us and invite our passive contem-
 plation. The Dionysian, by contrast, does not invite contemplation, but
 seeks to take possession of us."[212] The Apollonian is thoughtful and
 ordered, the Dionysian anarchic and impulsive. Both are encased in
 the arts and in beauty.

- *Mittelwelt* suggests an in-between world, something veiled in sym-
 bolism and tragedy. Recognizing the symbolic nature in art, Jeroslav
 Pelikan points out that Nietzsche summarized the concept of "*Mittel-
 welt*—[as] an intermediate world—which veiled a terrible or awesome
 reality."[213] Pelikan believed the rationale behind Nietzsche's *Mittelwelt*
 "underlining motif of this notion was its realization that the worship
 of the Holy or of the Beautiful involved the surrender of one's own
 will and even his rational processes to the overwhelming power of the
 divine."[214] It was a contemplation of beauty that mattered for Nietzche.
 Pelikan writes, "Nietzsche, for in the frenzy of the Beautiful he saw the
 highest meaning of life."[215] Furthermore, "Nietzsche insisted that this
 contemplation of the Beautiful had to be existential . . . [that it] dare
 not be from the standpoint of a spectator."[216] In other words, one must
 engage, act, and engulf oneself in the arts and beauty. And in order
 to act, it one may have to remove oneself from all previous thoughts
 regarding culture and life, Christian morality included. Pelikan sug-
 gested that "Nietzsche's doctrine . . . helped him to overcome the equa-
 tion of the Holy and Beautiful. The essence of human nature Nietzsche
 saw in the will-to-power, of which all human striving and values
 were merely expression. . . . Nietzsche perceived . . . how demonic the

212. Graham, *Philosophy of the Arts*, 155–56.
213. Pelikan, *Fools For Christ*, 127.
214. Pelikan, *Fools For Christ*, 128.
215. Pelikan, *Fools For Christ*, 135.
216. Pelikan, *Fools For Christ*, 137.

identification of the Holy and the Beautiful could be. It could act as a mask for the will-to-power."[217]

Nietzsche's aesthetical strength lay in his treatment of the opposing mindsets at work within the arts, the Apollonian and Dionysian. His weakness was relegating beauty to a purely human phenomena—acting as a "mask." Instead of finding beauty, Nietzsche fled from its objectivity, searching for what he believed was the stronger aspect of human thought: will and power.

CONTEMPORARY (1945–PRESENT)

More recently, post-modern thought—with its emphasis on relativism, deconstruction, and the absence of clear meaning—has taken root. Yet, many great thinkers of the era were still largely indebted to the preceding thinkers of the previous eras, as Gilson, Gadamer, and Evdokimov will attest. Others reacted to the preceding views, as Jacques Derrida did with Structuralism.[218]

In *Aesthetics: Key Thinkers*, many people are listed who've influenced a contemporary understanding of beauty and aesthetics. The broad swath of postmodern aesthetic philosophers contains both secular and Christian thinkers, including individuals such as Arthur Schopenhauer, Benedetto Croce, Robin Collingwood, Roger Fry, Clive Bell, John Dewey, Marin Heidegger, Walter Benjamin, Theodor Adorno, Monroe Beardsley, Nelson Goodman, Richard Wollheim, and Arthur Danto.[219] Gordon Graham lists others, comprising of George Dickie, Louis Althusser, Claude Lévi-Strauss, and Janet Wolff—to name a few.[220]

And in *Beauty: Documents of Contemporary Art*, editor Dave Beech provides yet another grouping, ranging from Saul Ostrow and Jacques Derrida to Richard Woodfield. With someone like Derrida, a dense network of understanding comes into the mix concerning beauty, featuring things such as play,[221] free-interpretation, and deconstruction.[222]

Coinciding with the broader thinkers are the Christian philosophers such as Jacques Maritain, Joseph Pieper, Nicolas Wolterstoff, William

217. Pelikan, *Fools For Christ*, 142.

218. See Graham, *Philosophy of the Arts*, 238–43.

219. See *Aesthetics*.

220. See Graham, *Philosophy of the Arts*, 221–48.

221. Deridda's understanding of play is different than Gadamer. For Deridda, it was associated with free-interpretation, as one can play with the meaning of something. See Graham, *Philosophy of the Arts*, 23–25.

222. See Graham, *Philosophy of the Arts*, 238–43.

Dyrness, Jean-Luc Marion, Richard Viladesau, David Brown, Piotr Jaro-szynski, Frank Brown, Brendan Thomas Sammon, and Cecilia Gonzalez-Andrieu –to name a handful.[223]

Furthermore, there are various schools of aesthetics in the contemporary world. Kai Hammermeister notes in *Philosophy Now* that there are several streams of thought concerning art and beauty. These include Marxism and Feminism, Green Aesthetics (ecology), Postmodern, Deconstruction, and Analytic Aesthetics—and more.[224]

To say the least, the contemporary world is ripe with aesthetic philosophy and interpretation.

In this section I've take a slight turn from the preceding sections. Rather than focus on the broader thinkers in the field of contemporary aesthetics, I'll concentrate on upon three people that fall within a Christian worldview, those that have provided Christians a contemporary framework. With each person, I'll summarize the given movement he represents in the contemporary age, offering the architecture, the scaffolding, of a foundational—broadly, Christian—understanding of beauty in our modern world. Please note: I've chosen these three individuals as conduits of contemporary Christian thought. They by no means represent the full-orbed nature of how the current world—Christians or otherwise—views beauty. For this, I'd recommend Beech's *Beauty: Documents of Contemporary Art* to offer the delectable range of tastes. There are three other reasons I chose them. One, they have definite connections to the past; Gilson with Aquinas' Roman Catholicism, Gadamer with Classical Philosophy and various Protestant thinkers, and Evdokimov with Eastern Orthodoxy. Two, a couple (Gilson and Evdokimov) are underrepresented in the broader aesthetic schools of discussion. Three, the three individuals' tie-up some of the thoughts presented in this book thus far, helping set the stage for the final section, heuristics.

Étienne Gilson (Methodological Realism)

1884–1978

As a philosopher and historian, Frenchman Étienne Gilson was instrumental in bringing a Thomistic understanding of beauty to the contemporary world. He deemed his approach to Thomistic thought as Methodological Realism, "the fact that what is real precedes our concepts about it."[225]

223. Others are discussed within this book.

224. See Hammermeister, "What's New in Aesthetics."

225. Gilson, *Methodical Realism*, back cover, and 19–25 for a full treatment.

Writing several books on the arts and beauty, Gilson's thoughts are found in three works: *Painting and Reality* (1955), *The Arts of the Beautiful* (1965), and *Forms and Substances in the Arts* (1966). Much of Gilson's thought is rooted in Thomas Aquinas, so there's a correlation between the two. Here's a few points to consider.

One, Gilson linked the beautiful to the word *calology*, a philosophy of art that connects it to the broader transcendentals (truth, beauty, goodness, and unity).[226] Gilson states, "The ultimate roots of *calology* are to be found in ontology."[227] And because the transcendentals are controvertible with being, the "beautiful is a kind of good, and, as such, it is an object of the will."[228] And the "object itself, taken in its physical reality, that is the end of our desire and of which the possession is coveted."[229] Gilson clarifies the object-desire interaction as thus: "The object of such desire is not so much the thing itself as the good of apprehending it."[230]

Two, Gilson understood beauty as that which causes admiration, likened to "a sensible perception whose apprehension is desirable in itself for itself."[231] Put another way, beauty pleases a person.

Three, Gilson did not want to confuse the sensation of beauty with beautify itself. He writes, "We are not saying that the beautiful itself consists in the pleasure it gives, but rather that the presence of the beautiful is known by the pleasure that attends it apprehension."[232] In other words, beauty is objectively found in an object and elsewhere (God) and someone who perceives beauty is recognizing a broader beauty, an eternal value.

Four, beauty is bound in the act of being and our knowledge of the object in which one perceives, with pleasure or delight as the outcome. Gilson writes, "The pleasures of art are of this kind, for they are associated with our knowledge of certain objects and closely bound us with the act itself through which we apprehend them. Hence this nominal definition of the beautiful: that of which the apprehension please in itself and for itself."[233]

Five, the act of perception can be found in any form of being. Gilson states, "The beautiful under discussion could be caused indifferently by nature, by truth, or again by a work of art expressly willed for its very

226. Gilson, *Arts of the Beautiful*, 22.

227. Gilson, *Arts of the Beautiful*, 27.

228. Gilson, *Arts of the Beautiful*, 28.

229. Gilson, *Arts of the Beautiful*, 28.

230. Gilson, *Arts of the Beautiful*, 28.

231. Gilson, *Arts of the Beautiful*, 23.

232. Gilson, *Arts of the Beautiful*, 23.

233. Gilson, *Arts of the Beautiful*, 24.

beauty."[234] Simply put, beauty is manifest in being—in various ways (nature, art, transcendentals) as a gift from God.

Finally, Gilson relates the "marks of the beautiful."[235] These marks are found in the imagination, arts of time (music and poetry), arts of space (sculpture and painting), and have both objective and subjective elements.[236] Some of the marks Gilson highlights are very Thomistic in orientation. First, a beautiful object should be *whole*, "lacking nothing essential to its nature."[237] Second is the *form* of the object, the "essence or idea."[238] Gilson expands this thought by stating, "Being is always given in experience, under the form of such or such being; and what we call type, idea or form is the intrinsic determination that makes being to be such and such. Inasmuch as it is a cause of being, the form is a cause of beauty."[239] Third is *harmony*, "the proportion of the parts between themselves and with the whole."[240] Fourth is *radiance*: "With Saint Augustine, this element was merely color and the pleasure it causes. . . . it is, in the sentient being itself, the objective basis of one of our relations with it."[241] For Gilson, radiance was the "objective basis of our own perception of the beautiful."[242]

For Gilson, wholeness, form, harmony, and radiance are the marks of what makes something beautiful. In the end, Gilson valued beauty on a cosmic scale, writing, "A universe having no other function than to be beautiful would be a glorious thing indeed."[243]

Hans-Georg Gadamer (Hermeneutics)

1900–2002

Hans-Georg Gadamer was a prominent German philosopher in the movement known as hermeneutics. Having root in Biblical exegesis, philosophical hermeneutics sought to "set rules that provide the basis for good

234. Gilson, *Arts of the Beautiful*, 24.
235. Gilson, *Arts of the Beautiful*, 28.
236. Gilson, *Arts of the Beautiful*, 29.
237. Gilson, *Arts of the Beautiful*, 29.
238. Gilson, *Arts of the Beautiful*, 30.
239. Gilson, *Arts of the Beautiful*, 30.
240. Gilson, *Arts of the Beautiful*, 31
241. Gilson, *Arts of the Beautiful*, 31.
242. Gilson, *Arts of the Beautiful*, 31.
243. Gilson, *Arts of the Beautiful*, 34.

interpretive practice no matter what the subject matter,"[244] seeking meaning within the humanities and sciences. Gadamer is best known for his work *Truth and Method*, whereby he delves into human understanding, "a philosophical effort to account for understanding as an ontological—the ontological—process of man."[245] According to Kai Hammermeister, Gadamer "argued that philosophical aesthetics must be overcome as a discipline, because it treats works of arts just like other objects, i.e. something that can be methodologically investigated and controlled."[246]

Part of Gadamer's quest for understanding as the process of human thought was his insight on art and beauty.[247] In his influential essay *The Relevance of the Beautiful*, Gadamer tackles a host of topics: beauty, theater, writing, art, poetry, and aesthetics—among others.

As a philosopher rooted in classical thought (Plato, Aristotle, and Socrates), Gadamer begins his understanding of beauty by discussing how the classical philosophers approached the subject, comparing it to modern artistic manifestations (such as found in Cubism).[248] In Gadamer's approach he sought to unpack two overarching aspects: human "historical consciousness"[249] and the "self-consciousness reflection of modern man and the artist."[250] In arguing why a historical understanding is important, Gadamer writes, "without this historical sensibility we would probably be unable to perceive the precise compositional mastery displayed by earlier art. . . . Such a person would be unable to experience in an immediate way that unity of form and content that clearly belongs to the essence of all true artistic creation."[251] Gadamer felt "the Platonic heritage permeates all our reflections upon the beautiful."[252]

After unpacking Plato's and Aristotle's views on art and beauty—with a hermeneutical look at various words, Gadamer turns his attention to beauty. Gadamer points out that a contemporary understanding of beauty is rooted in the historical, expressed in the Greek word *kalon*.[253] There is much con-

244. Malpas, "Hans-Goerg Gadmer," 2.2.

245. Palmer, *Hermeneutics*, 163.

246. Hammermeister, "What's New in Aesthetics," para. 5.

247. I find Gadamer's thought very Pauline, connecting beauty to similar things as Paul: sport (play), community (festival), and transcendence (symbol). See Gadamer, *Relevance of the Beautiful*, 3–53.

248. Gadamer, *Relevance of the Beautiful*, 9.

249. Gadamer, *Relevance of the Beautiful*, 10.

250. Gadamer, *Relevance of the Beautiful*, 10.

251. Gadamer, *Relevance of the Beautiful*, 11.

252. Gadamer, *Relevance of the Beautiful*, 17.

253. Gadamer, *Relevance of the Beautiful*, 13.

tent found in the word *kalon*, linking it divergent themes such as ethics and art. In the spirit of ethics and art, Gadamer states, "the beautiful is convincingly defined as something that enjoys universal recognition and assent. Thus it belongs to our natural sense of the beautiful that we cannot ask why it pleases us. . . . The beautiful fulfills itself in a kind of self-determination and enjoys its own self-representation."[254]

To help bring further insight into beauty, Gadamer uses Plato's story of *Phaedrus*,[255] stating, "what this story has to teach us is that the essence of the beautiful does not lie in some realm simply opposed to reality. On the contrary, we learn that however unexpected our encounter with beauty may be, it gives us an assurance that the truth does not lie far off and inaccessible to us, but can be encountered in the disorder of reality with all its imperfections, evils, errors, extremes, and fateful confusions. The ontological function of the beautiful is to bridge the chasm between the ideal and the real. Thus, the qualification of art as 'beautiful' or 'fine' provides a second essential clue for our considerations."[256]

Gadamer concludes his contemporary understanding of beauty by stating, "Our recourse to ancient thought helps us see that in art and the beautiful we encounter a significance that transcends all conceptual thought."[257]

Asking "How do we grasp this truth," by which he means beauty as a means of transcendence, Gadamer points to the study of aesthetics. Using Baumgarten's phrase "sensuous knowledge," Gadamer writes that sensuous knowledge (*cognitio sensitiva*) "means that in the apparent particularity of sensuous experience, which we always attempt to relate to the universal, there is something in our experience of the beautiful that arrests us and compels us to dwell upon the individual appearance itself."[258]

When Gadamer turns his attention towards Kant, he finds a balance between a universal, scientific verification (objective) and a personal taste (subjective). Gadamer writes, "'Criticism' as the discrimination of degrees of beauty is not really a subsequent judgment by means of which we could subsume the 'beautiful' scientifically under concepts or produce a comparative assessment of quality. Rather it is the experience of the beautiful itself." And reflecting on Kant's definition of "free beauty" ("beauty free from concept

254. Gadamer, *Relevance of the Beautiful*, 14.

255. A dialogue written by Plato between Plato and Phaedrus, consisting of three speeches on love, incorporating sub-themes of the soul, madness, inspiration, and art.

256. Gadamer, *Relevance of the Beautiful*, 15.

257. Gadamer, *Relevance of the Beautiful*, 16.

258. Gadamer, *Relevance of the Beautiful*, 16.

and significant content"[259]), Gadamer states, "we always find ourselves held between the pure aspect of visibility presented to the viewer by the 'in-sight', as we called it, and the meaning that our understanding dimly senses in the work of art."[260]

Towards the end of *The Relevance of the Beautiful*, Gadamer provides his personal insight on art and beauty, asking "how can we find an all-embracing concept to cover both what art is today and what it has been in the past."[261]

His answer is found in three concepts: play, symbol, and festival.[262]

Play. Gadamer sees play as an "elementary function of life."[263] It encompasses "repeated movement," "a movement that is not tied down to any goal."[264] When applied to art, Gadamer states, "This freedom of movement is such that it must have the form of self-movement."[265] Furthermore, play or movement "arises from the basic character of excess striving to express itself in the living being. . . . In the end, play is thus the self-representation of its own movement."[266] And with play, there is "participation, an inner sharing in this representative movement"[267] and "communication."[268] In other words, there is someone else to observe and is a part of the activity. For Gadamer, art as a conduit of beauty is "intended as something . . . [if] only the pure autonomous regulation of movement."[269] Play is a form of action. Concluding his thoughts on play, Gadamer writes, "This activity necessarily reveals the human experience of finitude in a unique way and gives spiritual significance to the immanent transcendence of play an excess that flows over into the realm of freely chosen possibilities."[270]

Symbol. Gadamer points out that the Greeks used the word symbol as a technical term, "a token of remembrance."[271] Gadamer points to Plato's *Symposium* as a means to reflect that "the beautiful work of art refers to something that does no simply lie in what we immediately see and understand

259. Gadamer, *Relevance of the Beautiful*, 20.

260. Gadamer, *Relevance of the Beautiful*, 20.

261. Gadamer, *Relevance of the Beautiful*, 19.

262. Gadamer, *Relevance of the Beautiful*, 22.

263. Gadamer, *Relevance of the Beautiful*, 22.

264. Gadamer, *Relevance of the Beautiful*, 22.

265. Gadamer, *Relevance of the Beautiful*, 23.

266. Gadamer, *Relevance of the Beautiful*, 23.

267. Gadamer, *Relevance of the Beautiful*, 24.

268. Gadamer, *Relevance of the Beautiful*, 24.

269. Gadamer, *Relevance of the Beautiful*, 24.

270. Gadamer, *Relevance of the Beautiful*, 46.

271. Gadamer, *Relevance of the Beautiful*, 31.

before us as such . . . to direct our view towards something else that can be experienced or possessed in and immediate way."[272] Put another way, there is a deeper meaning, a symbol or an allegory, of something more profound in art, pointing us to a transcendent beauty. And the effect of beauty upon the person is stated by Gadamer as, "the experience of the beautiful, and particularly the beautiful in art, is the invocation of a potentially whole and holy other of things, wherever it may be found."[273] Gadamer goes on to describe this transcendent experience as thus: "Indeed, this seems to provide a more precise answer . . . concerning beauty and art. . . . in any encounter with art, it is not the particular, but rather the totality of the experienceable world, man's ontological place in it, and above all his finitude before which transcends him, that is brought to experience."[274] For Gadamer, the symbolic nature of art as a conduit of beauty "rests upon an intricate interplay of showing and concealing."[275] Art is a symbol that shows and conceals beauty, preserving "its meaning within itself."[276]

Festival. For Gadamer, festival is linked to community. Gadamer writes, "one thing that pertains to all festive experiences . . . is surely the fact that they allow no separation between one person and another. A festival is an experience of community and represents community."[277] Furthermore, there is a facet of time influenced in festivals. Gadamer summarizes three types of time as "bustle . . . have time for something," boredom . . . we have nothing to do," and "fulfilled . . . [time] that fulfills every moment of its duration."[278] In a festival, "fulfilled" time is created, causing one to partake in a particular moment, reflecting on the festival for its own sake." Gadamer relates this "fulfilled" time to art, acquiring a transcendent moment of encounter, partaking in beauty.[279] Gadamer writes, "And perhaps it is the only way that is granted to us finite beings to relate to what we call eternity." It's no wonder that Gadamer equates "the real nature of the festival and of festive time . . .[as] a theological question."[280]

272. Gadamer, *Relevance of the Beautiful*, 32.

273. Gadamer, *Relevance of the Beautiful*, 32.

274. Gadamer, *Relevance of the Beautiful*, 33.

275. Gadamer, *Relevance of the Beautiful*, 33.

276. Gadamer, *Relevance of the Beautiful*, 37.

277. Gadamer, *Relevance of the Beautiful*, 39.

278. Gadamer, *Relevance of the Beautiful*, 41–42.

279. Gadamer, *Relevance of the Beautiful*, 44–45.

280. Gadamer, *Relevance of the Beautiful*, 39.

Paul Evodokimov (Neo-Patristics)

(1901–70)

Paul Evdokimov was a Russian, Christian teacher and writer who immigrated from Saint Petersburg to France during the October Revolution. Evdokimov taught at St. Sergius Seminary in Paris.

In his influential book *The Art of the Icon: A Theology of Beauty*, Evdokimov outlines four overarching aspects of beauty: *Beauty, the Sacred, the Theology of the Icon*, and a *Theological Vision*.

For the sake of this summary on his thought, I'll concentrate on the first facet, *Beauty*.

Beauty Is the Splendor of Truth

Evdokimov opens his work in a very classical manner. Quoting Plato, he writes, "Beauty is the splendor of truth."[281] Right off the bat, Evodkimov links beauty to another transcendental attribute of God—truth. Evdokimov then links beauty to the Greek term *kalokagathea*, a word combining both beauty and goodness.[282] Evdokimov writes, "At the highest degree of synthesis, that which is found in the Bible, truth and goodness offer themselves for our contemplation. Their living union, symbiosis, denotes the integrity of being from which beauty spring forth."[283] Like Christian thinkers before him, Evdokimov links truth, beauty, goodness withing unity.

For Evdokimov, beauty is completely integrated to, and springs from, both truth and goodness. However, there is a paradox. "Even though truth is always beautiful, beauty is not always true."[284] Here, Evdokimov is warning against the "blinding power"[285] of beauty, its means to sway and lead to unmoral behavior.

Christ Is Beauty

Like Hans Urs von Balthasar, Evdokimov links ultimate beauty to Christ. Evdokimov, quoting Nicolas Cabasilas, writes "'those who were able to love sovereign Beauty above everything else,' that sovereign Beauty which is the

281. Evdokimov, *Art of the Icon*, 74.
282. Evdokimov, *Art of the Icon*, 74.
283. Evdokimov, *Art of the Icon*, 74.
284. Evdokimov, *Art of the Icon*, 663.
285. Evdokimov, *Art of the Icon*, 663.

seed of the divine and agape enrooted in heart."[286] In other words, for the Christian, beauty is invested in our heart by the Beautiful One. Later, Evdokimov states, "The face of Christ is the human face of God. The Holy Spirit rests on him and reveals to us absolute Beauty, a divine-human Beauty, that no art can ever properly and fully make visible."[287]

Furthermore, Evdokimov connects splendor, truth, and beauty to Christ. He states,

> Splendor is inherent in truth which does not exist in the abstract. In its fullness, truth requires a personalization and seeks to be "enhypostazied," that is, rooted and grounded in a person. In answer to this requirement, Christ states, "I am the truth." Since truth and beauty are intimately united and are but two aspects of one reality, the Lord's saying also signifies "I am Beauty."[288]

Creation Is God's Work of Beauty

Using creation as an example of God's act of beauty in the world, Evdokimov calls God's creative act as "his Symphony in Six Days,"[289] noting that the word used for this act is "*kalon*—beautiful and not *agathon*—good; the Hebrew word carries both meanings at the same time."[290] Again, Evdokimov is infusing truth, beauty, and goodness into one coherent package. Beauty is likened to God's thoughts and will of beauty made visible.

The Holy Spirit and Beauty

Observing a connection between God's kingdom, the Holy Spirit, and beauty, Evdokimov states, "If therefore the contemplated Kingdom is Beauty, the third Person of the Trinity reveals himself as the Spirit of Beauty. Dostoyevsky understood the point very well: 'The Holy Spirit is the direct seizure, grasping Beauty."[291] Here, Evdokimov is linking beauty to the Triunity of the Godhead, Father, Son, and Holy Spirt. For Evdokimov, all three Persons reveal God's beauty, truth, and goodness, a unified triunity of wills.

286. Evdokimov, *Art of the Icon*, 75.
287. Evdokimov, *Art of the Icon*, 293.
288. Evdokimov, *Art of the Icon*, 464–65.
289. Evdokimov, *Art of the Icon*, 75.
290. Evdokimov, *Art of the Icon*, 75.
291. Evdokimov, *Art of the Icon*, 101.

Evdokimov also connect beauty to life and light, as "characteristics of the Holy Spirit."[292] From this line of argument, Evdokimov postulates that "From the optical point of view alone, we know that the eye does not really perceive objects but only the light reflected in the objects. An object is only visible if light makes it luminous."[293] From the vantage point of light, Evdokimov seems to be doing two things: one, connecting beauty back to the Holy Spirit, and two, setting up the Orthodox understanding of icons as window to heaven, showing forth the light of God and eternal truth, something he unpacks later in the book.[294]

Beauty Binds God and Believers

In the Triune God's light his people are "drawn upward; we might even say '[fall] up' and [attain] the level of divine beauty."[295] This, again, would correspond to Evdokimov's understanding of human's becoming like God, a theological teaching in Orthodoxy known as *divinization*. But there's another thought: through beauty, God's people engage with beauty. There's a perichoresis—a mutual exchange—between the Lover and beloved as a beautiful interchange. Beauty is one facet in which God binds himself to believers.

Beauty and Being

Like many Christian thinkers before him, Evdokimov ties beauty to being and wholeness; beauty is found in being. He writes, "What is even more important is the affirmation that the idea of the beautiful is interchangeable with the idea of being; this means that beauty is the final stage of the progression toward fullness of being; it is identical with the ideal wholeness and integrity of being."[296]

292. Evdokimov, *Art of the Icon*, 125.

293. Evdokimov, *Art of the Icon*, 138.

294. Later in the chapter Evdokimov contrasts the light with the night and darkness, drawing parallels between Christ (light) and Judas (darkness), and showing how Genesis showcases light as a factor of beauty.

295. Evdokimov, *Art of the Icon*, 202.

296. Evdokimov, *Art of the Icon*, 391.

Art and Beauty

In Evdokimov's mind, the icon is more than art, it's a window to God. However, for Evdokimov, normative art (non-icon art) does serve a purpose: it opens up the mystery of being. Evdokimov said, "At its highest level, art aspires to present a vision of the fullness of being, of the world as it must be in its perfection. Art thus opens the way towards the Mystery of Being. The intuitive perception of Beauty is already a sort of creative victory over chaos and ugliness."[297]

Like thinkers from antiquity, Evdokimov connects beauty to harmony. He writes, "The beautiful is present in the harmony of all its elements and brings us face to face with a truth that cannot be demonstrated or proved, except by contemplating it. The mystery of the beautiful illuminates' external phenomena from within, as the soul radiates mysteriously on a person's face."[298]

Transcendence and Beauty

Though Evdokimov sees creation as a witness of beauty, nature is not beauty itself, as art is not beauty itself. He states, "true Beauty is not found in nature itself but rather in the epiphany of the Transcendent."[299] In other words, nature reflects—manifests—the transcendent, eternal value of God.

With the three contemporary thinkers (Gilson, Gadamer, and Evdokimov) we find a definite connection to a historical—Christian inherited—understanding of beauty, linking beauty to God, being, and imaginative creation. And in the case of Evodkimov, beauty as it relates to Jesus Christ as God's incarnation.

297. Evdokimov, *Art of the Icon*, 400.

298. Evdokimov, *Art of the Icon*, 400.

299. Evdokimov, *Art of the Icon*, 464.

Chapter 3

Hermeneutically

What Does the Bible Say about Beauty?

Now that we have a basic understanding of how some people viewed beauty throughout history, the next question for the Christian is: what does the Bible have to say about beauty?

Before we address the question, however, a short word on the name of the chapter: *Hermeneutically*. The title is derived from the word *hermeneutic*, which entails the art and science of the interpretation of a text. I use it in this sense—Biblical interpretation—not the philosophical school of thought as promoted by Gadamer and others.

Now, let's reframe the question above via theologian and musician Jeremey Begbie, who noted there are two types, or modes, of beauty: "On the one hand, the beauty that is in some sense already 'there' in the nature of things . . . and on the other, the beauty human beings make. . . . Put more theologically, there is the beauty directly given to the world by God and that which we are invited to fashion as God's creatures."[1] For Begbie, both being

1. Begbie, *Peculiar Orthodoxy*, 2. For Begbie, it's essential for the Christian to identify beauty with the triune nature of God as expressed in the Bible. Begbie would agree with Hans Urs von Baltasar, that the supreme picture of beauty is found in Jesus Christ and that "primordial beauty is the *beauty of this ecstatic love for the other*. God's beauty is not static structure but the dynamism of love" (*Peculiar Orthodoxy*, 4).

("nature of things") and creativity (the beauty people make) are bound in the Bible.

Therefore, to answer the question "what does the Bible have to say about beauty?" we need to understand that beauty is bound in both senses, the world and word. First, general revelation, creation, the world; that which is "there," beauty given to all. God created all things for the good of his creation. The Bible is testament to this fact. Second, specific revelation, that which is specific to a believing community (Jews and Christians). Put another way, beauty is found in both God's handbook (the Bible) and handiwork (creation). God is the author of both books.

To help further answer the question—*what does the Bible says about beauty?*—we'll look at three overarching areas, three "I's": inferences, infusion, and inspiration. To do so, we turn to the Bible, seeing how beauty is portrayed within its pages, offering an understanding of what Biblical beauty entails.

INFERENCES

I won't be exhaustive in expositing all the references to God's beauty within the Bible. Instead, I'll put forward five thoughts concerning the all-encompassing role beauty has within Holy writ, and thereby indicate what the Bible implies about God and his beautiful works. Here is something to note, however: The Bible does not give a treatise on the beauty of God. There's only a handful of clear references to God and beauty, and these are largely connected to other attributes of God, such as his glory. But even one mention is enough. Richard Viladesau put the impasse this way: "Although the concept of 'beauty' does not play an important or autonomous part in Scripture, it is essential to the theological explanation of God's glory."[2] The overall biblical teaching on beauty can be simply summarized: God is gloriously beautiful. Karl Barth said: "He is beautiful, divinely beautiful, beautiful in His own way, in a way that is His alone, beautiful as the unattainable primal beauty, yet really beautiful."[3]

God Himself Is Beautiful

The opening chapter in the Bible contains the clearest clue on revealed beauty: "In the beginning God created." But we need to go further back

2. Viladesau, *Theological Aesthetics*, 26.
3. Barth, *Church Dogmatics* II/1, 656.

than Genesis, further than creation. We need to find our way to the Necessary Being, Pure Act, that put all being in motion. To do so, I invoke one of the psalmists:

> One thing I ask from the Lord,
> this only do I seek:
> that I may dwell in the house of the LORD
> all the days of my life,
> to gaze on the beauty of the Lord.

The Psalmist immediately tells us where beauty begins—with the Lord himself, the Necessary Being, the Uncaused Cause. The word used in this text is *no'am* in Hebrew. It connotes several definitions: agreeableness, delight, splendor, grace, and beauty.[4] The *Common Book of Prayer* translates it as "fair beauty."[5]

For the Psalmist—and many authors of the Bible—beauty begins with the Beautiful One. Before there was creation—the cosmos, the planets, the first chirping bird, the fluttering butterfly, and or awesome beasts—there was a Beautiful God. And because God is beautiful, he creates beautiful things. As design infers a Designer, so, too beauty a Beautiful One; Beauty begets beauty.

God himself is beautiful.

God's Handiwork Is Beautiful

Now let's go back to the beginning of the Bible. In the first chapter of Genesis, where we first learn about God's creative powers, we discover that he creates: "In the beginning God created the heavens and earth" (v. 1). The Hebrew word for "create "is *bara*, which means to shape, fashion, or form.[6] In verse 7, we see the word "made"; the Hebrew word is *asah*, which means do or make.[7] So, the opening verses of the Bible paint a picture of God as an artist, creating and making. And all of creation was called "good." In Hebrew, "good" is *tov*,[8] which connotes several complimentary words:

4. See Strong, *Strong's Lexicon and Concordance*, H5278.

5. Episcopal Church, *Common Book of Prayer*, 617.

6. Strong, *Strong's Lexicon and Concordance*, H1257.

7. Strong, *Strong's Lexicon and Concordance*, H6213.

8. Brendan Thomas Somman notes, "As Hebrew scholars point out, the word *tov* has the sense of something well-made, which includes being attractive or pleasing when seen. In the eyes of God, it might be said, what is good is also what is beautiful" (*Called to Attraction*, 12).

beautiful, bountiful, and best.[9] God enjoyed his beautiful creation; his creative acts manifest his bountiful grace and love.[10]

The beauty of God's creation is appreciated by many throughout the Bible, but particularly King David, a musician and poet. In Psalm 8, David extols God's beautiful handwork, leading him to worship:

> LORD, OUR LORD,
>> HOW MAJESTIC IS YOUR NAME IN ALL THE EARTH!
> YOU HAVE SET YOUR GLORY
>> IN THE HEAVENS . . .
>
> [3] When I consider your heavens,
>> the work of your fingers,
> the moon and the stars,
>> which you have set in place,
> [4] what is mankind that you are mindful of them,
>> *human beings that you care for them?*
>
> [5] You have made them a little lower than the angels
>> and crowned them with glory and honor.
> [6] You made them rulers over the works of your hands;
>> you put everything under their feet:
> [7] all flocks and herds,
>> and the animals of the wild,
> [8] the birds in the sky,
>> and the fish in the sea,
>> all that swim the paths of the seas.
>
> [9] Lord, our Lord,
>> how majestic is your name in all the earth!

From David's Psalm, we learn that God's handiwork includes the cosmos (the heavens), creatures (humans and animals), and all of creation (waters, angles, etc.), physical and metaphysical. Extending the metaphysical aspects of creation, they would include numbers, math, logic, language, and the laws of nature that govern the physical aspect of creation.

Regarding the Psalm, Brendan Thomas Sammon states, "So here, in this earliest Hebraic text we find the first and most important attributes of beauty: order, proportion, harmony, or what could be also called fittingness."[11]

9. Strong, *Strong's Lexicon and Concordance*, H2896.

10. See John 3:16.

11. Sammon, *Called to Attraction*, 12.

Think of creation as God's thoughts made visible. And because God is beautiful, he created beautiful things, his thoughts put into action. As the apostles John and Paul indicates, this was accomplished through the Logos (the Word) of God, Christ Jesus.[12]

God's Holiness Is Beautiful

In 1 Chronicles 16:29, the author of Chronicles (traditionally ascribed to either Ezra or Nehemiah), describes the placement of the Ark of the Covenant within the tabernacle. The rendering is striking. During the ceremony the people present peace offerings to God, praise and worship pours forth, and music—with stringed instruments, percussion, and brass—all sound out with a dramatic flair.

In the middle of all this, David writes a poem-song, given to Asaph, the chief musician, to sing. The song begins with "Oh, give thanks to the Lord," and ends with "Blessed be the Lord God of Israel, from everlasting to everlasting." It's magnificent.

But tucked two-thirds of the way down in his poem-song, one finds these words: "Give to the Lord glory and strength. Give to the Lord the glory due His name; bring an offering and come before Him. Oh, worship the Lord in the *beauty of holiness*." Pause. What David is stating is that holiness—God's holiness and people who follow in God's ways—is beautiful.

The word David uses for beauty in this text is *hadarah*. It is a decorative and honoring beauty.[13] And the word David uses for *holiness* is one of the traditional words for the concept of holiness: *qodsh*, meaning a sacred or set-apart. It is something that is dedicated to the Lord.[14]

In short, David is saying that anything—a life, a witness, a piece of art (music, poems, etc.)—that is dedicated, set-apart, to the Lord for God's purposes is beautiful. Its function denotes it's beautiful favor.

Like beauty, holiness is an attribute of God. Both holiness and beauty are characteristics God shares with people. Humans can be both holy and beautiful, just as God is both beautiful and holy.

But David does something unique: he conjoins these two attributes, stating that holiness is beautiful, particularly within the context of worship.[15] God's holiness is beautiful and worthy of celebration through the arts, as described in the text. And here's a wonderful nuance to notice. After

12. See John 1 and Col 1.

13. Strong, *Strong's Lexicon and Concordance*, H1927.

14. Strong, *Strong's Lexicon and Concordance*, H6944.

15. Inferred is that holiness is beautiful when properly applied.

David gave his poem-song, regular worship continued. Meaning, there was beauty and holiness conjoined through the act of worship in the life of David and Israel.

God Honors Beautiful Things

In his book, *Art and the Bible*, Christian author Francis Shaeffer does a fine job in pointing out God's desire to have his people create beautiful objects. The creation of beautiful objects is clearly seen in the Jewish temple. Shaeffer asked, "What, therefore, was to be in the temple? For one thing, the temple was to be filled with artwork."[16] And the artwork God desired for the temple—the place people came to worship and meet him—was full of precious stones, fine furniture, and awesome architecture.[17] Shaeffer also recognized other forms of beautiful things found in the Bible: from the poetry of David to the parables of Jesus; from the songs of the psalmists to drama and dance.[18] All are found in the Bible. To summarize Schaeffer: Because God is beautiful, he yearns for his people to make beautiful things. The God of beauty often inspires the creation beautiful particulars through his people.

Yet, the Bible doesn't just focus on earthy beauty. There is recognition in eternal beauty, as well. In Revelation 4, where a throne room of heaven is described, John, the author, has a vision that portrays a fascinating configuration of beautiful items. Though many of the items symbolically correlate to the temple, they also take on eternal meaning within the context of Revelation. In this heavenly scene, we find beautiful stones (jasper, varied in color, and sardius, red brown in color; v. 3a), an emerald-colored rainbow (v. 3b), and people clothed in white robes with crowns of gold (v. 4). Proceeding from the throne is lightning and thunder (v. 5, a fierce beauty). Before the throne is a sea of glass (v. 6), a configuration of unusual living creatures (vv. 6b–8), and a series of poetic utterances (vv. 8 and 11). Theologian Vernard Eller describes the scene like this: "Surely his lordship is powerful and glorious; but John's picture also affirms that it is wise, benevolent, and beautiful—worthy of boundless praise and adoration."[19]

In chapter 5, one finds more beautiful things, including a scroll (v. 2), Jesus (vv. 4–7), unusual creatures (v. 8), musical instruments (v. 8), golden bowls of incense (v. 8), and song (vv. 9–13).

16. Schaeffer, *Art and the Bible*, 26.

17. Schaeffer, *Art and the Bible*, 27–30.

18. Schaeffer, *Art and the Bible*, 31–48.

19. Eller, *Most Revealing Book of the Bible*, 73.

In this heavenly scene there is a bounty of beauty, from poetry and music to people and natural things. There is both fierce beauty (lightning and thunder and unusual creatures) and fetching beauty (lovely, attractive). Beauty abounds in God's sphere, both on earth and in heaven.

The Incarnation Is Beautiful

Hans Urs von Balthasar pointed out that the clearest biblical representation of beauty is Jesus Christ.[20] In Christ, we have every aspect of beauty's realm: immutability (its eternal presence: John 1), physical being (incarnation), teleology (order, purposed, and understanding), and transcendence (a profound and sublime meaning). In an analogous way, Jesus is Beauty incarnate, the image of God. Theologian, Anne Carpenter, in her understanding of von Balthasar, said: "Thus, all the intra-worldly distinctions of created being find resonance in the Incarnation of the Word, who bears in himself the insurmountable distinction between God and the world, as well as the distinction present within creation, while at the same time uniting them."[21]

But as art historian Daniel Siedell points out, the beauty of Christ is often conjoined to a "theology of the cross."[22] In Christ, suffering and pain is part of the splendor. It's a fierce beauty—but beauty nonetheless.[23] In Christ, the fierce (the crucifixion and pain) is met with the fetching (parables, compassion, and love). In both ways, Jesus "shine-outs" God's beauty— in himself and his sacrifice, for he is God's Son, his Image in the world.

Now that we've looked within Scripture and found that which touches on beauty, let's move on to a broader view. If touching on the text (as demonstrated above) is akin to the fine details of a painting, the next section is like a broad brush, giving a sweeping view of how beauty is infused in the cosmos.

INFUSION

The Bible doesn't delineate (via a dictionary definition) beauty, per-se, but describes beauty's infusion in the world. In other words, beauty is dependent

20. See von Balthasar, *Glory of the Lord.*

21. Carpenter, *Theo-poetics*, 94. Carpenter presents von Balthasar's thoughts as a conjoining of Thomas Aquinas and Maximus the Confessor. See Carpenter, *Theo-poetics*, 101.

22. Siedell, *Who's Afraid of Modern Art?*, 59.

23. Schmidt, *Scandalous Beauty.*

upon God—as an attribute of his person, but not demarcated in the Bible as a philosophical treaty.

Still, in the Bible, the whole host of beautiful existence is described: from space, earth/nature, to cultural delineations: people, language, towns, communication, government, etc. It's all there in Scripture—the beauty and the not-so-beautiful.

To help uncover how beauty (and by extension, art) is infused in the world and culture, I turn to the understanding of the influence of the arts as espoused by art historian E. John Walford.[24] Walford took art beyond a simple definition and applied it to larger themes, including spirituality, the self, nature, and the city.[25] In each of these themes, Walford widened the notion of what art—and beauty—is. Walford then applies his understanding to belief, humanity, nature, and our relationship to technology and the city. In short, Walford infused art and beauty in all of life.

In Walford's themes, I find four core undercurrents: God, humanity, the natural world, and human culture. I believe these provide a clear portrait of the infusion of beauty within our broader world.

God

As noted throughout this book, it goes without saying that beauty has its origin in God, the Necessary Being. The Bible tells us that God is beautiful. Norman Geisler pointed out the following in relationship to God and beauty: "His holiness, His regality, His temple, and His city are all said to be beautiful. . . . Not only is God beautiful, but He gives beauty to His creation"[26] (see Gen 1 and Ezek 16:14).

Jonathan Edwards puts it this way: "For as God is infinitely the greatest Being, so he is allowed to be infinitely the most beautiful and excellent: and all the beauty to be found throughout the whole creation is but the reflection of the diffused beams of that Being who hath an infinite fullness of brightness and glory; God . . . is the foundation and fountain of all being and all beauty."[27] Furthermore, "God is a being infinitely lovely, because he hath infinite excellency and beauty."[28]

Likewise, God's beauty can be found in the harmony of his perfect unity, his trinitarian nature, the attributes conjoined within his perfect character,

24. John Walford was an art historian and professor at Wheaton College.

25. Walford, *Great Themes in Art*, 13–14.

26. Geisler, *Systematic Theology*, 239.

27. Edwards, *Nature of True Virtue*, 252–53.

28. As quoted in Geisler, *Systematic Theology*, 244.

Father, Son, and Holy Spirit. This harmonious confluence of the Godhead itself is an indicator of harmony, balance, and form. The word *perichoresis* (the Greek word for "rotation") is a fine word to use in relationship to the beautiful harmony found within the Godhead. Scientist John Polkinghorne summarized it as a *mutual exchange of love within the Godhead,*[29] and, later, in relationship to creation, as "The Work of Love: Creation as Kenosis."[30]

To make a similar point, Hans Urs von Balthasar analogized a mother's smile to showcase the harmonic beauty innate in God: An awakening of a child to an outside presence, a beautiful love; the loved and the Lover; the beauty and the Beautiful.[31] God's love within the godhead extends to the entire cosmos. For as God loves within himself (*perichoresis*) so, too, does he love the world.[32]

Touching upon the beauty of God, poet George Herbert (1593–1633) wove together similar themes in his poem *Sonnet II*. In the poem, Herbert addresses God's love for the world (both creation and people), creation, "speaking" of God, words describing God's majesty, and the discovery of God's beauty. Herbert's central theme in the poem is that, though the beauty of a woman is enticing, ultimately it is the beauty of God one seeks.

SONNET II

Sure Lord, there is enough in thee to dry
 Oceans of Ink; for, as the Deluge did
 Cover the Earth, so doth thy Majesty:
Each Cloud distills thy praise, and doth forbid
Poets to turn it to another use.
 Roses and *Lillies* speak thee; and to make
 A pair of Cheeks of them, is thy abuse.
Why should I *Womens eyes* for Chrystal take?
Such poor invention burns in their low mind,
 Whose fire is wild, and doth not upward go
 To praise, and on thee Lord, some *Ink* bestow.
Open the bones, and you shall nothing find
 In the best *face* but *filth*, when Lord, in thee
 The *beauty* lies, in the *discovery.*

29. Polkinghorne, *Quantum Physics and Theology*, 102–5.

30. Polkinghorne, "Work of Love: Creation as Kenosis."

31. See Carpenter, *Theo-poetic*, 133–37, for more insight.

32. John 3:16.

For Herbert, ultimate beauty is found and bound in God: "in thee/The beauty lies."

Beyond God's beauty bound in himself (as discussed throughout this book), we find the Lord is also the instigator of beauty found within creative human pursuits and nature, where the "effect derives from its Cause."[33] Herbert showcases this as well in *Sonnet II*, touching on oceans, the earth, clouds, poets, roses, lilies, and a host of natural phenomena. Because of God's creative nature, the very concept and ability for humans or nature to create is rooted in the Lord. God is the foundation of beauty in all things, the arts, humanities, nature, and sciences. As Geisler said: "God cannot give what He hasn't got—He cannot produce what He does not possess. . . . God is beautiful; His creation is merely a reflection of His beauty."[34]

As the Cause of all creativity, God is the "Foundation and fountain" (as Edwards, above, reminds us) of all beauty and the Originator of all objects; he is the Beholder and Base of beauty.

In the end, all beauty is a reflection of God's beauty. Beauty is a gift of love that emanates and illuminates; it and bounces beauty to the world.

Humanity

Second, beauty gives us a glimpse into our humanity: the good, the bad, and the ugly (the distortion of beauty). The search for beauty through human history is a commencement derived from God's divine constitution. God created all things from his nature (attributes) and humans are recipients of much of what the Lord has gifted.[35] In turn, humans can reflect some of these attributes within the world. Beauty being one. With beauty, humanity finds a way to highlight what it means to be a human, made in the image of God. People pursue beauty in order to give purpose to life, connecting us to our Creator.

And through the pursuit of beauty, humans express a perspective (such as art), opine with opinion (philosophy or the sciences), and search for significance (ethics, religion, morals). Within beauty (or the lack-there-of), humanity—in all its multifaceted complexities—is on view. We find the quest for beauty universally applied to all cultures and people.

33. Geisler, *Systematic Theology*, 239.

34. Geisler, *Systematic Theology*, 240.

35. Communicable attributes are those that God shares with human beings (love, beauty, etc.), at least in degrees. Incommunicable attributes are those that God does not share with humanity (omnipotence, omniscience, omnipresence, etc.).

Furthermore, beauty mirrors a culture's worldview, signifying what the culture finds appealing or appalling. Writer Steve Turner reminds us that culture—beauty included—"can be a useful indicator of the Zeitgeist, the 'spirit of the times.'"[36] So if beauty gives a glimpse of our humanity and helps us understand what an individual thinks about life, it can also be a means by which people understand the thinking of a culture and society. And by understanding our society and self—a worldview—one can assess the themes and values of culture. In this way, beauty isn't just a value, but provides a vision of who we are. The pursuit of beauty is a longing, a yearning for something significant, a quest to understand our humanity and what we are on earth for.

Von Hildebrand provided several thoughts on how beauty infuses our humanity:

One, a "lived-life is a distinct bearer of beauty."[37] This is being itself; a human life bears beauty, a recipient of life. The fact one is living is a mark of beauty. Two, "the metaphysical beauty of the values of personality."[38] Human personality is full of value; these include compassion, humor, thoughts, ideas, and the like. What it tells us is that beauty is more than meets the eye; it has an internal component, the content of a personality. Beauty is not just our physical person, but our inward person—our values, thoughts, and actions. Three, the "beautiful atmospheres of a particular situation."[39] These are the moments in life that transform or define a human being, gifting one with beautiful moments; human experience. Four, "the beauty of love."[40] Love has an internal beauty all its own, and is closely connected to God, for God is love.[41] Love is the supreme mark of God in the lives of his people.[42]

The pursuit of God—and his beauty—is expressed wonderfully in an unconventional poem by Christopher Smart (1722–71) entitled *Jubilate Agno*.[43] In the poem, Smart invokes natural, human, and cultural beauty

36. Turner, *Pop Cultured*, 20.

37. Hildebrand, *Aesthetics*, 347.

38. Hildebrand, *Aesthetics*, 353.

39. Hildebrand, *Aesthetics*, 355.

40. Hildebrand, *Aesthetics*, 358.

41. 1 John 4:7–21.

42. See John 15:12.

43. I was first introduced to the poetry of Christopher Smart by Dr. Bruce Redford, Professor Emeritus of Baroque and Eighteenth-Century Art at Boston University. As part of a lecture series at St. John's Cathedral in Albuquerque, New Mexico, Redford taught how the poem was written while Smart was in an asylum. *Jubilate Agno* depicts idiosyncratic praise and worship of God by all created beings and things, each in its own way.

within an array of images and words, offering a world unto itself. Using biblical characters as representatives of humanity, the poem in part, reads:[44]

> Rejoice in God, O ye Tongues; give the glory to the Lord, and the Lamb.
>
> Nations, and languages, and every Creature, in which is the breath of Life.
>
> Let man and beast appear before him, and magnify his name together.
>
> Let Noah and his company approach the throne of Grace, and do homage to the Ark of their Salvation.
>
> Let Abraham present a Ram, and worship the God of his Redemption.
>
> Let Isaac, the Bridegroom, kneel with his Camels, and bless the hope of his pilgrimage.
>
> Let Jacob, and his speckled Drove adore the good Shepherd of Israel.
>
> Let Esau offer a scape Goat for his seed, and rejoice in the blessing of God his father.
>
> Let Nimrod, the mighty hunter, bind a Leopard to the altar, and consecrate his spear to the Lord.
>
> Let Ishmael dedicate a Tyger, and give praise for the liberty, in which the Lord has let him at large.
>
> Let Balaam appear with an Ass, and bless the Lord his people and his creatures for a reward eternal.
>
> Let Anah, the son of Zibion, lead a Mule to the temple, and bless God, who amerces the consolation of the creature for the service of Man.
>
> Let Daniel come forth with a Lion, and praise God with all his might through faith in Christ Jesus.
>
> Let Naphthali with an Hind give glory in the goodly words of Thanksgiving.
>
> Let Aaron, the high priest, sanctify a Bull, and let him go free to the Lord and Giver of Life.
>
> Let the Levites of the Lord take the Beavers of the brook alive into the Ark of the Testimony.
>
> Let Eleazar with the Ermine serve the Lord decently and in purity.
>
> Let Ithamar minister with a Chamois, and bless the name of Him, which cloatheth the naked.
>
> Let Gershom with an Pygarg bless the name of Him, who feedeth the hungry.

44. *Fragment A* is just one part of the epic poem, with the segment about his cat Jeoffry being the most popular. Smart, *Selection of Poetry*, 44.

Let Merari praise the wisdom and power of God with the Coney, who scoopeth the rock, and archeth in the sand.

Let Kohath serve with the Sable, and bless God in the ornaments of the Temple.

Let Jehoida bless God with an Hare, whose mazes are determined for the health of the body and to parry the adversary.

Let Ahitub humble himself with an Ape before Almighty God, who is the maker of variety and pleasantry.

Let Abiathar with a Fox praise the name of the Lord, who ballances craft against strength and skill against number.

Let Moses, the Man of God, bless with a Lizard, in the sweet majesty of good-nature, and the magnanimity of meekness.

Let Joshua praise God with an Unicorn—the swiftness of the Lord, and the strength of the Lord, and the spear of the Lord mighty in battle.

Let Caleb with an Ounce praise the Lord of the Land of beauty and rejoice in the blessing of his good Report.

Let Othniel praise God with the Rhinoceros, who put on his armour for the reward of beauty in the Lord.

Let Tola bless with the Toad, which is the good creature of God, tho' his virtue is in the secret, and his mention is not made.

Let Barak praise with the Pard — and great is the might of the faithful and great is the Lord in the nail of Jael and in the sword of the Son of Abinoam.

Let Gideon bless with the Panther — the Word of the Lord is invincible by him that lappeth from the brook.

Let Jotham praise with the Urchin, who took up his parable and provided himself for the adversary to kick against the pricks.

Let Boaz, the Builder of Judah, bless with the Rat, which dwelleth in hardship and peril, that they may look to themselves and keep their houses in order.

Let Obed-Edom with a Dormouse praise the Name of the Lord God his Guest for increase of his store and for peace.

Let Abishai bless with the Hyaena — the terror of the Lord, and the fierceness, of his wrath against the foes of the King and of Israel.

Let Ethan praise with the Flea, his coat of mail, his piercer, and his vigour, which wisdom and providence have contrived to attract observation and to escape it.

Let Heman bless with the Spider, his warp and his woof, his subtlety and industry, which are good.

Let Chalcol praise with the Beetle, whose life is precious in the sight of God, tho his appearance is against him.

Let Darda with a Leech bless the Name of the Physician of body and soul.

Let Mahol praise the Maker of Earth and Sea with the Otter, whom God has given to dive and to burrow for his preservation.

Let David bless with the Bear — The beginning of victory to the Lord — to the Lord the perfection of excellence — Hallelujah from the heart of God, and from the hand of the artist inimitable, and from the echo of the heavenly harp in sweetness magnifical and mighty.

Let Solomon praise with the Ant, and give the glory to the Fountain of all Wisdom.

Let Romamti-ezer bless with the Ferret — The Lord is a rewarder of them, that diligently seek him.

Let Samuel, the Minister from a child, without ceasing praise with the Porcupine, which is the creature of defence and stands upon his arms continually.

Let Nathan with the Badger bless God for his retired fame, and privacy inaccessible to slander.

Let Joseph, who from the abundance of his blessing may spare to him, that lacketh, praise with the Crocodile, which is pleasant and pure, when he is interpreted, tho' his look is of terror and offence.

Let Esdras bless Christ Jesus with the Rose and his people, which is a nation of living sweetness.

Let Mephibosheth with the Cricket praise the God of cheerfulness, hospitality, and gratitude.

Let Shallum with the Frog bless God for the meadows of Canaan, the fleece, the milk and the honey.

Let Hilkiah praise with the Weasel, which sneaks for his prey in craft, and dwelleth at ambush.

Let Job bless with the Worm — the life of the Lord is in Humiliation, the Spirit also and the truth.

Let Elihu bless with the Tortoise, which is food for praise and thanksgiving.

Let Hezekiah praise with the Dromedary — the zeal for the glory of God is excellence, and to bear his burden is grace.

Let Zadoc worship with the Mole — before honour is humility, and he that looketh low shall learn.

Let Gad with the Adder bless in the simplicity of the preacher and the wisdom of the creature.

Let Tobias bless Charity with his Dog, who is faithful, vigilant, and a friend in poverty.

Let Anna bless God with the Cat, who is worthy to be presented before the throne of grace, when he has trampled upon the idol in his prank.

Let Benaiah praise with the Asp — to conquer malice is nobler, than to slay the lion.

Let Barzillai bless with the Snail — a friend in need is as the balm of Gilead, or as the slime to the wounded bark.

Let Joab with the Horse worship the Lord God of Hosts.

Let Shemaiah bless God with the Caterpiller — the minister of vengeance is the harbinger of mercy.

Let Ahimelech with the Locust bless God from the tyranny of numbers.

Let Cornelius with the Swine bless God, which purifyeth all things for the poor.

Let Araunah bless with the Squirrel, which is a gift of homage from the poor man to the wealthy and increaseth good will.

Let Bakbakkar bless with the Salamander, which feedeth upon ashes as bread, and whose joy is at the mouth of the furnace.

Let Jabez bless with Tarantula, who maketh his bed in the moss, which he feedeth, that the pilgrim may take heed to his way.

Let Jakim with the Satyr bless God in the dance. —

Let Iddo praise the Lord with the Moth — the writings of man perish as the garment, but the Book of God endureth for ever.

Let Nebuchadnezzar bless with the Grashopper — the pomp and vanities of the world are as the herb of the field, but the glory of the Lord increaseth for ever.

Let Naboth bless with the Canker-worm — envy is cruel and killeth and preyeth upon that which God has given to aspire and bear fruit.

Let Lud bless with the Elk, the strenuous asserter of his liberty, and the maintainer of his ground.

Let Obadiah with the Palmer-worm bless God for the remnant that is left.

Let Agur bless with the Cockatrice — The consolation of the world is deceitful, and temporal honour the crown of him that creepeth.

Let Ithiel bless with the Baboon, whose motions are regular in the wilderness, and who defendeth himself with a staff against the assailant.

Let Ucal bless with the Cameleon, which feedeth on the Flowers and washeth himself in the dew.

Let Lemuel bless with the Wolf, which is a dog without a master, but the Lord hears his cries and feeds him in the desert.

Let Hananiah bless with the Civet, which is pure from benevolence.

Let Azarias bless with the Reindeer, who runneth upon the waters, and wadeth thro the land in snow.

Let Mishael bless with the Stoat — the praise of the Lord gives propriety to all things.

Let Savaran bless with the Elephant, who gave his life for his country that he might put on immortality.

Let Nehemiah, the imitator of God, bless with the Monkey, who is work'd down from Man.

Let Manasses bless with the Wild-Ass — liberty begetteth insolence, but necessity is the mother of prayer.

Let Jebus bless with the Camelopard, which is good to carry and to parry and to kneel.

Let Huz bless with the Polypus — lively subtlety is acceptable to the Lord.

Let Buz bless with the Jackall — but the Lord is the Lion's provider.

Let Meshullam bless with the Dragon, who maketh his den in desolation and rejoiceth amongst the ruins.

Let Enoch bless with the Rackoon, who walked with God as by the instinct.

Let Hashbadana bless with the Catamountain, who stood by the Pulpit of God against the dissensions of the Heathen.

Let Ebed-Melech bless with the Mantiger, the blood of the Lord is sufficient to do away the offence of Cain, and reinstate the creature which is amerced.

Let A Little Child with a Serpent bless Him, who ordaineth strength in babes to the confusion of the Adversary.

Let Huldah bless with the Silkworm — the ornaments of the Proud are from the bowells of their Betters.

Let Susanna bless with the Butterfly — beauty hath wings, but chastity is the Cherub.

Let Sampson bless with the Bee, to whom the Lord hath given strength to annoy the assailant and wisdom to his strength.

Let Amasiah bless with the Chaffer — the top of the tree is for the brow of the champion, who has given the glory to God.

Let Hashum bless with the Fly, whose health is the honey of the air, but he feeds upon the thing strangled, and perisheth.

Let Malchiah bless with the Gnat — it is good for man and beast to mend their pace.

Let Pedaiah bless with the Humble-Bee, who loves himself in solitude and makes his honey alone.

Let Maaseiah bless with the Drone, who with the appearance of a Bee is neither a soldier nor an artist, neither a swordsman nor smith.

Let Urijah bless with the Scorpion, which is a scourge against the murmurers — the Lord keep it from our coasts.

Let Anaiah bless with the Dragon-fly, who sails over the pond by the wood-side and feedeth on the cressies.

Let Zorobabel bless with the Wasp, who is the Lord's architect, and buildeth his edifice in armour.

Let Jehu bless with the Hornet, who is the soldier of the Lord to extirpate abomination and to prepare the way of peace.

Let Mattithiah bless with the Bat, who inhabiteth the desolations of pride and flieth amongst the tombs.

Let Elias which is the innocency of the Lord rejoice with the Dove.

Let Asaph rejoice with the Nightingale — The musician of the Lord! and the watchman of the Lord!

Let Shema rejoice with the Glowworm, who is the lamp of the traveller and mead of the musician.

Let Jeduthun rejoice with the Woodlark, who is sweet and various.

Let Chenaniah rejoice with Chloris, in the vivacity of his powers and the beauty of his person.

Let Gideoni rejoice with the Goldfinch, who is shrill and loud, and full withal.

Let Giddalti rejoice with the Mocking-bird, who takes off the notes of the Aviary and reserves his own.

Let Jogli rejoice with the Linnet, who is distinct and of mild delight.

Let Benjamin bless and rejoice with the Redbird, who is soft and soothing.

Let Dan rejoice with the Blackbird, who praises God with all his heart, and biddeth to be of good cheer.

The poem continues throughout the template of Scripture into Smart's contemporary world, alluding to people, places, cultures, and spiritual giftings. For Smart, all of humanity (every human, nation, and culture) is bidden in a quest for beauty as God's giftings via creation and culture, bringing delight and "good cheer" for all those we can see and hear. In the cornucopia vision Smart paints, humanity is wrapped up in a world infused with God and his beautiful works: from rams, camels, and rhinoceroses, and even

to particular people. Why print so many lines to make a point? In Smart's theopoetic vision, he doesn't just write about theology using a poem, his poem *is* a type of theology, summarizing God's investment in creation and humanities' response—thanksgiving and praise. *Jubilate Agno* is Smart's quest to articulate beauty in various ways, his yearning for transcendence that incorporates many facets of the human experience.

Nature

Third, beauty helps us see nature—God's magnificent canvas—with greater attention. For example, when a photographer is about to take a picture of a flower, a horse, or the ocean, she is attuned to nature more attentively than if she were just walking by; she is beheld by the beauty before her. When a painter studies the nature he's about to put on canvas, let's say for a landscape, his eyes study, sometimes with great technical detail, the scene. He familiarizes himself with its nuances, its intricacies, its distinctive form that makes it unique within the world. The artist attempts to capture beauty via his or her experience and vision, an impression imposed by his or her brain, breathed through engagment with beauty. Beauty in nature is that way; it causes one to stop and look, providing a moment to ponder and appreciate the natural world with greater insight. People respond to the beauty of nature. Natural beauty allows us to see the minutiae and monumental in reality. And as stated throughout this book, creation (nature) is one of God's greatest gifts.

Think of God's relationship to nature as volume one of a two-volume masterpiece. The book of nature and the book of the Bible; his world and his word. Nature is a book of being.

Poet Gerard Manley Hopkins (1844–89) captures the sense of awe and beauty manifest in nature in his poem, "The Windhover,"[45] where he concentrated on the flight and majesty of a falcon.

The Windhover

> To Christ Our Lord
> I caught this morning morning's minion, king-
> dom of daylight's dauphin, dapple-dawn-drawn Falcon, in his riding
> Of the rolling level underneath him steady air, and striding
> High there, how he rung upon the rein of a wimpling wing
> In his ecstasy! then off, off forth on swing,

45. Hopkins, *Gospel in Gerard Manley Hopkins*, 103.

As a skate's heel sweeps smooth on a bow-bend: the hurl and gliding
Rebuffed the big wind. My heart in hiding
Stirred for a bird,—the achieve of, the mastery of the thing!

Brute beauty and valour and act, oh, air, pride, plume, here
Buckle! AND the fire that breaks from thee then, a billion
Times told lovelier, more dangerous, O my chevalier!

No wonder of it: sheer plod makes plough down sillion
Shine, and blue-bleak embers, ah my dear,
Fall, gall themselves, and gash gold-vermilion.

Notice the intricate nuances Hopkins touches upon in nature: the morn-
ing, daylight; the "dapple-dawn-drawn Falcon," wings, the majesty of flight;
wind; feathers; and the wonder of it all. It's a truly glorious picture of a won-
der-infused natural world. Hopkins found beauty in nature, both materially
(in things—being) and immaterially (beauty and valor, danger and awe).

Concerning nature and beauty, Dietrich von Hildebrand wrote: "A
mysterious, purposeful tendency permeates the immense structure of na-
ture and makes even the inanimate world serve the sphere of life," provid-
ing an "immense diversity [to] its ontological value, about which we can
never be sufficiently amazed. . . . its inexhaustible fullness of being and of
meaning."[46] Put simply, nature amazes us, just as the falcon did Hopkins.

To help understand the correlation of beauty to nature, von Hildeb-
rand lists five "themes," "basic types of bearers of beauty"[47] found in nature.

- One, "the basic elements." These include the firmament and the times
of day.[48]

- Two, "the individual beings in nature." These include plants and ani-
mals, the organic and non-organic particulars.[49]

- Three, "the working together of the basic elements and individual
things." This includes the experience of nature and being in nature.[50]

- Four, "nature that is formed within in the sense of 'region' that has
unity as a landscape."[51] The unique beauty of a certain place.

46. Hildebrand, *Aesthetics*, 295.
47. Hildebrand, *Aesthetics*, 295.
48. Hildebrand, *Aesthetics*, 297–303.
49. Hildebrand, *Aesthetics*, 303–6.
50. Hildebrand, *Aesthetics*, 306–8.
51. Hildebrand, *Aesthetics*, 308 and 321.

- Fifth, "the individual, concrete landscapes as a structural aesthetical unity."[52] How the landscape works within a place or region.

Summarizing the effects of nature on people, von Hildebrand states,

> When we bear in mind the happy fact that the world is God's creation, that it presupposes the existence of God in its contingency and bears the stamp of the created—not of an emanation from God—then we see in beauty of nature not only something that contains in itself a theme of its own, its *raison d'etre*, but also a profound and significate message from God. The beauty of nature contains a natural revelation of God; it is a word addressed to the human person, and at the same time a song of praise of God.

Culture

The final aspect of God's beauty bound in creation is culture. Google Dictionary defines culture as "the arts and other manifestation of human intellectual achievement regarded collectively," and the "customs . . . and achievement of a particular nation, people, and other social groups." Culture goes beyond just the abilities of an artist or scientist; it is the all-encompassing manifestation of human intellectual achievement. Art, skill, craft, science—and a lot of other things—fall within culture. In ancient Rome, Cicero defined culture as *cultura animi*, the cultivation of the soul. Culture does that: it cultivates. This gives a glimpse into the power of culture: it can shape the soul of a person or a people. Culture is intertwined with our humanity.

Culture is the "big picture" photograph of our society and world. It helps us see who we are as a people group. It gives us a snapshot of our beliefs, our philosophy, and our way of doing things. However, there is a sidenote: culture changes; it is a living tradition. As it relates to cultural art, Sarah Thornton noted that a culture's understanding of art is about a lot of things: roles, behaviors, understanding, and beliefs.[53] And these beliefs shape how we view beauty and the meaningful way they are interpreted.[54] Daniel Sidell, commenting upon Thornton, stated, "In this context, art is not a qualitative judgment but a particular cultural practice that acquires meaning and significance within a specific institutional framework, which

52. Hildebrand, *Aesthetics*, 308–12.
53. See Thornton, *Seven Days in the Art World*.
54. See Siedell, *Who's Afraid of Modern Art?*, 47.

generates a living tradition that guides and provokes artistic decisions."[55] Culture—fixed and firm—at times is also flexible and forever changing.

I like Sidell's phrase—"a living tradition." One way to look at culture is that it is a practice in the pursuit of beauty, truth, and goodness, affording humanity a living tradition of finding meaning and purpose to life. Why is culture living? Because there's always beauty, truth, and goodness to discover, it's growing; and the existence of these eternal values keeps culture entreating and pursuing them. Beauty, truth, and goodness are real, "ancient footsteps" upon the world, found in creation and culture.[56]

Beauty is bathed within culture, ancient footsteps in the grains of its framework. Beauty is found in many wonderous ways in culture, a confluence of the bane and the beautiful.[57] John Stott comments, "Culture may be likened to a tapestry, intricate and often beautiful, which is woven by a given society to express its corporate identity. The colors and patterns of the tapestry are the community's common beliefs and common customs, inherited from the past, enriched by contemporary art and binding the community together."[58]

In Eugene O'Neill's play, *Beyond the Horizon*, two brothers sit at a fence talking. The younger brother, Robert, explains why he wants to travel the world to his older brother, Andrew. After pointing to the horizon, Robert stated, "Supposing I was to tell you that it's just Beauty that's calling me, the beauty of the far off and unknown." For Robert, there is Beauty (capital "B" in the original) to behold in the world and in culture (for him, the far East).[59] As the play progresses, Robert doesn't find the beauty. Rather, Robert finds ugliness and pain. But it's his yearning for beauty—a transcendent quest—that captures him. Robert hopes to find beauty in culture, but beauty eludes him via choices made and fallen dreams.

People—as the conduits of human culture—seek beauty.

Dorothy Day exclaims something similar in her autobiography, *The Long Loneliness*. As she comes to terms with the existence and presence of God in her life and the world, she writes: "How can there be no God, when there are these beautiful things."

55. Siedell, *Who's Afraid of Modern Art?*, 47.

56. It's as Bob Dylan (b. 1941) sings in his "Every Grain of Sand." See https://www.bobdylan.com/songs/every-grain-sand/ for full lyrics.

57. Nixon, *Tilt*, 15.

58. Stott, *Authentic Christianity*, 350.

59. In *Beyond the Horizon*, Robert doesn't find beauty—he finds death. In a way, Robert is akin to Eugene O'Neill who, himself, wrote his early plays in an attempt to make sense of life within God's abandonment. But with his last work, a semi-autobiographical drama, *A Long Day's Journey Into Night*, O'Neill conceded he needed something more in life.

Beauty is a signpost, and culture can capture that beauty in many ways.

Another example of finding beauty in culture is the character of Owen Warland in Nathaniel Hawthorne's *The Artist of the Beautiful*. The opening section of Hawthorne's short story finds a father, Peter Hovenden, and daughter, Annie, walking by two craftsman's shops: a watchmaker (Owen Warland) and a blacksmith (Robert Danforth). The father wonders which skill is a more noble craft. The father finds the blacksmith more amicable (he had been a watchmaker himself). As the story commences, however, we learn that Warland is creating something greater than a watch, a "secret occupation." Here's how Hawthorne describes the scene:

> From the time that his little fingers could grasp a penknife, Owen had been remarkable for a delicate ingenuity, which sometimes produced pretty shapes in wood, principally figures of flowers and birds, and sometimes seemed to aim at the hidden mysteries of mechanism. But it was always for purposes of grace, and never any mockery of the useful. . . . Those who discovered such peculiarity in the boy as to think it worth their while to observe him closely, sometimes saw reason to suppose that he was attempting to imitate the beautiful movements of Nature as exemplified in the flight of birds or the activity of little animals. It seemed, in fact, a new development of the love of the beautiful, such as might have made him a poet, a painter, or a sculptor, and which was as completely refined from all utilitarian coarseness as it could have been in either of the fine arts.[60]

In this passage, we see how Warland sought the sublime, a quest for an awe-inspiring invention of beauty: something new and mysterious. Using the skills given to him by culture and nature, he reached for a hidden reality, a place where love and beauty reside. His quest wasn't practical—like Danforth's—but was profound.

As the story progresses, we find that Warland abandoned his quest, leaving, "the Artist of the Beautiful in darkness."[61] Warland despaired.

Yet, Warland begins to study butterflies and to work on a new creation. When Annie returns to Warland's shop, she mistakenly breaks the machine Warland is making. However, with the destruction of his creation, beauty was not dead, but asleep in Warfield's world. His quest for beauty was alive and well.

Again, Annie and Robert Danforth (now married) return to Warland's shop, asking Warland if he has yet found beauty. Warland says *yes*. He takes

60. Hawthorne, *Artist of the Beautiful*, 5.

61. Hawthorne, *Artist of the Beautiful*, 9.

out a small box and hands it to Annie. She opens it, and finding an object resembling a butterfly, says, "Beautiful, beautiful!" The butterfly then flies away. Warland is asked if the butterfly is living. Warland states, "Yes, Annie; it may well be said to possess life, for it has absorbed my own being into itself; and in the secret of that butterfly, and in its beauty—which is not merely outward, but deep as its whole system—is represented the intellect, the imagination, the sensibility, the soul of an Artist of the Beautiful!"

However, when the butterfly lands on Robert's hand, its life fades, only to be restored when placed on the hand of the child. Incensed, Robert crushed the butterfly. But by this time, the act of vengeance didn't matter to Warland. Beauty was beheld.

Hawthorne concludes with this: "When the artist rose high enough to achieve the beautiful, the symbol by which he made it perceptible to mortal senses became of little value in his eyes while his spirit possessed itself in the enjoyment of the reality."[62]

In other words, Warland discovered the eternal value of beauty, bound in being, imagination, and creativity—all the thing culture entails; but transcends them all. The butterfly is a picture of an eternal verity.

In this short story, we find an example of culture's pursuit of beauty. Art and literature, language, craftmanship, invention are all placeholders for human achievement and longing. But like Warland sought more than just an invention, culture's search is for the sublime, a quest for the beautiful, ultimately transcendent Beauty.

Hawthorne's *The Artist of the Beautiful* is a metaphor for the importance of culture appreciating and apprehending beauty. True, culture provides the foundation—the canvas—for people to paint, creating unique works, inventions, and technology. But the beautiful transcends culture. Like the quest to find beauty in the world, Warland sought something similar in his butterlfly invention, but discovered something deeper, more durable. In this way, culture plays an important role—via arts, sciences, language, human longing, craftmanship (all the things that make up culture) in discovering beauty.

So, then, culture lays a foundation, providing a conduit of celebration and a canvas for creation, a festivity for finding beauty in the cosmos. As Brendan Tomas Sammon writes:

> Everyone knows when he or she is touched by something beautiful. Beauty is such that it does not require an advanced degree, an insider's knowledge, or any studious labor to be recognized. It appears when and where it wants to, and the human person cannot but submit to its appearance. . . . beauty's immense power to

62. Hawthorne, *Artist of the Beautiful*, 23.

take hold of a person derives from the fact that its reach extends to the radical particularity of the person where it inhabits his or her subjective experience. Yet like the enthusiastic friend who refuses to let another stay home from the celebration, beauty's indwelling stirs us to a place of glorious unrest, proving us out of ourselves into its shared splendor.[63]

This is how beauty acts in culture: it appears, takes hold of us, and acts like an enthusiastic friend. Beauty invites people to its celebration, a "glorious unrest," and allows us to partake in its splendor, pointing us towards something—Someone—even more beautiful. We see this when a scientist finds a cure for a disease, when an inventor conceives something new, when a sculptor creates a masterpiece, when a linguist cracks a language code, when an archeologist uncovers an ancient city, when a poet lyricizes, when a preacher teaches, when an artist paints, when a philosopher thinks, when a musician composes. Beauty bathes our culture in marvelous ways, reminding us of its impact. We do well to give beauty a voice in our ethos and allow its eternal spring to overflow and point us to the Beautiful One.

INSPIRATION

Let's move on to the final "I," inspiration. And remember, we're still addressing the broader topic of hermeneutics, learning what the Bible states or infers about beauty. In this last section, the question is: What does it mean to be inspired by God? Though there are many avenues to discuss inspiration, such as *general inspiration* (which is likened to mental illumination, inventiveness, and intuition), and *specific inspiration* (which is likened to the formation of the Bible), my intent in this section is to highlight a broadly biblical narrative of inspiration, including elements from both.[64]

A general definition of inspiration is "the process of being mentally stimulated to do or feel something, especially to do something creative."[65] This is the inspiration and motivation one gets, as an example, to write a poem or a musical composition.

A specific definition—as it relates to inspiration and the Bible—is viewed as "God-breathed."[66] Specific inspiration is concentrated on the Bible, how God superintended the writing of Scripture. Geisler positions it as

63. Sammon, *Called to Attraction*, 1.

64. For more information delineating the differences, see Geisler and Nix, *From God to Us*, chapter 2.

65. See https://www.lexico.com/en/definition/inspiration.

66. See 2 Tim 3:16–17.

thus: Biblical inspiration is "the *product* which is inspired, not the *persons*" (emphasis added). Geisler goes on to write that within specific inspiration, there contains "three essential elements: divine causality, prophetic agency, and written authority."[67]

We won't unpack the various nuances of the "product" versus "person" inspiration. Instead, for the sake of brevity, we'll meld the two definitions together, using the Bible to paint a picture of someone inspired by God to do something creative. The point being that God, via the Spirit, inspires people with gifting; God can inspire a person with the end result being a beautiful product. The Bible gives us several examples of artists inspired by God.[68] We'll focus on one: Bezalel. With Bezalel, we'll briefly look at the calling, equipping, knowledge, and leading.[69]

The Calling

Exodus 31:1–4 reads,

> Then the Lord spoke to Moses, saying: "See, I have called by name Bezalel the son of Uri, the son of Hur, of the tribe of Judah. And I have filled him with the Spirit of God, in wisdom, in understanding, in knowledge, and in all manner of workmanship, to design artistic works, to work in gold, in silver, in bronze, in cutting jewels for setting, in carving wood, and to work in all manner of workmanship."

Who was this guy that God called to be an artist? We don't know much. The text tells us that he was from the tribe of Judah, and his father's name was Uri. We do know that God "called" him. "Called" means to call out or call by name. In a way, Bezalel was marked, "called," to be an artist.

The Equipping

Next, we read that God "filled" him with the Spirit of God. "Filled" means to accomplish, confirm, and consecrate. In other words, God set apart Bezalel to do something specific; in his case, to be an artist. This is a supernatural calling, empowering, and enablement. In some Christian circles, many have

67. Geisler and Nix, *From God to Us*, 13.

68. For a longer look at art and Scripture, see Francis Shaeffer's *Art and the Bible*, particularly the sections on the tabernacle and temple on pp. 20–30.

69. I've gleaned from Skip Heitzig's teaching on this text in his exposition of Exodus 31:1–6: Calvary Church with Skip Heitzig, "Exodus 3–4."

likened the filling as equipping: "God's callings are His enabling. If God calls you to do something, He'll enable you to do it."[70] So, if God has enabled someone to be an artist, He, likewise, will give him or her a desire—a calling, a filling, an enablement—to accomplish what he or she has been called to do. Calling and enabling: the two go hand in hand; it is God filling a person to accomplish work.

The Knowledge

What did God fill Bezalel with? The text tells us *wisdom, understanding*, and *knowledge*. Here, the word "wisdom" refers to skillful wisdom, the ability to create something. "Understanding" means reason and caprice. Bezalel knew instinctively, or "on a whim" (as *caprice* means), how to do the tasks that were set before him. "Knowledge" refers to cunning or craftiness. God filled Bezalel with "insight into his craft," giving him the mental prowess to accomplish the massive job. As an artist and a workman, Bezalel was given knowledge, and he utilized that knowledge to form specific, beautiful objects.

The Leading

What is it that God led Bezalel—and his group of artist friends—to do? In verses 4–6, it reads:

> To design artistic works, to work in gold, in silver, in bronze, in cutting jewels for setting, in carving wood, and to work in all manner of workmanship. And I, indeed I, have appointed with him Aholiab the son of Ahisamach, of the tribe of Dan; and I have put wisdom in the hearts of all the gifted artisans, that they may make all that I have commanded you.

What does God lead an artist to do? To create, to make artistic things, to be an artist. In this text, God led them to design, to make jewelry, to cut stone, to make wooden items. God led them to do a whole bunch of creative things. And then the verse ends with "to make everything I have commanded you." So, an artist called by God is equipped by God with knowledge provided by God to make things that God has led them to make. In the case of Bezalel, he was commanded by God to create objects both to beautify the temple and to serve intended purposes.

70. Nixon, *Called To Be an Artist*, 18.

So, as it relates to inspiration, and using Bezalel as the example:

One, God calls.

Two, God equips.

Three, God provides knowledge (either directly through inspiration, or indirectly through general revelation).

Four, God leads.

Or, put in another popular axiom: "Where God guides, He provides."[71]

71. A common axiom found within Christendom, based upon Prov 3:5–6.

Chapter 4

Heuristically

What Are Some Practical Explorations of Beauty?

In this final chapter, we'll delve into some exploratory points, applying them to beauty. In a sense, this chapter will walk out where we came in, using "Comedian" as the illustration of all we've covered thus far. Heuristic—as the title of this chapter states—means "enabling a person to discover or learn something."[1] It's my hope that the reader will learn how to apply beauty to life, innately and intelligently, and thereby, understand the immutability of beauty.

Exploring beauty's impact is an immense endeavor. One could take beauty in a multitude of directions (aesthetics, psychology, scientific, etc.). But as I stated in the introduction, my goal is to break beauty down into its fundamental factors, providing a theopoetic foundation. In essence, I'll offer three notes of a longer, more complex melody. But before I do that, I need to briefly relate beauty back to art.

Gordon Graham said, "To state the necessary and sufficient conditions of art is to set out the properties something must have in order to be a work of art."[2] In this chapter, I'll argue beauty, like art, has "necessary and sufficient conditions." These conditions—or dimensions—are being (innate),

1. See Google's definition of "heuristic."
2. Graham, *Philosophy of the Arts*, 222.

90

teleology (intelligence), and transcendence (immutability). These three things "bear the beauty, and the beauty appears by means of it."[3]

As we begin these exploratory thoughts, let me repeat what I've stated: from a human perspective, being is our basic starting point. We can only understand beauty because there is being, something exists rather than nothing. So, at its base, beauty corresponds to being, and being is dependent upon Being, an Uncaused Cause, Pure actuality, namely, God.

Dimensions of Beauty

Philosopher Dietrich von Hildebrand had similar thoughts regarding my *dimensions* of beauty, which we'll get to soon.[4] However, instead of calling them dimensions, Hildebrand described beauty as "powers" or "levels." Beauty in the first and second powers; but inferred within the second power is a third.[5] These powers could be summarized as sensuous (primitive), spiritual (metaphysical), and saintly (my designation, not Hildebrand's).[6] All powers are connected on certain levels since each communicate a semblance of beauty; but, each are distinguished from one another in degrees.[7] As John F. Crosby stated, each level "ha[s] a certain radiance or splendor of beauty, and thus have aesthetic value."[8] In his introduction to *Volume II* of von Hildebrand's *Aesthetics*, Scruton summarized the two powers: "The first power belongs to those objects that, through their intrinsic form and harmony, attract an unreflective sensory delight. . . . The second power is exhibited when a spiritual idea is expressed in artistic form . . . an apprehension of deeper truths."[9]

For Hildebrand, the first power is *sensory* experience; a person using his or her senses to absorb a beautiful object.[10] The second power, then, encompasses levels of sublimity and "plentitude," and points to something

3. Hildebrand, *Aesthetics, 204.*

4. See Hildebrand, *Aesthetics.*

5. Hildebrand, *Aesthetics*, 152–54.

6. For more information on Hildebrand's aesthetical approach, see *Handbook of Phenomenological Aesthetics*, John F. Crosby, 145–49. Hans Urs von Balthasar also had a "saintly" understanding of beauty.

7. Hildebrand said: "The beauty that appeals to the senses is indeed very significant and represents a great gift from God, but it does not have the specifically spiritual element possessed by the beauty. . . [of the second power]." *Aesthetics*, 152.

8. Hildebrand, *Aesthetics*, 146.

9. Scruton, *Aesthetics*, xx.

10. See Hildebrand, *Aesthetics*, ch. 8.

beyond itself, where one captures deeper, *spiritual* truth.[11] The third power, inferred within Hildebrand's second power, is what I call *saintly*, pointing or connecting a person to the values of God.[12] Hinting at this unnamed third value, Hildebrand wrote, "The human person is raised up by the moral value of his behavior. He shares fully in this moral value, through which he acquires a new preciousness. This is why he is clothed in the beauty, which is the fragrance, the splendor of this moral value. It adorns him—it is his beauty. . . . It proclaims much higher realities. It kindles in us a yearning for the world of lofty immaterial realities. Basically, this is a longing for that which is 'above us,' *quae sursum sunt* ('the things above,' Colossians 3:1); it draws us upward."[13]

For Hildebrand, all beauty ultimately acts as signposts of meaning,[14] indicating the divine. I'd agree. But rather than use the words "powers" or "levels," I prefer to use the word *dimensions*.[15] Why? Dimensions is a word that extends beauty beyond a purely hierarchical framework. (There are hierarchical aspects to beauty, which I'll later refer to as *influences*).[16] Dimensions link to a broader mode of analysis based on something foundational, basic building blocks that beauty embodies. These building blocks are being (ontology), intelligence (teleology), and immutability (a type of transcendence—delight, awe, wonder, and interest). In the end, all dimensions of beauty act as a signal for the Beautiful One. I would also say that metaphysical beauty (what I call immutable) is that which corresponds most directly to God, for God is a Spirit.[17] Metaphysical beauty is a correspondence or profundity of his beauty (even if the viewer is unaware), an awakening *within* the metaphysical truths manifest in the beautiful, a form of transcendent awe and wonder; and for the Christian, a conduit of worship.[18] Or, to use Hildebrand's phrase, "It draws us upward."

11. Hildebrand, *Aesthetics*, ch. 10.

12. This theme is woven throughout Hildebrand's work, but is emphasized in chs. 2; 13–15 of *Aesthetics Volume 1*; and chs. 1 of *Aesthetics Volume 2*.

13. Hildebrand, *Aesthetics*, 210–11. For Hildebrand, the third power is an extension of the second power, but somehow moves beyond it, speaking of the "world of God, the world above us" (*Aesthetics*, 213).

14. Hildebrand, *Aesthetics*, 157–58. Von Hildebrand believed the "sign" transcends the object, pointing towards corollary meaning. He said, "The act of meaning is not a subsection of the sign, but far transcends the signitive relationship. It is much richer in meaning and more differentiated than the signitive relationship" (160).

15. Using "dimensions" over "power" does not mean to say I wholly disagree with Hildebrand; I rather seek to expand upon the ideas he initiated.

16. See Hildebrand, *Aesthetics*, 187.

17. See John 4:24.

18. Hildebrand's philosophy is very similar to mine, although some of the

This is how I'll unpack the dimensions: I'll start by defining the terms, then move to the implications of the meaning. To begin, here's the basic architecture of my argument for beauty.

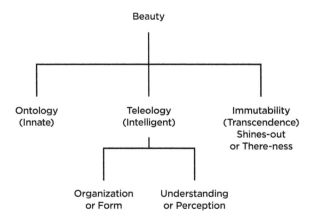

INNATE BEAUTY (ONTOLOGICAL)

Ontology is the study of being. At its heart, ontology asks, "Why is there something rather than nothing?" This is a question of existence and reality; it is fundamental. Being is the basic building block to an understanding of beauty, at least from an earthly, human vantage point, as opposed to one that is heavenly and eternal.

Innate beauty begins with the idea that something is beautiful because it exists; it has being. From a theological standpoint, being is beautiful because God created being; it flows from his creative mind. And from a philosophical standpoint (non-theistic), being is beautiful because existence depends on something; the concept of beauty arises from being itself. After all, we can't discuss beauty—or anything else—if there is no being, if existence didn't exist. But there is something rather than nothing, there is being. And because there is being, we can—and should—talk about beauty.

Since we defined beauty and being in chapter 1, we won't cover them here. The basic principle of this section is to understand that beauty is innate, is embodied, in being. If something is, it has an echo of beauty. Regarding

hierarchical systems ingrained in his thinking do not always resonate with me. For example, "One kind of tree is more . . . beautiful . . . than another kind" (*Aesthetics*, 198). However, von Hildebrand does contribute deep insight into the order of being, ontological versus qualitative values. He gives much to ponder.

beauty found in all being, Bence Nanay said, "Everything has beauty but not everyone sees it."[19] There is truth to this statement: if it has being, it has beauty, whether we see it or not.

The idea of beauty-in-being applies to material objects, such as art and nature, and to more ethereal objects, such as language, ideas, imagination, mathematics, and music. Though harder to test, the latter examples are still something rather than nothing. As pointed out in chapter 1, they have "mental being."[20] Expanding on this view of mental being, W. Norris Clarke said, "that which is present not by its own act of existence but only within an idea. . . . 'Its being,' St. Thomas says, 'is its to-be-thought-about' by a real mind."[21] Clarke then provided four traits of mental being:[22] "*past and future*"; "*contents of dreams*"; "*abstractions*"; and "*mental constructs.*" Though Clarke prioritized "real being," "mental being" is still being in that it is connected to "real being," a mind.

Other than the subtleties between "real" and "mental" *being, innate beauty* is the easiest fundamental factor of beauty to comprehend.

So . . .

An atom is, it has being; it is beautiful.

DNA is, it has being; it is beautiful.

A cell is, it has being; it is beautiful.

An organism is, it has being; it is beautiful.

All creation is, it has being; it is beautiful.

Art is, it has being; it is beautiful.

The same applies to noncorporal being:

Math is, it has being (existence); it is beautiful.

Language is, it has being (existence); it is beautiful.

Music is, it has being (existence); it is beautiful.

Ideas are; they have being (existence); they can be beautiful.

If it has being, it is beautiful.

Like Aquinas, Geilser, von Balthasar, and a host of other thinkers throughout history have argued, being gives a basic analogy for existence; it provides the foundational building block for an understanding of beauty in an objective sense: there is something, and the something innately can be beautiful. Theologically, it's important to remember that beauty is bound and embodied in being, not dependent on being. It is a value and attribute

19. Nanay, *Aesthetics*, 10. The original quote is attributed to Confucius.

20. In the case of the later examples, particularly music and math, they can be verified, tested, and applied in our world, metaphysical (non-corporeal) being incarnate.

21. Clarke, *One and the Many*, 30.

22. Clarke, *One and the Many*, 30.

of God. In the end, beauty is dependent on God, the Beautiful One; Beauty begets beauty.[23] But in non-theological terms, being is important, as well, since it offers the basic building block for an understanding. In the end, without being, we'd be hard-pressed to understand or experience anything at all, beauty included.

INTELLECTUAL BEAUTY (TELEOLOGICAL)

If being is the basic foundation to beauty,[24] then the intellectual dimension is a further building block. With *intellectual beauty*, one looks at the organization or form of being using teleology as a factor.

In theology, teleology is the study of order and design in nature, asking "How and why did God create something?" It's a question of the structure of the design and the end goal of the design.

In philosophy, teleology attempts to explain the purpose of an object, rather than its causes. So, it's not so much a matter of who created an object (God, nature, or animal), but what the actions mean. What is the function or purpose, the end result or goal? A philosopher may ask, "What is the function of an object, what is its end target?" A philosopher is seeking understanding.

In either sphere, teleology involves judgment, assessing the value and of the object. Furthermore, both modes of thought (theological or philosophical) deal with the unique form of the object. And found within the form is beauty: shape, color, proportion, size, medium, and other such characteristics. Hildebrand tied the basis of teleology to beauty by saying: "In order to be beautiful, or even just pleasing, a being must have a particular structure"[25] and "this new level of beauty is . . . in a much deeper sense where the form constitutes one particular invention in ever new variations."[26]

Theologian Richard Viladesau connects beauty to form in this way: "The experience of beauty is a kind of delight: a joy in the experience of 'form,' the organizing principle that gives 'shape' to things and to our knowledge of them."[27]

23. See Carpenter, *Theo-poetics*, chapter 3.

24. At least the ontological understanding of its existence. As mentioned, beauty is not dependent on a person's understanding of being, but on God's Person.

25. Hildebrand, *Aesthetics*, 192.

26. Hildebrand, *Aesthetics*, 197.

27. Viladesau, *Theology and the Arts*, 42.

Viladesau continues, "To experience beauty is to experience a deep-seated 'yes' to being."[28]

Design. Order. Purpose. Goals. Structure. Form. Each of these have connections to teleology.

Concerning form and beauty, Brendan Thomas Sammon stated, "First and foremost, beauty identifies a principle of form: in the most primary way, beauty accounts for the particular form of any and every existing thing. That is to say, beauty is what makes a thing to be a particular, unique thing that occupies this time and space. A thing is beautiful because it has form, which enables it to be apprehended or perceived. And conversely, anything that is capable of being apprehended or perceived has form and is therefore *to some degree* beautiful."[29]

And Jacques Maritain draws a connection between intelligence and beauty by stating, "Beauty is essentially an object of intelligence, for that which knows the full sense of the word is intelligence, which alone is open to the infinity of being."[30]

Teleology helps with a discussion of beauty because teleology insinuates two overarching points. One, there's something (an object, an idea) with a semblance of order—it has existence, form. Second, one can ask questions about the object or medium to seek an understanding of its existence and purpose. In both cases, beauty is embodied in the objective reality—in being and form.[31]

At the heart of teleology is the idea that an object corresponds to its unique structure as created. For example, a tree is beautiful because it corresponds to its particular arrangement: it's a tree. A tree was ordered; it was designed (or evolved, if an evolutionist) according to its distinctive nature and organization, as imbued within its cellular structure. The same holds true for everything. For example, art is beautiful because it corresponds to its unique form, its medium; so, too, books, furniture, carpets, stars, bacteria, ideas, math, music, and all things in existence. There is teleology to the cosmos.

If being is the first step in understanding beauty, teleology is the second; it recognizes the specific character of each individual thing in existence. I believe teleology is a concept that is similar to Aquinas' *existence* versus *essence*, with existence being "'what a thing is,' and a narrow sense,

28. Viladesau, *Theology and the Arts*, 42.

29. Sammon, *Called to Attraction*, 15.

30. Maritain, *Art and Scholasticism*, 27.

31. As a theist, I believe teleology has intelligence incorporated into its design and form; design points to a designer, as an iPhone implies an engineer and a host of other contributors.

'the definition, or genus plus specific difference of a thing'";[32] whereas *existence* is "the actuality of an essence, that act by which something is."[33]

Throughout history, people have developed points of formal criteria to measure teleology in an attempt to understand why something is beautiful. They have used concrete standards such as proportion (length, width, height, etc.), color, shape, and wholeness to help calculate its beauty. Science has also weighed in on the specifics of teleology, looking at chemical makeup, wave functions, and biological configurations. Why? Teleology prompts one to ask if an object it is complete within itself: Why does it work as it does? Is there order to its structure or function? Does it fulfill its purpose according to an end goal?

As noted, people such as Aquinas provided formal criteria to understand form: proportion, integrity, and clarity,[34] a means to understand the inherent qualities of an object's design and relationship to beauty. As a theologian, Aquinas connected both being and teleology to God.

But non-theologians use teleology as well. Kant understood the integration of teleology in beauty as a way to determine the purpose the object serves rather than how the object arose.[35] Kant wasn't asking a theological question, per se, but a practical one: How is one to judge the object? What purpose does the object serve? What are the criteria that makes something sublime or beautiful?

I believe that both aspects of teleology—form and purpose—are important factors in understanding the unique relationship teleology has to beauty. The two understandings (form and purpose) of teleology account for an object's being, design, and organization (form) and how one judges or understands an object (purpose). I'll use both concepts within *intelligent beauty*.

In the end, I agree with Kant: teleology is important to beauty. No matter how one chooses to structure the rationale behind teleology, there is order to the object. There is a form, structure, design, and possibly, meaning to its makeup, which elicits judgment, investigation, and study.

Two-Part Invention

Like Bach's *Two-Part Invention* composition, where a melody and countermelodies work within the piece, *intellectual beauty* has a two-part

32. Aquinas, *Summa of the Summa*, 25.
33. Aquinas, *Summa of the Summa*, 25.
34. Aquinas, *Introduction to the Metaphysics*, 89.
35. Ginsborg, "Kant's *Aesthetics and Teleology*."

configuration. One melody of *intellectual beauty* connects it with *innate beauty* in that the object exists; it has being (as noted). But the counter melodies go beyond *innate beauty*, offering more phrases as part of the overall structure to the composition, seeking understanding of the being and form. Together, the melodies provide a unified a basis of teleology for *intellectual beauty*.

Maybe an analogy will be helpful. Let's say written numbers represent the innate quality of beauty. The numbers are fairly fixed, foundational truths; 1 is 1 (at least in non-theoretical math); it is *innate*. In contrast, formulas or theorems are more akin to *intellectual beauty*. They represent the relationship between the numbers (as expressed symbols) and larger, more complex truths (the laws of physics, as an example). They expand—or use the numbers—in unique ways, according to the physical, natural phenomena they are describing. (Think motion, mechanics; the fundamental ways in which the universe interacts.) Both numbers and theorems are metaphysical but are able to describe the universe's workings rather accurately. There is a relationship between *innate beauty* and *intelligent beauty*, as one is the foundation, and the other is expanding upon the foundation.

Let's leave math and get back to the music.

The first melody of *intellectual beauty* is organization. As mentioned, it is connected to the form of the object, and thereby rooted in being. The melody the object intones is based on the reality that it is; it exists according to its unique makeup or arrangement, shape, or structure—either metaphysical (such as math) or physical (such as art or nature). So, something is beautiful according to its unique form, design, and configuration. This applies to electrons and elephants, music to math. Organization is objective; it is reality.

The second melody of *intellectual beauty* is understanding, bringing a subjective angle, a particular opinion or evaluation of an object.

The two countermelodies twist and turn in intellectual beauty, creating a more complex composition, involving various motifs in the understanding of beauty. On one hand someone recognizes a form, and on the other hand, the person judges the form's worth. In this active composition, some of the melodies are harmonious (deemed pretty or beautiful), others discordant (deemed unattractive or jarring). In both cases, there is judgment involved, an individual assessment of the objects worth and loveliness. This is where people like Kant and Scruton camped out in judgment, recognizing that people place different values upon an object. I'd agree with Kant and Scruton; judgement is needed and personal. But I would not neglect the object itself, which is inherent with being, thereby providing an objective side

to *intellectual beauty*. Both the object (form) and judgment (understanding) of the object are important with intellectual beauty.

In a big picture, *intellectual beauty* implies an ordered object and implicitly calls—at least from a human vantage point—for understanding, a human desire to know, assimilate, and appreciate the object or form. As Aristotle said, "All human beings by nature desire to know."[36] Both—organization and understanding, objective and subjective—are essential in the broader implications of *intellectual beauty*, offering a two-part melody to what makes something intelligent.

Organization and Form

Let's hum the first melody: organization, form. With organization there is order to the object, a beauty according to its structure or form. It is beautiful because it consists of certain qualities that make it what it is. Either God, nature, or both, depending on one's worldview, configured the object with order. The fact that it is what it is according to its form, conveys a semblance of basic beauty: it's organized as a corporeal or incorporeal object or idea; it's beautiful for what it is. Remember what we learned at the beginning: an object "shines out" it's being. And this *shining-out* is the basis for our understanding of beauty.

In this case, a banana is beautiful because it adheres to the quality unique to its form, design and order. A baby, the same; it is beautiful because it adheres to the qualities of its form. So, too, with bumblebees, bikes, brains, bridges, bar graphs, base angles, bacteria, and banjos—all of it has inherent beauty according to its form. There is organization of its matter or concept; it has teleology. Even supposedly chaotic or difficult-to-understand objects such as black holes or wave-particle duality have their own organization (though humans have yet to fully grasp it). What seems chaotic to us has an internal order according to its form and structure.

Let's pause and address a nuance of *intellectual beauty* as it relates to order that can be tricky and lead to misconceptions. Let me give two examples.

36. As quoted in Hutchings and Wilkinson, *God, Stephen Hawking and the Multiverse*, 15.

Complexity

The first relates to complexity. For many, the more complex an object is, the more beautiful. For example, someone views a painting by the late Renaissance painter Albrecht Durer—with Durer's knowledge of perspective, science (use of lenses), color, and technique. Because of all of this, the person might believe it must be superior in beauty, then, say, a painting by the modernist painter, Agnes Martin, with her simple, straight lines and muted color painted in graph-like renderings. But we know this is not the case. Complexity does not make something more beautiful. Both paintings have organization and purpose according to their form. And though a person may prefer (judge) one superior to the other, complexity does not negate the object's inherent beauty.

Time

Nor does the second example, time. For some reason, some people believe that if something took longer to create, a longer investment in time, it must be more beautiful than something created in five minutes. Again, not the case. Some composers had an idea for a melody in a relatively short period of time (Duke Ellington mused he wrote some of his finest melodies in fifteen minutes[37])—and the outcome was beautiful, intellectually speaking. Others had to labor over the notes to form a beautiful melody, an investment of months and even years (Beethoven worked on his symphonies over long periods of time). So, complexity or time is not a determining factor in intellectual beauty.

If it's not time or complexity, what is? As stated, above, it is teleology, the order and organization that corresponds to the form of the object. Is the object (composition, poem, nature, etc.) true to its form? To many, this belittles art and beauty. Something simple surely can't be as beautiful as something complex and time-tested! Yes, it can. If it has the organization of properties unique to its form, it is beautiful. This is why an abstract painting by William de Kooning, say, *Woman 1*, can be beautiful as well as Leonardo da Vinci's *Mona Lisa*. They both have properties that correspond to its form; there's design and order. There is color, shape, and intention in both de Kooning and da Vinci; one abstract (de Kooning's non-objective abstraction), the other realistic (da Vinci's objective realism).

37. Wilson, "Duke Ellington," para. 11.

Fierce and Fetching

Maybe a better understanding of the difference between the two paintings is that de Kooning's rendering of women can be interpreted based upon a couple of words I addressed earlier in this book: as *fierce* beauty, incongruous, abstract beauty;[38] whereas da Vinci's is *fetching* beauty, realistic, appealing. But de Kooning's beauty is beautiful because it has shape, color, and order according to its form, a product of a mind. This would apply to a tidal wave (*fierce* beauty) and a calm ripple in a pond (*fetching* beauty). There are different subtleties of beauty, but beauty, nevertheless.[39]

Let's return to Sir Roger Scruton for a moment. He addressed differing subtleties of beauty in the context of music. Scruton stated, "There is not a contradiction in saying that Bartok's score for *The Miraculous Mandarin* is harsh, rebarbative, even ugly, and at the same time praising the work as one of the triumphs of early modern music. Its aesthetic virtues are of a different order from those of Faure's *Pavane*, which aims only to be exquisitely beautiful, and succeeds."[40] What Scruton called "harsh, rebarbative, and ugly" I call *fierce*. And what Scruton called "exquisitely beautiful," I call *fetching*. Scruton clarified these two senses as "success in aesthetics":[41] "In one sense 'beauty' means aesthetic success, in another sense it means only a certain kind of aesthetic success." In other words, Scruton said that one is "pure beauty,"[42] while the other is "beautiful for works of its kind."[43] Whether one agrees with the distinction of "pure" versus "certain kind" is not the issue. Both—*fierce* and *fetching*— have teleological beauty, albeit with subtleties.

The concept of time applies to nature, as well. Just because it took epochs of time to form mountains does not necessarily mean the mountains are any more beautiful than something that took a small amount of time— say, an egg laid by a chicken (roughly twenty-one days). Both are beautiful according to its own form, the essence of what they are; there is order and design in their own unique character.

In final analysis, someone may appreciate one object over the other (i.e., da Vinci over de Kooning or an egg over a mountain), but the subjectivity of taste or opinion does not negate an objects inherent intellectual

38. Incidentally, this applies to Christ's crucifixion: a fierce beauty.

39. Scruton addresses this concept in relationship to Edmund Burke's work *On the Sublime and Beautiful*, differentiating the polarizing aspects of beauty as love and fear, or serene and sublimity. See Scruton, *Beauty*, 61.

40. Scruton, *Beauty*, 13.

41. Scruton, *Beauty*, 13.

42. Scruton, *Beauty*, 15.

43. Scruton, *Beauty*, 15.

beauty, its order, design, and, ultimately, intentions. And this leads to the second point of intelligent beauty, understanding.

Understanding

The second counterpoint melody to sing is understanding, a type of judgment. The basic principle is that because there is *something* ordered in the universe, an object or an idea, that *something* is open for analysis and interpretation. According to Scruton, Kant held a similar view: "Kant . . . supposing that taste [judgment] is common to all human beings, a faculty rooted in the very capacity for reasoning."[44] In short, judgment is universal to the human condition, particularly as it relates to an appreciation of nature: "Nature, unlike art, has no history, and its beauties are available to every culture and at every time."[45] Humans seek to understand, and judgment—a comprehension of purpose—is part of the quest to know.

Before we proceed further, let's step back for a moment and listen to the harmony and discord between the two melodies established in *intellectual beauty*, so as to not get lost.

Intellectual beauty is found in both the organization of the object (its form) and in the intelligence that *shines-out* the object in a purposeful way through judgment and understanding. There is both the objective and subjective senses found in *intellectual beauty*. Someone can interpret a particular form or medium (an objective acknowledgment of the object), but do so with varying judgments, such as delight and appreciation or disgust and abhorrence. There are two qualities manifest in *intellectual beauty*: the object and the subjective judgment, requiring an intellectual process, understanding or a lack thereof. Even if someone says, "You don't understand the meaning of the artwork or math problem," there is still a basic form of understanding (misunderstanding or comprehension). Whether or not a person dislikes the artwork or doesn't fully understand the math problem, he or she understands that they don't understand, which is a type of understanding (one of intellectual humility).

Something further to note: the first melody (being/order) doesn't necessarily require a person; it is present whether or not a person sees or hears it. However, it does require organization or design via God or nature. In contrast, the countermelody (understanding) does require a person, intelligence (human or divine). In either case, there is order, design, and purpose

44. Scruton, *Beauty*, 49. This, of course, would be the case for a cognitively cogent person, not one hampered by any type of disease or disorder.

45. Scruton, *Beauty*, 50.

(either natural or supernatural or both) to the object, an objective and subjective sense within one factor.

Subjective Beauty

The second countermelody of *understanding* accounts for the subjective nature of beauty: "Beauty is in the eye of the beholder." A person seeing an object responds with judgment, interpretation, or opinion regarding its worth or value. And often, the more exposure one has to a particular object, the greater the understanding and appreciation of the object.[46]

Norman Geisler positions the dual nature of beauty as thus: "It should be pointed out that beauty has two sides: The admirable (the objective side) and the enjoyable (the subjective side)."[47] Geisler goes on to qualify the two sides as follows:

1. There is widespread agreement that some things are beautiful.

2. Beauty has identifiable factors (e.g., unity, order, balance).

3. Recent studies show a transcultural element to human beauty.

4. That some things are more beautiful than others . . . reveals and objective standard.[48]

One may disagree with Geisler on some points (such as the "identifiable factors" or the words "admirable" and "enjoyable"), but his insight, I think, is true. And though there's never been consensus on the "objective standards," there is an objective side and a subjective side to beauty: being, and ultimately, Being.

In final analysis, the two aspects of *intelligent beauty* offer two countermelodies: a subjective understanding (implying a unique personality and judgment), and an objective form, an object or thing's particular teleology. And it's the particular form that connects it to a universal, objective essence of beauty found in design, order, and purpose—and ultimately in being.[49] One could argue that the subjective aspect of *intelligent beauty* also points to something objective, a Greater Intelligence. As stated, design implies design, and so, too, intelligence implies Intelligence.

Here's my point: with the two melodies of *intellectual beauty*, there is a melodic sequence occurring, a tune is being constructed with the

46. Nanay, *Aesthetics*, 68–69.

47. Geisler, *Systematic Theology*, 244.

48. Geisler, *Systematic Theology*, 244.

49. For greater insight, see Carpenter, *Theo-poetics*, 97.

composition of a melody, both objectively (via the organization of the object) and subjectively (an understanding and emotional response to the object). Both aspects of *intelligent beauty* are needed to frame the overall impact of it's worth: the object and the judgement, the order and understanding.

In the end, the intellectual dimension that I propose has both objective and subjective aspects and responds to beauty on various levels: personal, scientific, cognitive, contextual, and emotional. This, then, allows for a person's experience—or context—of beauty to hold a level of importance. On this note, Bence Nanay said, "Even if beauty is not in the eye of the beholder—even if it's 'objective' in some sense, it is highly sensitive to what context we encounter it in."[50] Nanay would also say that a personal aesthetic is tied closely to the way one "exercises" his or her "attention."[51]

I'd agree with Nanay. All of this—objective, contextual, or emotional—is an intellectual exercise, rooted in the brain, forming judgments and impressions, providing meaning and context to an experience with beauty, the way one attends to its effects within a subjective structure. But rest assured there is both objective and subjective at work within *intellectual beauty*. The objective brain is beholding—via a subjective experience—an objective form or idea. As Richard Viladesau suggests, "virtually anything can be an aesthetic object, give the right subjective conditions."[52]

Conditions and Contexts

Within these "conditions" suggested by Viladesau there are several factors, or *contexts*, that influence a person's judgment or attention: familiarity, knowledge, personal taste, societal norm, the immediate experience of a moment, and the like. But the point of *intellectual beauty* is that the person is using his or her brain to process the information based upon an actual object or thing, be it physical or non-physical (such as math or an idea). And the more one understands the object, the greater the appreciation, or at least respect. So, the *understanding* component of *intellectual beauty* incorporates both the senses (smell, touch, taste, hear, etc.) and the intellect, the process of our brain working to comprehend an object.

Or maybe the *understanding* component of *intellectual beauty* is more akin to what Scruton states regarding a cumulative approach: "Rather than emphasize the 'immediate,' 'sensory,' 'intuitive' character of the experience of beauty, we consider instead the way in which an object *comes before us*, in

50. Nanay, *Aesthetics*, 9.

51. Nanay, *Aesthetics*, 61.

52. Viladesau, *Theological Aesthetics*, 8.

the experience of beauty."[53] Either way—*coming before us* or sensory—our mind is the main vehicle in experiencing, in understanding, and in judgment of the thing before us—an object, a form; and this requires intelligence.

The Influence for Greater Understanding

Before we leave the *understanding* section, let me give you an example of how greater understanding of an object can influence our appreciation of something using the tidal wave motif used above.

If someone were to look at a tidal wave in action— awe, fear, and trepidation may be the initial reaction. "It can't be beautiful; it's horrible," someone may say. But once the person begins to learn about wave functions, the ocean climate, the chemical makeup of water, then the sheer force of operation, appreciation, and consequently healthy respect may arise. The person begins to understand the order, the wave's teleology, manifest in the form. And teleology is a marker of beauty. Then, as an understanding of how the wave *comes before us*, we can experience the object in a new, respectful way. Understanding often (but not all the time) can engender appreciation, and other times insight further fear. In either case, our intellect is processing the effect of the object.

Even if someone may not like a particular form or shape based upon further understanding, rather than disproving *intellectual beauty*, it demonstrates that it is real: judgment and intelligence has been used to assess the value of the form, in the case of someone who continues to dislike and object—the intellect was used, in both an objective and subjective sense.

Recap

Don't worry. My head is spinning a tad as well. These can be tough concepts to figure out.

But let's recap.

The first aspect of *intellectual beauty*—*organization* and order—does not require a receiver, it has beauty inherent in its teleology, it's form and design; it's being; it is objective. The second aspect, *understanding*, does require a receiver; one to interpret based upon opinion, taste, emotion and judgment; it is subjective. But both aspects, *organization* and *understanding*, or form and function, are part of the broader teleological dimension.

53. Scruton, *Beauty*, 20.

Depending on one's worldview, *intellectual beauty* doesn't necessarily point to something beyond itself—such as beauty or God, having transcendent qualities (I argue it does, of course). It may or may not in the final analysis. But what *intellectual beauty* does entail is order and interpretation of the order; therefore, it has objective and subjective elements. Contrast this with *innate beauty*. *Innate beauty* is found in the object's existence, it's being, not the understanding of it's being.

As it relates to beauty, it seems to me that *innate beauty* qualifies beauty (provides an objective foundation), whereas *intellectual beauty* quantifies beauty (expands upon the foundation). In final analysis, *intellectual beauty* is beauty that accounts for order, design, and purpose and the apprehension of these qualities; it's judgment based upon an object's form.

Augustinian View of Art Appreciation

Before we move to immutable beauty, it's fair to ask: is there a better understanding of *intellectual beauty* that helps give direction to its appreciation of art, one connecting it to God? More so than simply an object has being and order? I think there is.

As I hinted at towards the beginning of this book, Augustine of Hippo's understanding of beauty provides a tantalizing clue: "The eyes delight in beautiful shapes of different sorts and bright and attractive colors." For Augustine, shape—a type of form (which includes color)—and the response to the shape (judgment and understanding) is what make something beautiful, causing an intellectual response— "delight." Of course, depending on the artistic medium, shape and color take on differing meanings, as in the case of music or dance; but shape and color are still there; all artistic mediums have an overall shape, form, and exude color, either realistically or metaphorically.

If we take Augustine's thoughts as a model (and as pointed out earlier in the book, it contains certain corollaries with Langer), the intellectual appreciation of beauty is based upon the form (objective) and response to the form (subjective), an appreciation for what the object is. On one hand, the form is inherently beautiful due to its being (innate), and on the other hand—through judgment and understanding of its shape—the form elicits both order and a response to the order (intelligence).

This is why in my definition of art I rendered it as *being engaged with form as enveloped in implication*. If an object has these simple characteristics—being, form, and potential response (judgement)—as part of its makeup, there is order and design, hence *intellectual beauty*, and this elicits a response.

So, one can welcome an object simply by liking the form, color, and shape of its form or medium. In relationship to art, a basic appreciation doesn't have to be objective (realism) or non-objective (abstract); classical music, pop, or folk music; square dance or ballet dance; Bauhaus or De Stijl architecture. All art is open for enjoyment based upon the simple criteria of its teleology: form, design, and purpose, leading to understanding (and hopefully delight and wonder). My advice: Delight in the foundational factors first—it's being and teleology, then be enamored by the loftier fabric of its place and meaning.

As an example, when you approach a Jackson Pollock (splatters of paint on a canvas), before you pass judgment on it—"I could do this in my sleep"—take in the shapes, appreciate the color, the lines, and the movement. Find a specific spot or dash of color, follow it until it dissipates into others. The same applies for Vermeer or a Vasquez: enjoy the color, the form, the lines, shape, and perspective. Then, if you're so inclined, look further for meaning and interpretation, symbolism, and connotations. Use both the objective sense and subjective sense of *intellectual beauty* when dealing with art. Soak it in and let it seep into your mind; become familiar with it. Learn the particular artwork's unique language, ponder its pronouncements. And off course, this leads to the transcendental aspects of beauty—meaning, awe, dealing, interest, and even discard or disdain.

And as reminded throughout the book: all art forms—at their base—proclaim the glory of God. Design connotes a Designer; form conveys a Form-maker; purpose suggests a Purpose; and intelligence infers Intelligence. So, humans—especially Christians—can delight in these things, both in the spirit of a scientist (studying the makeup, seeking its design, purpose, and unique form) and as an artist (rejoicing in its color, shape, uniqueness, and creative output). In the final assessment, when you enjoy being and teleology, you reveal in the Revealer.

IMMUTABLE BEAUTY (THEOLOGICAL)

I hope you're hanging in there. These concepts take time to comprehend. Taking something physical—such as an object (its being and teleology)—and trying to understand its broader relationship to beauty (understanding and judgment) takes some thought. And thought and ideas are non-physical, metaphysical ideas, though based in the physical, the brain. With this in mind (pun intended), it's to the purely non-physical side of beauty we now turn.

The third dimension of beauty is *immutable beauty*. Immutability is something that is not capable of change; it can't be modified; it transcends things. As Peter Kreeft reminded us at the beginning of the book regarding the transcendentals, attributes of God's nature, "we'll never get bored with [them], and never will, for all eternity, because they [truth, beauty, and goodness] are three attributes of God."[54]

Immutability derives from Latin, *immutabilis*. *Immutable* is immense, eternal, and constant. And paired with beauty, *immutable beauty* has both theological and philosophical overtones. Like the previous summaries on teleology, a tad more explanation is needed to unpack the particular definitions of theology and transcendence, relating them to immutability and beauty.

Theology

Theology is the study of God. And part of the study of God is the analysis of his character via the written text, the Bible (which is called theology proper), and nature (which is called natural theology). Part of theology proper is the study of God's attributes (qualities of his person). In theology proper there are non-moral attributes (things unique to God) and moral attributes (characteristics shared with creation). Immutability is a non-moral attribute of God. Only God can't change. Beauty is also an attribute of God, though an attribute shared with creation. When connected to God, beauty can't change; God's beauty is eternally consistent. But when connected to creation, it can change; hence, non-beautiful things (the absence of beauty).[55] But even in the changing nature of subjective beauty (a human evaluation of beauty), there is the presence of eternal, transcendent beauty.

When the two words are combined—*immutable beauty*—it is understood as the unchanging beauty of God; the eternal splendor of his being, the never-changing reality of his beauty within himself as reverberated in his created order. His immutability and beauty are all-encompassing in scope and extent. In other words, they exceed creation, but are echoed in creation. Or as Scruton suggests, there is a "there-ness"[56] of beauty in creation.

According to Dr. Norman Geisler, God's immutability is connected to pure actuality ("God has no potential to change"), simplicity ("there is no

54. Baggett et al., *C. S. Lewis as Philosopher*, 17.

55. Hildebrand would argue that "the opposite of beauty is not only an absence of beauty but also a pronounced disvalue, namely ugliness, that is something positively present" (*Aesthetics*, 76).

56. Scruton, *Beauty*, 60.

composition in God"; he is one), perfection ("God cannot acquire anything new"), infinity ("an infinite being cannot change"), and necessity (God is the Necessary Being, "changeless in His essential being.").[57] Immutability is encompassed in God's person; it is part of who he is, God is beautiful.[58]

Immutable beauty is beauty that surpasses the physical realm but is seized, grasped, within creation. Like a script written for a drama, God's beauty is conjoined within the words of the drama, or the notes in musical composition, in which all creation—from the cosmos to creatures—plays a role. And as stated multiple times in this book, immutable beauty points to the Beautiful One; Beauty that begets beauty. Carpenter, summarizing von Balthasar's view, renders it as such: "a complete transfiguration of existence and its transcendent end."[59]

Scruton likens the transcendental nature of beauty using art as an example: "Art, as we have known it, stands on the threshold of the transcendental. It points beyond this world of accidental and disconnected things to another realm, in which human life is endowed with an emotional logic that makes suffering noble and love worthwhile."[60]

Overall, beauty (not just art) does as well: it makes "suffering noble and love worthwhile." Theologian and scientist Alistair McGrath put it this way: "Beauty is not irrational, it's not rational, it's . . . trans-rational. As if it it's appealing to something deep within us, saying 'something is really significant here.'"[61]

And the response to the "significance" before a person elicits wonder, an awe-like experience. As Anne Carpenter reminds us: "Wonder is an expression of our transcendence and the mystery of being."[62] "We are capable of wonder because we have ends toward which we are drawn, and because we are fundamentally not-God."[63]

Beauty Circle

Think of *immutable beauty's* relationship to innate (being) and intelligent (teleology) beauty as three interrelated circles. In the center of the circle is a small circle, analogous to being. The second circle is intelligent beauty,

57. Geisler, *Systematic Theology*, 76–77.

58. See Geisler, *Systematic Theology*, 238–40.

59. Carpenter, *Theo-poetics*, 128.

60. Scruton, *Beauty,* 156.

61. McDermott, "Creation: Natural Theology," para. 39.

62. Carpenter, *Theo-poetics*, 93.

63. Carpenter, *Theo-poetics*, 93.

analogous to teleology—order, design, and understanding. The encompassing, outer circle is analogous of immutable beauty, that which is part of the others, but transcends the other circles.

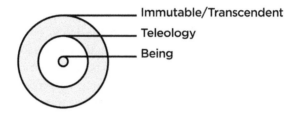

All three circles encompass beauty, but immutable beauty exceeds the others in that it is connected to a larger metaphysical truth, an illumination of the attribute of God's beauty (much like the natural laws that govern the universe, not seen, but present). Hans Urs von Balthasar renders it this way, "'Illumination' is at once the form itself and the splendor of that form, that splendor that draws the perceive to itself."[64] Immutability is resonated in the other regions (being and teleology), but transcended them as a distinct presence.

To connect *immutable beauty* to my understanding of *intellectual beauty*, think of it this way: *Intellectual beauty* hints—implies—at transcendent beauty but is not equal to the transcendent beauty.[65] Put theologically, beauty in creation reflects the beauty of the Creator, but is not the Creator.[66]

64. As summarized by Dr. Anne Carpenter in *Theo-Poetics*, 57.

65 According to the Oxford Dictionary, *transcendence* means "existence or experience beyond the normal physical level." And *transcendent* means "beyond or above the range of normal or merely physical human experience, and "surpassing the ordinary, exceptional." Something is transcendent when it transcends the physical realm; properties that are metaphysical. As we've seen, when applied to philosophy and theology, the transcendentals (unity, truth, beauty, and goodness) are properties that transcend the physical order, ideals that are co-extensive, corresponding to all existence (being), and exceptional in nature. Why? All four transcendentals, ultimately, apply to God; he is One, True, Beautiful, and Good.

66. In classical theology, this is the distinction between classical theism versus panenthism: God is not in creation but is reflected through creation.

Atmosphere in a Room

In trying to understand *immutable beauty*, think of this analogy:[67] atmosphere in a room.

Immutable beauty is like the atmosphere in a room, the unseen reality. In the room there are tables, chairs, a carpet, books, and such. All of these things have being. And because there's being, there is teleology, design, and order in the room (the chairs, carpet, books). But there are also things not seen, principles that govern the room, such as physical realities (molecules of oxygen, hydrogen, waves, radiation, etc.), and dare I say, metaphysical laws (principles of mathematics, thermodynamics, and gravity[68]). Immutable beauty is one of the metaphysical laws that govern the room. How? As pointed out throughout this book, there's a correspondence between being and beauty. If there is being, there is teleology, and therefore there is beauty—that which "shines out" being. And being necessitates a Necessary Being, namely God, and God is immutable.

Or return to one of Geisler's points: beauty has qualifiable attributes such as order, unity, and balance. And these characteristics are found in the room; therefore, *immutable beauty* is there as well. In the end, our brains register beauty, an unseen reality.

Going back to Hildebrand for a moment, the ideas found in his second power of beauty can be very helpful in connecting *innate* and *intelligent beauty* to *immutable beauty*. For Hildebrand, the second power of beauty encompasses levels of sublimity (which include intelligence), pointing to something beyond itself, a type of transcendence, capturing a deeper truth about the world, pointing to God. Hildebrand writes, "The beauty of the second power that is found in the visible and audible speaks of the world of God, the world above us."[69]

Expanding the Math Analogy

Earlier in the book I provided an analogy of mathematics, likening numbers (innate) to formulas or theorems (intelligent). If I were to expand this analogy, I'd liken *immutable beauty* to the laws that govern the universe, the reality numbers and formula try to describe. *Immutable beauty* is akin to the hidden fabric of the universe. *Immutable beauty* has this property

67. Like all analogies, they fall short at some point, but do help give a clear word picture to grasp a concept.

68. Natural laws, after all, are something, not nothing.

69. Hildebrand, *Aesthetics*, 213.

as well, it's a concealed reality, but revealed through being and teleology. As an attribute of God, it leaps over the physical, acting as a metaphysical law of existence, a concealed—but reverberated realty—much like gravity or quantum mechanics does in the physical realm. The immutable properties are there, we just can't see them. Rather, we experience the effects; the concealed is revealed in being, teleology, and physical existence. And like numbers are used to describe the laws via formulas and theorems, the laws transcend the numbers, or are enveloped in them; we only experience the effects of the unseen.[70]

Another analogy from physics is the rainbow. According to a science-trained theologian Kenneth Boa, "The rainbow of colors we see with our eyes represents only a tiny fraction of the whole spectrum of electromagnetic radiation. This spectrum begins with high-energy and high-frequency particle gamma rays, nuclear gamma rays, and x-rays; it moves through the middle range of ultraviolet to infrared wavelengths of light; and it ends with the lower-energy and lower-frequency range of microwaves, radio and TV communications, and sound waves. Just as the electromagnetic radiation that is visible to human eyesight is but a speck on a much larger spectrum, so human reason can perceive only a minute trace of the awesome mystery we call God."[71] The immutability of beauty is like this—we only experience some of its resonance, with a trail of colors leading back to God.

70. Another, less effective, analogy may help. Think of a person, let's say a woman, who has several relational characteristics: daughter, wife, mother. With this analogy, the woman's existence is akin to being; she lives; it is innate in that she is. *Teleological beauty* is recognized as her body with unique physical character in the world—her form; she's a woman. With *immutable beauty* the analogy connects to the physical-metaphysical qualities of her relation to her being and physical form, experienced in multiple ways: she's a daughter, a mother, a wife, she loves, has thoughts, ideas, and emotions; akin to her mind and soul. Though we joke at times when someone says, "Me, myself, and I," there is a tad of truth to this statement: an inner trinitarian nature of a person, including seen and unseen aspects: a person's existence, their teleology (physical makeup), and metaphysical concepts and relations. All aspects of person are wrapped up in a conjoined unity, with a foundation in being. The woman can be three things (or more) at once: she is, she acts according to her form, and she corresponds to others according to her experiences, relations, and thoughts. All aspects of personhood are found in her but are expressed in differing ways, and others can respond to her in a multitude of ways (as friend, child, etc.). So, too, with beauty: it has existence, is found and experienced in being and teleology, and has unseen qualities (immutability) that we see the effects of in the world via its relation to being and form, though leaping over both.

71. Boa, *Handbook to Spiritual Growth*, 158.

Being-Affected

Hildebrand positions the experience of beauty using the term "being-affect-ed." He writes, "But this being-affected is clearly distinct from the beauty of the object on the object side. It is ontologically and quantitatively very different from the beauty."[72] Meaning, the object (it's innate or intelligent order) is distinct from the broader reality of beauty (it's immutability). Hildebrand continues, "It is precisely this being-affected, that shows us how impossible it is to make beauty a product or a projection of the experience that beauty awakens in us, and that can be awakened only by beauty."[73] In other words, beauty is not conditioned to our response to it; rather, it is, an immutable value, concealed, yet revealed in many ways, whereby we are awakened to it. So, when a person is judging something, he or she is con-templating the objects' being and teleology, yes, but also beauty itself, the unseen immutable value, part of the fabric of the cosmos.

I'd argue that in order to recognize, innately, beauty, and to respond to it intelligently, we must realize that beauty is a reality to reckon with: that it is a quality, a value, a form, unto itself, much like love is a benevolent action and emotion unto itself; beauty moves beyond the being, to an immutable dimension. Beauty is, our brains know it, and the universe shows it.

Kick-back

Someone reading this may say to her or himself, *I get being and teleology as measurable factors of beauty, we can, after all, see, measure, hear, taste, these as something real. But why put in something that we can't see? How do we really know there is immutable, transcendent beauty? We can't prove it!*

Good questions. Though the first two are fairly measurable (under-standing or judgment can be tested via various cognitive assessments), im-mutability is measurable only in that it is experienced in thought, history, and as part of the human condition as an imprint, a function of the human mind and soul, releveling an emotional or intellectual response to it. We can only experience the effects of beauty.

Though we can't see beauty as a physical reality, we sure can see its in-fluence in art, music, math, language, nature, and culture . . . and on and on. Again, beauty is akin to the laws of nature: we can't see the laws, but we sure see the effects in reality. As an example, scientists can't totally answer the question of why an electron acts both as a wave and particle, but they know

72. Hildebrand, *Aesthetics*, 48.
73. Hildebrand, *Aesthetics*, 49.

electrons share these properties by the effects they exude, seemingly being in two places at one time.[74] Electrons, are, as scientists David Hutchings and David Wilkinson report, "undeniably there."[75] By analogy, I propose the same with beauty: we see the echoes of beauty in nature, culture, and the cosmos, an imprint upon reality; though we don't fully understand it's unseen reality, beauty is "undeniably there."[76]

This is why I relegate beauty analogously to natural law. Though we can't see the laws of physics, we can show them to be reliable via math (which, in its essence, math is also metaphysical). And though we can't see music, our minds process the waves via hearing and seeing notes on a score, responding to it accordingly. And though scientists are just learning how to measure beauty in a purely scientific fashion, one thing is clear: our minds and souls respond to beauty, showing that it is real.[77] And though beauty is real subjectively, I argue the objectivity of its presence is also real; it is something bound in being and teleology, but surpassing both as revealing that which is concealed. Afterall, if beauty wasn't real, if it didn't exist, we wouldn't be talking about it. Even non-real things such as a unicorn is real in that it is an idea, a metaphysical construction within our brain (see above summary of "mental being"). An idea has being, a type of existence.[78] Furthermore, beauty is universal in scope. All people experience beauty, either in the form of a desire for it, or integrating it within its particular culture or preferential sphere. Beauty is real: our brains know it, history shows it, and experience flows from it.

In the end, the three foundational dimensions of beauty (innate, intelligent, and immutable) are found in, derive from, and consumed in God, whom we can't see, but can experience. And as transcendent creatures, humans are aware of the realm of the transcendent in life.

Hans-Georg Gadamer reminds of the transcendent nature of beauty when he writes concerning the effect art has on a person: "The consistent reproduction [of an artform] . . . has been raised to ideality in our inner ear. . . . Why is this? Clearly we encounter once again that intellectual effort, that spiritual labor, that is rooted in all our so-called enjoyment of the work. The ideal creation only arises insofar as we ourselves actively transcend all

74. For a nice summary of this concept, see *God, Stephen Hawking and the Multiverse*, chapter 3.

75. Hutchings and Wilkinson, *God, Stephen Hawking and the Multiverse*, 43.

76. For more on this concept, see Hart, *Experience of God*, 87–94.

77. There is, however, cumulating work on the science of beauty. For an overview, see Landau, "Beholding Beauty."

78. See Clarke, *One and the Many*, 29–31.

contingent aspects."[79] In other words, someone touched by beauty has a transcendent moment, a moment of liberation.[80]

Karl Rahner puts it this way, "Whatever is expressed in art is a product of human transcendentally by which, as spiritual and free beings, we strive for the totality of all reality. . . . It is only because we are transcendental beings that art and theology can really exist."[81]

With immutable beauty we get a taste of why David Bentley Hart made his statement, beauty is "a category indispensable to Christian thought." Beauty is, being shines it, our brains refine it, and history helps define it.

Put It All Together

A quick summary of our thought thus far is helpful before we move along. *Immutable beauty* is beauty that points beyond itself. It rises to a level of otherworldliness, directing the viewer to something (in a Christian context, Someone) beyond the object and interpretation of the object. *Immutable beauty* is an unchanging characteristic, because God is unchanging. *Immutable beauty* carries specific metaphysical meaning, usually connected to other attributes of God. *Immutable beauty* transcends, but corresponds, to both *innate beauty* (being) and *intellectual beauty* (order and purpose), as the circle above demonstrates.

In a theist context, *immutable beauty* awakens the mind and soul to God. When one looks at a beautiful sunrise or stands at the edge of an ocean or views a beautiful painting or listens to a magnificent musical composition, he or she feels overwhelmed, and emotions of awe, wonder, and immensity can arise, causing the person to adulate. Even for an agnostic or atheist person, the beautiful can conjure delight, awe, and interest. In all cases, there is a reaction, a transcendent experience, usually of an emotive kind. *Immutable beauty* can bring a person to revere, a place of intimacy with creation and the Creator.

Put in a Christian context, during these moments where one connects with *immutable beauty*, one gives back to God what God has bestowed upon people—the beauty of himself; it is a circle of beauty. In the end, *immutable beauty* is objective in a metaphysical manner, reflected via correspondence with being, intelligence, and transcendence. But it outshines the objective in that it leads to wonder and awe, and, for the Christian, a type of worship; "for worship consists in delight over what it received and

79. Gadamer, *Relevance of the Beautiful*, 44.

80. Gadamer, *Relevance of the Beautiful*, 44.

81. Rahner, "Art Against the Horizon of Theology and Piety," 165.

perceives."[82] Carpenter, reflecting on Balthasar, says this about wonder and worship: "Though analogous, this saintly wonder is really worship. . . . By this very fact (this immutable fact that creation is *not God*), created being is ordered toward—made for, in tented for, finds its fulfillment in—worship."[83] But Carpenter clearly clarifies this distinction: "Worship is only possible if the real distinction between essence and existence is maintained,"[84] that is between the created being and God. God is not his creation (expect via Christ), but his beauty is, and humans respond to it.

BACK TO THE BANANA

Now, using these three dimensions of beauty, let's tackle "Comedian."

Innate (Being).

The first aspect of assessment is fairly easy to address. Does "Comedian" have being? The answer is yes; it is real in a purely physical sense. We can touch it, study it, and taste it—as artist David Datuna testified. Only the fallow of mind or those in denial of physical reality (a type of denialism, people who reject verified scientific fact) may try to argue it is not real. But photographs, observation, testing (Datuna ate the banana), and using the scientific method—if needed, can demonstrate that "Comedian" exists. There is a banana and duct tape. Period. And if it exists, it has being, and being has a basic form of beauty. Therefore, the first dimension of beauty shows that beauty is innate in it; it is. "Comedian" is beautiful in the most fundamental dimension.

Check one.

Intelligence (teleological).

The second question is fairly easy to grasp as well. Is there design, intention, and order to "Comedian?" The answer, again, is yes. Artist Maurizio Cattelan had an idea (intention, a form of intelligence) and ordered the idea accordingly (design and organization). So, the first aspect of intelligent beauty is a go—check. It has beauty through its construction, thought, and

82. Carpenter, *Theo-poetics*, 95.

83. Carpenter, *Theo-poetics*, 94.

84. This goes back to something mentioned in chapter 1: being as it relates to the difference between existence and essence.

design—albeit simple and somewhat tongue-in-cheek (but remember complexity and time should not be a factor in determining beauty).

But it's the second aspect of *intelligent beauty*—understanding—that causes one to pause: the judgement and appreciation of intelligent beauty. As noted above, this is where subjectivity enters the picture.[85]

When the second aspect of *intelligent beauty* is applied to "Comedian," one may not appreciate, like, or even consider "Comedian" art or beautiful. Yet, here's the reality: others do. What one thinks of the beauty of an object, however, does not negate the reality that "Comedian" has a sense of intention, order, and design. And the fact that "Comedian" causes one to think is testament to the point that it incorporates *intelligent beauty*; it elicits a response; it toys with the imagination and emotions; it calls one to form judgments and opinions. You may be the person that states, "I'd never pay $150,000 for a banana and duct tape! I don't even understand it!" That's fine, don't. But, obviously, others have dished out the cash. Why? They consider the piece noteworthy; it has, for them, intelligence manifest in its design and form, even if it's it kitschy, a product of the mind and will of an artist; it's a unique thought. And mind you, the people or organizations that paid the money did so largely as intellectual property. Meaning, it's not the object itself they purchased (the banana and duct tape), but the idea (the intangible concept) behind the "Comedian" that the purchase was made. After all, the banana will brown, and the tape will gradually unstick; "Comedian" won't last in physical form, only in metaphysical form (ideas).[86]

Go back to something I said at the beginning of this book: "contemporary . . . art is not so much about the creation or manipulation of material objects, but of the creation of ideas, original thought." What the art market is willing to pay for this idea fluctuates and is a world unto itself.[87] I personally wouldn't pay that type of money for "Comedian," but I understand (sort of) why others might. For one thing, the galleries that dished out the money have made up for the cost in international press. Someone may not like the art, but we can't argue that it has order and design, eliciting a response.

85. And please note: this area is metaphysical, involving ideas, imagination, nontangible concepts (opinion, taste, judgement, etc.); it is not necessarily physical (though ideas can take the form of physicality, as noted in the section of Aquinas).

86. Other artists throughout the ages have done similar things—John Cage's composition, *4' 33*—where no music was played at the piano for four minutes and thirty-three seconds—for example. Other than the performance and background sounds of the concert hall, *4'33* was a performance of an idea, as is all art ultimately is: ideas made manifest. In the end, all artwork is just ideas. Because all artwork will decompose according to thermodynamics.

87. For a study of the art world by a trained sociologist, I recommend Dr. Sarah Thorton's book *Seven Days in the Art World*.

Here it is in a nutshell: the teleology manifest in both aspects of intelligent beauty—order and understanding—demonstrates the broader point of *intelligent beauty* found in "Comedian;" it has both. And though one may not understand the piece in a direct way (it's meaning or purpose), one can understand that it has elicited response and reaction from intelligent people. Therefore, it fits the criteria for *intelligent beauty*. Some may not like this fact (subjectivity), but it does.

Up to this point, we've found that "Comedian" has *innate beauty* and *intelligent beauty*, fitting the first two dimensions. What about the final dimension, *immutable beauty*? The answer is simply complex, so hang on.

Immutable Beauty

Let me cut to the chase and state the obvious. If there is *innate beauty* and *intelligent beauty*, there must be *immutable beauty*. Remember: Beauty begets beauty. And since there are dimensions of beauty manifest in "Comedian" there must be *immutable beauty* as well. Think of the circle constructed above. *Immutable beauty* is all-encompassing, the atmosphere in the room. On a basic level, *immutable beauty* can be found in the object itself. So, yes, there is *immutable beauty* in "Comedian." Let's discover how.

First, in the banana, itself. The banana fits its form according to its nature, which is beautiful. It has (or had) a beautiful yellow color, and marvelous, natural curvature according to its form. Even if you don't like the color yellow or the banana shape, one should not deny its innate structure and teleology. When peeled (or chewed) it elicits sensations—maybe delight (if you like bananas) or disgust (if you dislike bananas); there's a smell, feel, and texture to the banana. Furthermore, the composition of the banana—its cellular structure, atomic makeup, and natural conformity to its design is a thing of beauty. It has intention, design, and purpose. And because of this, we find dimensions of the larger concept of beauty—immutability, a hint of the transcendent quality of something that pleases or delights the senses, it awakens us to something deeper, more complex. The banana and tape may be akin to the desk and chairs in a room, but the overall atmosphere points to something greater. Beauty is present.

And though not as flashy as the banana, the duct tape also has innate beauty: it is. It has color (gray), shape (elongated rectangular form), and purpose (used to stick things or hold things together). And if we delve into its cellular structure, we find the tape is more complex than we think. Again, there is *innate* and *intelligent beauty*, therefore there must be *immutable beauty*. Beauty is present.

Second, is the idea behind "Comedian," it's intellectual content. A human mind conceived the idea. And though simple, "Comedian" incorporates far reaching historical *connections* (yes, there is a history of bananas in art . . . à la Andy Warhol, as an example), *concepts* (Maurizio Cattelan is known for his satirical, off-beat art, pointing to other artists of the same ilk such as Marcel Duchamp[88]), and *comprehension* (how Maurizio Cattelan *conceived* the art as a reaction to the art world, if he did at all). In the end, there is beauty in "Comedian's" historical connections, imaginative concept, and conceptual content; it's creative. And all of these factors are transcendent rooted in ideas and thoughts, not physical reality. Hence, they reach towards the immutable. Again, beauty is present in the objects and ideas.

But before we leave this section, a final question should be asked, the hardest of the bunch: Does "Comedian" lead to deep wonder? For me, not so much. For others it might. For me "Comedian" doesn't lead to a transcendent, worship-like experience. For others it may. Maybe the environment one experiences could elicit wonder, but it's hard to say. I have not seen it in person.

But please note: just because it doesn't lead to wonder or a state of worship for me does not mean that it doesn't have a basic transcendental or immutable quality; it does. Others have been delighted by the tape and banana; it's been a source of pleasure, enjoyment, and perplexity.

Again, would I buy "Comedian" at $150,000? No. But I can't deny it has metaphysical meaning tying it to *immutable beauty*. I'll stress: don't let the subjective opinion of the banana or duct tape—or the concept behind the idea to construct them as art—taint the reality that there is beauty in its forms, *innate* and *intelligent*, therefore with *immutable beauty* encompassing both. There's much more to "Comedian" than meets the eye.

Influences on Beauty

Here's where it gets sticky, however. What I've argued up to this point is that beauty is largely non-hierarchical, it is based upon innate and intelligent beauty, being, order, judgement and understanding. What I'm about to propose may cause some to proclaim, "Hey, you do believe in "powers" of beauty, there are levels in your understanding! Something is more beautiful than something else, right?" "Come on," they continue, "you really don't believe 'Comedian' is as beautiful as Michelangelo's Sistine Chapel, do you?" To them, I'd say yes and no.

88. Marcel Duchamp (1887–1968). Dada artist and grandfather of conceptual art.

Let me tackle the *no* first. I don't believe in hierarchical beauty on purely ontological grounds, when it comes to the dimensions described above; all being, at its core, is beautiful (ultimately a gift from God), and therefore has innate, intelligent, and immutable beauty manifest in its form, as "Comedian" suggests. Even good that has turned evil or ugly (the opposition, or distortion, or devaluation, of the true, beauty, and good) has a root in being, and therefore had a base in beauty.

But on the other hand, I do think, for several reasons, there are varying weights—or influences—that make something appear more beautiful. I'm hesitant to call them *levels* or *powers*, so I prefer the term *influences*. These influences do affect our understanding of beauty. And taking the influences into consideration, one would say Western society does, indeed, find Michelangelo's Sistine Chapel of greater significance and, consequently, more beautiful, than Cattelan's "Comedian," at least at this point in history.

To unpack the influences is beyond the scope of this chapter. But suffice to say, the influences range from cultural/historical, personal, institutional, financial, and religious. Here are a few thoughts to ponder.

Influences

First, what a particular culture deems beautiful is an influence on how the society measures beauty (as referenced earlier). Some societies think neck rings are a sign of beauty (such as the Kayan people of Myanmar), where other cultures do not find this treatment as beautiful. Through a type of cultural osmosis, people are shaped by societal norms. This applies to fine arts and crafts as well, as the comparison between Michelangelo's Sistine Chapel and "Comedian" suggest. Western culture has valued Michelangelo's work as important, not so much with Cattelan's "Comedian," at least at this point. But with greater understanding, the norms may change. After all, many Americans hated jazz music—it was crude, disharmonious, some deemed evil music. And there still may be people out there that do hate jazz. But, generally, with greater knowledge comes respect and appreciation, seeing the beauty that is manifest in the form. Jazz is now a national treasure in the United States and parts of the world.

Second, personal taste. Think of the objective (realism) and non-objective (abstraction) debate described above between de Kooning and da Vinci. Is something that is rendered realistic more beautiful than an abstract work? Though the debate has cooled over the years, there still are people who think something that appears real (such as a landscape painting) is more beautiful than something that is not real (splashes of color and paint).

Of course, all art is only a representation of reality (photography included), so it's not real in concrete sense (a painting or a photograph of a tree is not a tree), but that doesn't stop people from chiming in with opinion. And they have the right to; that's part of *intellectual beauty*, of judgement. And, again, appreciation can change with deeper understanding, altering a particular vision of beauty. This is similar to what Bence Nanay calls "the mere exposure effect."[89] The *exposure effect* proports "the more you are exposed to something, the more you tend to like it. Just the mere exposure to something changes your preferences. . . . The mere exposure effect influences your liking of people, songs, colors, even paintings."[90]

Third, an "in the moment" encounter. For many, something is beautiful because she or he had an experience with it; it was beautiful in a moment of encounter. It's as Bence Nanay states, "Beauty is merely a placeholder for the character of our experience."[91] The experience provided an "aha" moment, eliciting awe or wonder. Maybe the moment shaped your perception of an object, only to find out when you return, your experience had changed, and the moment was not as beautiful. This is similar to our understanding of something as a child: A room looked huge when we were young, only to return as an adult and find that it isn't. An in-the-moment encounter affects how we experience beauty.

The same line of argument can be made with financial factors (what someone is willing to pay for artwork), thereby influencing it's worth and status in society. Finances do influence how people and culture weigh beauty. Something someone paid lots of money for has the tendency to grow in worth and respect, and, consequently, in the appropriation of being beautiful. "Comedian" is a case example of this point. I know I love to visit the Wikipedia page that lists the most expensive paintings. It's a marvel to compare and contrast them.[92] Most of the time I sit wide-eyed, mouth agape.

Closely tied to the financial aspects are the institutional portals: galleries, museums, and collectors, generally defined as the *art world*. Some art (think the *Mona Lisa* or works by Picasso or Andy Warhol) has assumed a large role in culture, affecting our lives on a daily level. These creations are considered important by institutions, and therefore grow in worth and alter our understanding of beauty. Formally, this type of influence is called the "Institutional theory." First proposed by George Dickey, the idea is that an institution sets the criteria for what is considered art. In essence, "Art is

89. Nanay, *Aesthetics*, 44.

90. Nanay, *Aesthetics*, 44.

91. Nanay, *Aesthetics*, 10.

92. Jacobs, "16 Most Expensive Paintings Ever."

what the artworld decides it is."[93] There's lots of problems with this theory, but many live by it.

I could go on.

Bottom line: Influences are a very real part of how people interpret and consider art and beauty, but they do not alter the basic reality of beauty: *innate* (being), *intelligence* (teleology), and *immutability* (transcendence).

So, yes, in all the above areas I would concur culture, institutions, finances, and personal preferences do influence a concept of beauty. I'm not sure if they are degrees or powers, but stimuluses on how we view understand beauty. And this applies to "Comedian." In some sectors (say, personal), it's a joke, thereby not beautiful; whereas in other sectors (say, financial/commercial), it's treated very seriously. The conception of beauty, its intrinsic worth, is influenced by outside factors. Given the importance of influences, there are gradations of beauty—all imposed upon the object or concept by outside forces. But as I stated, these influences do not affect the quantitative values of an object's worth; there is inherent beauty in and intelligent beauty, thereby having immutable beauty as well.

Judgement

The question arises, then: how does one judge if something is good or bad art? The question is tough. On one hand the judgment is personal (as Scruton described in his platitudes), on the other it's institutional (what the artworld states), and, yet another, cultural (what the culture defines as good). For Augustine, judgement may involve a grasp of the order of the object, how it relates to form, unity, numbers, and proportion.[94]

From a Biblical standpoint, beauty is that which is informed and infused by God: his Person, his handiwork, and his ordering of the cosmos. And as pointed out earlier, the ultimate standard of beauty is God in Christ.

From a theological standpoint, as robustly discussed, beauty is found in being, teleology, and immutability/transcendence.[95] But beyond this, I think the clearest way forward—in weighing judgement—is to ask a few questions:

One, does the art excel according to its form as the creator intended? Does it accomplish what it set out to do?

93. Graham, *Philosophy of the Arts*, 228.

94. See Beardsley, *Aesthetics*, 93–95,

95. Judgement—with the ideas of the beautiful and ugly, good and evil—have deep theological connotations. For von Hildebrand's understanding of the issue, see *Aesthetics*, 90–93. He would argue against a strict Thomist position.

Two, and specifically Christian, does the artwork expand on a notion of what is good, true, and beautiful? Does it adhere to a theistic rendering of reality? And if not, how does the challenge of the artwork strengthen a theistic worldview (as an example, a portrayal of something evil shows us there must be good)?

Three, does the art rise to a level of further thought and contemplation? Does it delight, challenge, and interest? Von Hildebrand touches on these last areas in chapter 12 of this book on aesthetics, calling ugliness, triviality, and boringness "the three antitheses to beauty."[96] And though one may not agree with all of his conclusions, they do act as a good springboard to discuss judgment in art.

And mind you, ugliness is not always a sign of non-beauty. Case in point: the death of Christ. Though horrific on many levels—particularly as it relates to the abuse of a human being (let alone God's Son), it does have beauty rising from the ashes. Daniel Siedell brings home this point when he insinuates that there is a correlation between Luther's "Theology of the Cross" and modern art: "a theology that experiences God in the suffering, evil, and ugliness that form each individual life experience."[97] So, even ugliness has *innate beauty*, latent and suppressed, but there. After all, Christ has being (or, rather, Being), and there was, and is, teleology to his person, teachings, and mission, therefore, there is beauty in his being, even in death.[98] And though the horrifying crucifixion marked his being, it did not modify his essence.[99] He is the Beautiful One. On this note, Umberto Eco points out that many medieval theologians went to great lengths "to show how, in the great symphony concert of cosmic harmony, monsters [ugliness] contribute, albeit purely by way of contrast . . . to the Beauty of the whole."[100]

Four, one can use some of the criteria discussed throughout this book to help frame beauty accordingly:

- Augustine: What is pleasing to the senses: "The eyes delight in beautiful shapes of different sorts and bright and attractive colors."

96. Hildebrand, *Aesthetics*, 261.

97. Siedell, *Who's Afraid of Modern Art?*, 101.

98. See Schmidt, *Scandalous Beauty*.

99. For more insight into this topic, see Mascall, *Whatever Happened to the Human Mind?*, 64–96.

100. Eco, *History of Beauty*, 147. Ugliness can be seen as the absence or contortion of beauty, the malice manipulation of form. Something ugly is usually understood to be unpleasant or disagreeable, a violence inflicted upon the object. Scruton would argue that not calling something ugly may "trivialize" the art (Picasso's *Guernica*, as an example), going against what the artist intended. See Scruton, *Beauty*, 107.

- Aquinas: integrity, proportion, clarity, and form.

- Terry Barrett. The assessment of "subject matter + medium + form + context = meaning."

- Five, do you like it? If so, ask yourself why? What attracts you to it? If you don't like it, why not? What about it doesn't appeal to you? And then try to understand the ground in between the two: like and dislike. In all, seek to understand.

Going back to something I mentioned at the beginning of this book. Let's say you are decorating a room in your house or apartment. Chances are, you'll probably use an assortment of these judgments. With Augustine, you pick something that is pleasing to your senses: attractive colors and wonderful shapes. With Aquinas, you look for order, proportion, and how it looks as a whole within the room. With Barrett, you choose something meaningful to you, and how that meaning is related to the context and form of what you chose. Now, you may not realize you're doing all of this, but you just may be.

Whatever method one uses to judge art, one must remember that a big part of the judging is the allotted time one affords to the experience, an increase in understanding towards the object or medium.[101] Judgment is a matter of taste, but taste based upon objective reality (being and teleology). Even the process of determining what one likes requires intelligence, pointing towards being (an object to like) and immutability (the fact that there is something one appreciates—beauty—at all).

In the end, the judgment of what one considers beautiful is very personal and subjective. But remember, this does not take away the objectivity of beauty—it's *innate, intelligent,* and *immutable* properties.[102]

Let me state the obvious: What is presented above are emblems, not edicts. Judgment ranges from that which pleases us to that which perturbs us—and everything in between. There is no fixed standard of judgment from an aesthetics vantage point; it's neutral in this sense. Contrast this with Christian ethics, where a moral standard of judgment from a Biblical standpoint is engaged. The best one can do in judging an object is envision the object in which beauty embodies.[103]

101. See Nanay, *Aesthetics*, chapter 5, for more insight.

102. In the end, judgement is not the focus of this introductory book. To gain a better understanding of judgment, read or reference the various books discussed within this volume, from Kant to Scruton, from Barrett to Graham.

103. Scruton positions it as thus: "In the last analysis there is as much objectivity in our judgments of beauty as there is on our judgments of virtue and vice. Beauty is therefore as firmly rooted in the scheme of things as goodness" (*Beauty*, 123).

Art Recap

A quick recap. The fact that art has being (it is) and teleology (order and form) showcases its immutable beauty. But how does its beauty engage with its form and communicate its meaning, and thereby envelop the receptor with interest, awe, or surprise? In the end, the deepest forms of art inspire transcendence, what I constructed from von Hildebrand's second power, a saintly level. And let me stress, the innate or intelligence factors within the object does not stop the object from having transcendent beauty; transcendent beauty is real regardless of the object or the mind. It's as Hildebrand states, "The value character of beauty as such is completely independent of whether the bearer of beauty presupposes a human mind or exists independently of such a mind. Beauty does not cease to be a genuine value."[104] In final analysis, beauty is actual regardless of being and teleological factors; there is something deeper going-on within beauties manifestation, as Christ is the prime example.

But the transcendent wonder of beauty leads us to the last point.

Within Beauty

And it's with the last point, religion—or faith—that I must pause. Why?

Because at his highest level of influence—spiritual, or religious—beauty does appear to take on deeper meaning, a step or degree above the others. And this is largely found in the assimilation of immutable beauty *within* a transcendent experience between the person and beauty. *Within* is the keyword.

Here are a few examples to ponder:

- Handel's *Messiah* moving a person to tears based upon the correspondence of *innate, intelligent,* and *immutable* beauty to the person's understanding of the historicity of Christ's passion. He or she is moved in faith (confidence, trust) based upon the composition; the person is drawn to and *within* the beauty.

- Someone sees a particular painting or natural landscape (ocean, mountains, etc.) that causes deep emotional enlightenment. Again, there is a correspondence between the interpretation of the beauty of the object and the person's emotional and spiritual confidence *within* the moment.

104. Hildebrand, *Aesthetics*, 58.

- Or maybe worship music. Music can move people, increasing faith. This is why most of the religions of the world—and humanity in general—incorporates music *within* its religious sphere; beauty primes the pump towards worship, providing a *within* experience between the person and God.

- And then there's the icons of Orthodoxy, Catholicism, some Protestants (and other religions of the world, for that matter). Their understanding of the icon is akin to a window to heaven, reminding the viewer of heavenly, metaphysical, reality. The painting (icon) enlarges the person's faith *within* the sphere of heavenly actuality.

I could go on and on with examples. But my point is that there does appear to be at least one degree—or power—of beauty that is able to pull the person up to a level of deep significance. I think this is what Hildebrand was getting at in his last power, the spiritual, and Balthasar calls *saintly*. My only guess is that it is during these moments of interwoven beauty where characteristics of God are more real and relevant to the person and the beauty of the moment and object (composition, painting, experience, etc.) embraces the immutable beauty of God; where the beauty that is manifest in God meets the person where she or he is at, a *within* beauty experience; the intersection of two wills, where God and the person kiss, and beauty is the lips. This experience is akin to the radial line of two circles, as this Venn diagram illustrates.

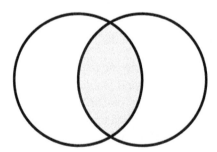

Wonder, worship, and awe ensue.

It's as Hans Urs von Balthasar states, "Before the beautiful—no, not really *before* but *within* the beautiful—the whole person quivers. He not only 'finds' the beautiful moving; rather, he experiences himself as being moved and possessed by it."

Come to think of it, this is much of what God did in Jesus Christ. But this is for another tale, a narrative of the incarnation of the Beautiful One, Jesus, the God-man engulfed in beauty, where the earthy and the eternal kiss.[105]

In the end, the *within* experience is where beauty points to, then draws in, and finally pulls one up to the Beautiful One.[106]

Beautiful Axioms

For now, I conclude with summary axioms, akin to Hart's "thematics" or Scrutin's "platitudes."

- Beauty is objective, real in both the physical and metaphysical realms.

- Beauty is natural and supernatural (metaphysical), found in the sphere of being/existence through creation, natural laws, values, ideas, and imagination.

- Beauty is historical. There is a long lineage of people and cultures thinking about, assimilating, and creating beautiful objects and ideas.

- Beauty is biblical. The Bible paints a picture of God, as Creator, either implied or rendered, that is beautiful and accounts for beauty in the world: God's thoughts made visible.

- Beauty is manifest in dimensions: innate (being, ontological), intelligent (teleological, with order and understanding), and immutable (theological and transcendent, never changing).

- Beauty has subtleties, both *fierce* (harsh, intense, awe-inspiring) and *fetching* (lovely, alluring, and becoming).

105. To delve into the concept of Christ as the Beauty of God, I'd suggest some works by Hans Urs von Balthasar. His massive *Theological Aesthetics* (fifteen volumes) is a good place to start. Or get the summation of Balthasar's thought in Anne M. Carpenter's *Theo-Poetics: Hans Urs Von Balthasar and the Risk of Art and Being*.

106. To help clarify the difference between the shining-out aspect of beauty discussed in the introduction (an emanation or reflection of God's beauty) and the "within" experience described here, a quick word is in store.

With the "shining-out" aspect of beauty the exchange is between the object and perceiver. It is beautiful based upon the object's being and form and someone recognizing its being and form as beautiful, a unilateral exchange between the object and perceiver. Whereas the "within" experience is closer to a participation in the beauty, an experience of God's presence through the transcendent nature of beauty: the parts-to-Whole, beauty-to-Beauty, microcosm to Macrocosm. In this way, beauty, the experience thereof, exemplifies an Ultimate reality, namely God.

- Beauty has influences on its meaning, largely subjective, that help determine the objects worth personally, culturally, institutionally, or financially.

- Beauty can engender a "within" experience, elevating a person to communion on an immutable level, bringing us closer to God.

EPILOGUE

You made it. Congrats. Not that everything presented is crystal clear; there's always room for improvement in one's thoughts. But what was positioned provides a foundational understanding of the basic building blocks of beauty, as least from an objectivist position. And let me be upfront. Not everyone will agree with my conclusions; many in the academic world do not see beauty as immutable or objective, as an example. Even within Christian circles there is a disagreement on beauty's relationship to being. As I pointed out in the footnotes, von Hildebrand and von Balthasar would not agree on the complete correlation to being. But both would bend over backwards to stress beauty is objective. And then there's the idea of levels or powers to beauty; both von Hildebrand and von Balthasar have inherent hierarchy, and to a certain extent, so do I, but not to the level of both men. And though I recognize a hierarchy to existence—let's say the complexity difference between a barnacle and a brain—I didn't want to unpack all the various nuances of this train of thought. Others have done it much better than I could. In the end, maybe Anne Carpenter is right: "A hierarchy is an attempt to understand *rightly*."[107] Aesthetics and beauty are an immense fields, with ongoing research happening around the world. And of course, there's the difference of opinion within Theo-poetic studies. Many in the First school would frown upon my heightened use of metaphysics but may enjoy my correlation to art or poetry. And within the Classical camp, they may think I didn't do enough justice to the integration of language or Christology. I think they'd all be correct. But again, this is book is on the fundamental factors of beauty, not a forest of illuminating Theo-poetic facts. I'd recommend you read all the books footnoted in this work to get the full picture. It's a journey worth taking.

107. Carpenter, *Theo-poetics*, 149.

To Have Known Beauty

To conclude, I leave you with a stanza of a poem. While visiting the cabin home of artist Maynard Dixon[108] (and later, artist Milford Zornes[109]) in Mount Carmel, Utah, various poems by Dixon were spread throughout the house, placed in small frames for refection. One poem sat upon a desk at the base of a window looking out to trees, fauna, and a surrounding, moat-like, acequia, gushing water. The poem is entitled *Toward Beauty*. It was written circa 1913. My wife, Melanie, read the poem as I stared upon the landscape, my mind pondering its sentiment. The poem encapsulates all foundational aspects of beauty, from the recognition of nature's being to particular forms and organization of being (air, rock, leaves, sun, etc.), to the transcendence of understanding, contemplation and prayer. It's all there. And hidden beneath the being and form are theological underpinnings, connecting beauty to glory (notice Dixon capitalized the "B"). And the fact that the poem was written by an artist, affords it weight.

The first stanza, not printed below, is a consideration on hard work, the toil of life. But in the last stanza (below), Dixon comments on contemplation and beauty, the need for reflection.

The last stanza reads:

There comes a time
When an invading stillness of the air
Bids him take respite, warms him to review
The unbelievable procession of mankind
Moving across his yes, distinct and small,
Merely a border-pattern upon space;
To note the slanted shadow of a rock,
The quiet drift of ceremonial spoke,
The last wild flare of autumn leafage,
The inevitable downward course of sun
Where satisfaction;
When contemplation so becomes a prayer
That simply to have known Beauty
Were itself a glory.

108. Dixon was born in 1875 in Freson, California. He died in 1946 in Tucson, Arizona. His second wife was famed photographer Dorothea Lange.

109. Noted California painter, Milford Zornes, was born in 1908 outside Camargo, Oklahoma. He died in 2008 in Claremont, California. I was honored to meet Zornes before his passing and attended his one hundredth birthday party per the request of his biographer, Gordon McClelland.

Dixon hits upon the weight of beauty wonderfully—"When contemplation so becomes a prayer/That simply to have known Beauty/Were itself a glory." In the poem we find innate, intelligent, and immutable beauty. Beauty is alive in well in the world, Dixon's world in particular.

Or maybe the eternal nature of beauty is as simple as Scottish American naturalist, writer, and defender of the wild, John Muir, states. While noting that nothing in nature is wasted, Muir poses: "It is eternally flowing from use to use, beauty to yet higher beauty."[110] Nothing is wasted in God's economy, and each in its own way points to something grander than itself. Beauty—like God—is eternal, because God is beautiful. In the end, being, form, understanding and transcendence is beauty flowing to "yet higher beauty"; beauty points to the Beautiful One.

Beauty Has a Name

As I began the work commenting on the pain of a pandemic, I conclude with a poem touching on the same topic, finding beauty in the midst of brutality. My first grandchild, Abraham, was born during the pandemic and the writing of this book. He's a wonder. And as I thought about his future while walking on a hot summer day in July, these words came out:

ON YOUR ARRIVAL

"Go from your country . . . to the land I will show you." —Gen 12:1

> It's hot outside.
> Clouds cover a parched earth.
> Cars drive by.
> Women wear masks.
> Men lie wearily in beds.
>
> The world is afloat in panic.
> There's a sparrow on a branch.
> A cricket is chirping; a crow, calling.
> Lines of cars wait by a tent,
> the only solace found in fear.
>
> Here, child, you were born;
> in the midst of a pandemic, a life

110. Muir, *Spiritual Writings*, 24. Muir was not a pantheist, but rather had an elevated understanding of God's imprint upon the cosmos.

of grace birthed in sorrow.
How can I tell you tomorrow
will be ok?

When today seems like a raging
fire? I can only say this: find the
country, a place where love exists,
a splendor found in the crucible,
an echo within an ache.

Putting this aside for now:

Here, in this moment, I give you
all of my sentiment and more.
I ponder your gentle frame.
Yes, my child,
beauty has a name.

Bibliography

Alves, Rubem. *Transparencies of Eternity*. Miami, FL: Convivium, 2010.

Aquinas, Thomas. *An Introduction to the Metaphysics of St. Thomas Aquinas*. Edited by James F. Anderson. Washington, DC: Regnery, 1977.

———. *Introduction to St. Thomas Aquinas*. New York: Modern Library College, McGraw Hill, 1948.

———. *The Pocket Aquinas*. Translated by Vernon J. Bourke. 4th ed. New York: Washington Square, 1965.

———. *Summa of the Summa*. Edited by Peter Kreeft. San Francisco: Ignatius, 1990.

Aristotle. *Metaphysics*. http://www.perseus.tufts.edu/hopper/text?doc=Perseus:text:1999 .01.0052.

———. *Nicomachean Ethics*. Edited by Robert Maynard Hutchins. http://www.perseus. tufts.edu/hopper/text?doc=Perseus%3Atext%3A1999.01.0054%3Abekker+page %3D1140a.

———. *Poetics*. Translated by S. H Butcher. http://classics.mit.edu/Aristotle/poetics .1.1.html.

The Art Assignment. Season 6, episode 19, "The $150,000 Banana." Aired January 21, 2020, on PBS. https://www.pbs.org/video/the-150000-banana-1di9km/.

Augustine of Hippo. *The Confessions of St. Augustine*. Translated by E. B. Pusey. New York: Barnes & Noble, 2003.

Balthasar, Hans Urs von. *Cosmic Liturgy: The Universe According to Maximus the Confessor*. San Francisco: Ignatius, 2003.

———. *Glory of the Lord*. San Francisco: Ignatius, 2000.

———. *Truth Is Symphonic*. San Francisco: Ignatius, 1987.

———. *Truth of the World*. San Francisco: Ignatius, 2000.

Baggett, David, et al. *C. S. Lewis as Philosopher: Truth, Goodness, and Beauty*. Lynchburg, VA: Liberty University Press, 2017.

Barrett, Terry. *Interpreting Art: Reflecting, Wondering, and Responding*. Boston: McGraw Hill, 2003.

Barth, Karl. *Church Dogmatics* II/1. Peabody, MA: Hendrickson, 2010.

Beardsley, Monroe C. *Aesthetics: From Classical Greece to the Present.* Tuscaloosa, AL: University of Alabama Press, 1966.

Beech, David, ed. *Beauty: Documents of Contemporary Art.* Cambridge, MA: The MIT Press, 2009.

Begbie, Jeremy. *A Peculiar Orthodoxy: Reflections on Theology and the Arts.* Grand Rapids, MI: Baker Academic, 2018.

———. *Redeeming Transcendence in the Arts: Bearing Witness to the Triune God.* Grand Rapids, MI: Eerdmans, 2018.

Boa, Kenneth. *Handbook to Spiritual Growth: Twelve Facts of the Spiritual Life.* Atlanta, GA: Trinity, 2008.

Braude-Spragg, Stacia. *To Walk in Beauty: A Navajo Family's Journey Home.* Santa Fe, NM: Museum of New Mexico, 2009.

Bredin, Hugh, and Liberato Santoro-Brienza. *Philosophies of Art and Beauty.* Edinburg, Scotland: Edinburgh University Press, 2000.

Brooks, Cleanth. *The Well Wrought Urn: Studies in the Structure of Poetry.* New York: Harcourt, 1970.

Brown, David. *God and Grace of Body: Sacrament in Ordinary.* Oxford: Oxford University Press, 2007.

Bukowski, Charles. *On Writing.* New York: Ecco, 2015.

Burke, Edmund. *On the Sublime and Beautiful.* New York, Routledge Classics, 2008.

Bychkov, Oleg, and James Foder. *Theological Aesthetics After Von Balthasar.* London: Routledge, 2008.

Caldecott, Stratford. *Beauty for Truth's Sake: On the Re-enchantment of Education.* Grand Rapics, MI: Brazos, 2009.

———. *Beauty in the Word: Rethinking the Foundations of Education.* Tacoma, WA: Angelico, 2012.

Carpenter, Anne M. *Theo-poetics: Hans Urs Von Balthasar and the Risk of Art and Being.* Notre Dame, IN: University of Notre Dame Press, 2015.

Carron, Julian. *Disarming Beauty.* Notre Dame, IN: University of Notre Dame Press, 2017.

Clarke, W. Norris. *Explorations in Metaphysics: Being, God, Person.* Notre Dame, IN: University of Notre Dame Press, 1994.

———. *The One and the Many: A Contemporary Thomistic Metaphysics.* Notre Dame IN: University of Notre Dame Press, 2001.

Corrigan, Kevin, and Michael Harrington. "Pseudo-Dionysius the Areopagite." *Stanford Encyclopedia of Philosophy.* Edited by Edward N. Zalta. April 30, 2019. https://plato.stanford.edu/entries/pseudo-dionysius-areopagite/.

Croce, Benedetto. *Guide to Aesthetics.* Indianapolis, IN: Hackett, 1995.

———. *Aesthetic as Science of Expression.* N.p.: Neeland Media, 2004. Kindle ed.

Crosby, John. *Handbook of Phenomenological Aesthetics.* Edited by Hans Rainer Sepp and Lester Embree. New York: Springer, 2010. https://download.e-bookshelf.de/download/0000/0727/02/L-G-0000072702-0002380485.pdf.

Curran, Angela. "Aristotle." In *Aesthetics: Key Thinkers*, edited by Alessandro Giovannelli, 21–33. London: Continuum, 2012.

Dostoevsky, Fyodor. *The Idiot.* Translated by Richard Pevear and Larissa Volokhonsky. New York: Vintage, 2001.

Drake, Robert S. "Walk in Beauty: Prayer From the Navajo People." https://talking-feather.com/home/walk-in-beauty-prayer-from-navajo-blessing.

Eco, Umberto. *The Aesthetics of Thomas Aquinas*. Cambridge, MA: Harvard University Press, 1988.

———. *History of Beauty*. New York: Rizzoli, 2004.

Edwards, Jonathan. *The Nature of True Virtue: A Jonathan Edwards Reader*. Edited by John E. Smith et al. London: Yale University Press, 1995.

Eller, Vernard. *The Most Revealing Book of the Bible*. Grand Rapids, MI: Eerdmans, 1974.

Episcopal Church. *The Book of Common Prayer*. Oxford: Oxford University Press, 2007.

Etymology Dictionary. "Yahweh." https://www.etymonline.com/word/yahweh.

Evdokimov, Paul. *The Art of the Icon: A Theology of Beauty*. Translated by Fr. Steven Bigham. Pasadena, CA: Oakwood, 1989. Kindle ed.

Farrer, Austin. *The Glass of Vision*. Westminster, UK: Dacre/Andesite Press, 2015.

Gadamer, Hans-Georg. *The Relevance of the Beautiful and Other Essays*. Cambridge: Cambridge University Press, 1998.

Garfagnini, Gian Carlo. "Medieval Aesthetics." In *Aesthetics: Key Thinkers*, edited by Alessandro Giovannelli, 34–47. London: Continuum, 2012.

Gayford, Martin. *The Pursuit of Art: Travels, Encounters and Revelations*. New York: Thames & Hudson, 2019.

Geisler, Norman. *God: A Philosophical Argument From Being*. Matthews, NC: Bastion, 2015. Kindle ed.

———. *Systematic Theology: Volume 2*. Minneapolis, MN: Bethany, 2003.

———. *Thomas Aquinas: An Evangelical Appraisal*. Eugene, OR: Wipf & Stock, 1991.

Geisler, Norman, and Paul D. Feinberg. *Introduction to Philosophy: A Christian Perspective*. Grand Rapids, MI: Baker Academic, 1980.

Geisler, Norman, and William Nix. *From God to Us: How We Got Our Bible*. Chicago: Moody Press, 1974.

Gilson, Etienne. *The Arts of the Beautiful*. New York: Charles, 1965.

———. *Being and Some Philosophers*. Toronto, Canada: Pontifical Institute of Medieval Studies, 1952.

———. *Forms and Substances in the Arts*. Chicago: Dalkey Archive, 2001.

———. *Methodical Realism*. San Francisco: Ignatius, 1990.

Ginsborg, Hannah. "Kant's *Aesthetics and Teleology*." *Stanford Encyclopedia of Philosophy*. Edited by by Edward N. Zalta. February 13, 2013. https://plato.stanford.edu/entries/kant-aesthetics/.

Giovannelli, Alessandro, ed. *Aesthetics: Key Thinkers*. London: Continuum, 2012.

Goldman, Alan H. "David Hume." In *Aesthetics: Key Thinkers*, edited by Alessandro Giovannelli, 48–60. London: Continuum, 2012.

Gonzalez-Andrieu, Cecila. *Bridge to Wonder: Art as A Gospel of Beauty*. Waco, TX: Baylor University Press, 2012.

Graham, Gordon. *Philosophy of the Arts*. London: Routledge, 2005.

———. *Re-enchantment of the World: Art versus Religion*. Oxford: Oxford University Press, 2010.

Green, Garrett. *Imagining God: Theology and the Religious Imagination*. New York: Harper & Row, 1989.

Hammermeister, Kai. "What's New in Aesthetics." *Philosophy Now*, Summer 1999. https://philosophynow.org/issues/24/Whats_New_in_Aesthetics.

Harris, Kevin. "Questions from Facebook, Part Two." *Reasonable Faith* (podcast), July 1, 2018. https://www.reasonablefaith.org/media/reasonable-faith-podcast/questions-from-facebook-part-two/.

Hart, David Bentley. *The Aesthetics of Christian Truth*. Grand Rapids, MI: Eerdmans, 2003.

———. *The Beauty of the Infinite: The Aesthetics of Christian Truth*. Grand Rapids, MI: Eerdmans, 2003.

———. *The Experience of God: Being, Consciousness, Bliss*. New Haven, CT: Yale University Press, 2013.

Hawthorne, Nathaniel. *The Artist of the Beautiful*. 1846. Good Readings. N.p.: Goodreads, n.d. Kindle ed.

Heidegger, Martin. "On the Origin of the Work of Art." In *Basic Writings*, edited by David Farrell Krell, 139–212. Harper Perennial Modern Thought. London, Harper Perennial, 2008.

Hildebrand, Dietrich von. *Aesthetics: Volume 1*. Steubenville, OH: The Hildebrand Project, 2016.

———. *Beauty in the Light of the Redemption*. Steubenville, OH: The Hildebrand Project, 2019.

Holland, Scott. "Theopoetics Is the Rage." *The Conrad Grebel Review* 31.2 (Spring 2013). https://uwaterloo.ca/grebel/publications/conrad-grebel-review/issues/spring-2013/theopoetics-rage.

———. "So Many Good Voices in My Head." *CrossCurrents* 49.1 (Spring 1999) 72–83.

———. "From Theo-logics to Theopoetics," *Messenger Magazine*, April 2017.

Hopkins, Gerard Manley. *The Gospel in Gerard Manley Hopkins*. Edited by Margaret R. Ellsberg. Walden, NY: Plough, 2017.

Hume, David. "Of the Standard of Taste." https://bradleymurray.ca/texts/david-hume-of-the-standard-of-taste-pdf.pdf.

Hutcheson, Francis. *An Inquiry into the Original of Our Ideas of Beauty and Virtue*. Royal Collection Trust. https://www.rct.uk/collection/1121079/an-inquiry-into-the-original-of-our-ideas-of-beauty-and-virtue-in-two-treatises-i.

Hutchings, David, and David Wilkinson. *God, Stephen Hawking and the Multiverse: What Hawking Said and Why It Matters*. London: SPCK, 2020.

Hutchins, Robert Maynard, ed. *Great Books of the Western World*. Vol. 7, *Plato*. 2nd ed. Chicago: Encyclopedia Britannica, 1952.

———. *Great Books of the Western World*, Vol. 8, *Aristotle*. 2nd ed. Chicago: Encyclopedia Britannica, 1952.

———. *Great Books of the Western World*, Vol. 9, *Aristotle*. 2nd ed. Chicago: Encyclopedia Britannica, 1952.

———. *Great Books of the Western World*. Vol. 17, *Plotinus*. 2nd ed. Chicago: Encyclopedia Britannica, INC., 1952.

———. *Great Books of the Western World*. Vol. 18, *Augustine*. 2nd ed. Chicago: Encyclopedia Britannica, 1952.

———. *Great Books of the Western World*. Vol. 19, *Thomas Aquinas*. 2nd ed. Chicago: Encyclopedia Britannica, 1952.

———. *Great Books of the Western World*, Vol. 20, *Thomas Aquinas*. 2nd ed. Chicago: Encyclopedia Britannica, 1952.

Inwagen, Peter van. *Metaphysics*. Boulder, CO: Westview, 2015.

Jacobs, Sarah. "The 16 Most Expensive Paintings Ever." *Business Insider*, May 15th, 2019. https://www.businessinsider.co.za/most-expensive-paintings-ever-sold-including-157-million-nude-modigliani-2018-5.

Jenkins, Scott. "Arthur Schopenhauer and Friedrich Nietzsche." In *Aesthetics: Key Thinkers*, edited by Alessandro Giovannelli, 86–99. London: Continuum, 2012.

Jiang, Cheng, and Zong-Qi Cai. "Aesthetics." https://www.oxfordbibliographies.com/view/document/obo-9780199920082/obo-9780199920082-0160.xml.

Kalar, Brent. *The Demands of Taste in Kant's Aesthetics*. London: Continuum International, 2006.

Kant, Immanuel. *Classic Collection on Critique of Pure Reason, Judgement, and Practical Reason*. N.p.: Wealth of Nations, 2010. Kindle ed.

Keefe-Perry, L. Callid. *Way to Water: A Theopoetics Primer*. Eugene, OR: Cascade, 2014.

Krabbe, Silas C. *A Beautiful Bricolage: Theopoetis as God-Talk For Our Time*. Eugene, OR: Wipf & Stock, 2016.

Landau, Elizabeth. "Beholding Beauty: How It's Been Studied." *CNN Health*, March 3, 2012. https://www.cnn.com/2012/03/02/health/mental-health/beauty-brain-research/index.html.

Loughnane, Adam. "Japanese Aesthetics." *Stanford Encyclopedia of Philosophy*. Edited by Edward N. Zalta. December 12, 2005. https://plato.stanford.edu/entries/japanese-aesthetics/.

Malpas, Jeff. "Hans-Goerg Gadamer." *Stanford Encyclopedia of Philosophy*. Edited by Edward N. Zalta. September 17, 2018. https://plato.stanford.edu/entries/gadamer/.

Mascall, E. L. *Whatever Happened to the Human Mind? Essays in Christian Orthodoxy*. London: SPCK, 1980.

Maritain, Jacques. *Art and Scholasticism with Other Essays*. Minneapolis, MN: Filiquarian, 2007.

McDermott, Gerald. "Creation: Natural Theology." *Via Media* (podcast), February 26, 2020. https://www.beesondivinity.com/the-institute-of-anglican-studies/podcast/2020/transcripts/Alister-McGrath-Natural-Theology-Transcript.txt.

McGrath, Alister. *Born to Wonder: Exploring our Deepest Questions—Why Are We Here and Why Does It Matter?* Carol Stream, IL: Tyndale Momentum, 2020.

———. *The Open Secret: A New Vision for Natural Theology*. London: Wiley-Blackwell, 2008.

Miller, David L. *Hells and Holy Ghosts: A Theopoetics of Christian Belief*. Nashville, TN: Abingdon, 1989.

Moss, Stanley. *Act V, Scene 1: Poems*. New York: Seven Stories, 2020.

Muir, John. *Spiritual Writings*. Edited by Tim Flinders. Maryknoll, NY: Orbis, 2013.

Nanay, Bence. *Aesthetics: A Very Short Introduction*. Oxford: Oxford University Press, 2019.

Nietzsche, Fredrich. *The Birth of Tragedy, or Hellenism and Pessimism*. Translated by W. M. A. Haussmann. https://www.gutenberg.org/files/51356/51356-h/51356-h.htm.

Nixon, Brian C. *Called To Be an Artist*. Albuquerque, NM: Connection Communications, 2013.

———. "eBay, Vernard Eller, and the Promise." *The Sloppy Noodle*, November 6th, 2012. http://www.sloppynoodle.com/wp/ebay-vernard-eller-and-the-promise/.

———. *The Master Teacher: Developing a Christ-based Philosophy of Education*. Costa Mesa, CA: Calvary Chapel, 2007.

———. *Tilt: Finding Christ in Culture*. Eugene, OR: Cascade, 2020.

O'Neill, Eugene. *Four Plays By Eugene O'Neill*. Lawrence, MA: Digireads, 2009. Kindle ed.

Owens, Joseph. *An Elementary Christian Metaphysics*. Houston, TX: University of St. Thomas Press, 1985.

Palmer, Richard. *Hermeneutics: Interpretation Theory in Schleiermacher, Dilthey, Heidegger, and Gadamer*. Evanston, IL: Northwestern University Press, 1969.

Pappas, Nickolas. "Plato's Aesthetics." *Stanford Encyclopedia of Philosophy*. Edited by Edward N. Zalta. June 27, 2008. https://plato.stanford.edu/entries/plato-aesthetics/.

Pelikan, Jaroslav. *Fools For Christ: Essays on the True, the Good, and the Beautiful*. Philadelphia: Fortress, 2015.

Pieper, Josef. *Only the Lover Sings: Art and Contemplation*. San Francisco: Ignatius, 1988.

Plato. *Republic*. Chicago: IDPH Publishing, 2012. https://faculty.mtsac.edu/cmcgruder/cmcgruder/sabbatical_aesthetics/republic.pdf.

Pogrebin, Robin. "Banana Splits: Spoiled by Its Own Success, the $120,000 Fruit is Gone." *New York Times*, December 8, 2019. https://www.nytimes.com/2019/12/08/arts/design/banana-removed-art-basel.html.

Polkinghorne, John. *Quantum Physics and Theology: An Unexpected Kinship*. Princeton, NJ: Yale University Press, 2008.

———. "The Work of Love: Creation as Kenosis." *Pro Ecclesia: A Journal of Catholic and Evangelical Theology* 11.3 (2002) 374–76. https://journals.sagepub.com/doi/abs/10.1177/106385120201100313.

Pseudo-Dionysius the Areopagite. *Divine Names*. Translated by John Parker. N.p.: Createspace, 2015. Kindle ed.

Rahner, Karl. "Art against the Horizon of Theology and Piety." In *Theological Investigations: Humane Society and the Church of Tomorrow*, 22:162–69. New York: Crossroad, 1991.

———. *Hearer of the Word*. New York: Continuum, 1968.

———. *Spirit in the World*. New York: Continuum, 1968.

Ramos, Alice M. *Dynamic Transcendentals: Truth, Goodness, and Beauty from a Thomistic Perspective*. Washington, DC: The Catholic University of America Press, 2012.

Romaine, James. *Art as Spiritual Perception: Essays in Honor of E. John Walford*. Wheaton, IL: Crossway, 2012.

Sammon, Brendan Thomas. *Called to Attraction: An Introduction to the Theology of Beauty*. Eugene, OR: Cascade, 2017.

———. *The God Who Is Beauty: Beauty as Divine Names in Thomas Aquinas and Dionysus the Areopagite*. Princeton Theological Monograph. Eugene, OR: Pickwick, 2013.

Sartwell, Crispin. "Beauty." *Stanford Encyclopedia of Philosophy*. Edited by Edward N. Zalta. October 5, 2016. https://plato.stanford.edu/entries/beauty/.

Schaeffer, Francis. *Art and the Bible*. Downers Grove, IL: InterVarsity, 1973.

Schindler, David L. *Hans Urs von Balthasar: His Life and Work*. San Francisco: Ignatius, 1991.

Schindler, D. C. *Love and the Postmodern Predicament: Rediscovering the Real in Beauty, Goodness, and Truth*. Eugene, OR: Cascade, 2018.

———. "On the Classical and Christian Understanding." *Mars Hill Audio* 147, Pt. 1 (Summer 2020). https://marshillaudio.org/catalog/volume-147.

Schmidt, Thomas. *A Scandalous Beauty: The Artistry of God and the Way of the Cross*. Grand Rapid, MI: Brazos, 2002.

Scruton, Roger. *Beauty: A Very Short Introduction*. Oxford: Oxford University Press, 2011.

Sepp, Hans Rainer, and Leter Embree, eds. *Handbook of Phenomenological Aesthetics*. London: Springer, 2010.

Sevier, Christopher Scott. *Aquinas on Beauty*. New York: Lexington, 2015.

Siedell, Daniel A. *Who's Afraid of Modern Art: Essays on Modern Art and Theology in Conversation*. Eugene, OR: Cascade, 2015.

Silvermann, Allan. "Plato's Middle Period Metaphysics and Epistemology." *Stanford Encyclopedia of Philosophy*. Edited by Edward N. Zalta. July 14, 2014. https://plato.stanford.edu/entries/plato-metaphysics/.

Smart, Christopher. *A Selection of Poetry*. Edited by David Wheeler. N.p.: Creatspace, 2012.

Sammon, Brendan Thomas. *Called to Attraction: An Introduction to the Theology of Beauty*. Eugene, OR: Cascade, 2017.

Spicher, Michael R. "Medieval Theories of Aesthetics." https://iep.utm.edu/m-aesthe/.

Stecker, Robert. "Plato." In *Aesthetics: Key Thinkers*, edited by Alessandro Giovannelli, 8–20. London: Continuum, 2012.

Stratton, Tim. "Objective Beauty & the Existence of God." *Free Thinking Ministries* (blog), July 23, 2018. https://freethinkingministries.com/objective-beauty-the-existence-of-god/.

Strong, James. *Strong's Lexicon and Concordance*. https://www.blueletterbible.org/lang/lexicon/lexicon.cfm?t=kjv&strongs=h5278.

Stott, John, *Authentic Christianity*. Downers Grove, IL: InterVarsity, 1995.

Thornton, Sarah. *Seven Days in the Art World*. New York: Norton, 2009.

Turley, Stephen R. *Awaking Wonder: Truth, Goodness, and Beauty*. Camp Hill, PA: Classical Academic Press, 2014.

Turner, Steve. *Pop Cultured: Thinking Christianly About Style, Media and Entertainment*. Downers Grove, IL: InterVarsity, 2013.

Van Inwagen, Peter. *Existence: Essays in Ontology*. Cambridge: Cambridge University Press, 2014.

———. *Metaphysics*. Boulder, CO: Westview, 2015.

Viladesau, Richard. *Theological Aesthetics: God in Imagination, Beauty, and Art*. Oxford: Oxford University Press, 1999.

———. *Theology and the Arts: Encountering God through Music, Art, and Rhetoric*. New York: Paulist, 2000.

Walford, John. *Great Themes in Art*. Upper Saddle River, NJ: Prentice Hall, 2002.

Wilder, Amos Niven. *Theopoetic: Theology and the Religious Imagination*. Lima, OH: Academic Renewal, 2001.

Wilson, Nancy. "Duke Ellington: 'The Maestro,' Pt. 1." *NPR Music*, November 7, 2007. https://www.npr.org/2007/11/07/16054497/duke-ellington-the-maestro-pt-1.

Wolterstorff, Nicholas. *Art in Action: Toward a Christian Aesthetic*. Grand Rapids, MI: Eerdmans, 1980.

———. *Art Rethought: The Social Practices of Art*. Oxford: Oxford University Press, 2015.